1978

ARTISTS AND WRITERS IN REVOLT

ARTISTS AND WRITERS
IN REVOLT

The Pre-Raphaelites

❦❧❦❧❦❧

Audrey Williamson

PHILADELPHIA
THE ART ALLIANCE PRESS

First American edition published 1976 by
Associated University Presses, Inc.,
Cranbury, N. J. 08512

Library of Congress Catalog Card Number: 76-40504
ISBN 0-87982-022-5

Printed in Great Britain

Contents

Preface

The Pre-Raphaelite movement, it is often forgotten, launched not only artists but writers. It was a poetic, socialistic and philosophic revolt, even although the first impetus was visual—a splendid outburst of pellucid medieval colour that transformed an art world stifling under thick brown layers of Royal Academy varnish. John Ruskin was its first valuable supporter, and Ruskin's brand of philosophic socialism, expressed above all in *Unto This Last,* also had lasting effects on the progress and development of the movement.

For the movement was not static. It absorbed cross-currents of styles and ideas. Each new recruit brought something of his own personality, and his own gifts, to the general pool, and in the end the personal lives interlocked no less than the work. None of these young men in revolt can be confined to one chapter; they drift in and out of each other's chapters as they drifted in and out of each other's lives, showing new facets according to the company and situation. Their women share the same tendency to interrelate, although they are very much more victims of circumstances they cannot control. Tragedy and comedy both resulted from this interplay of personality and artistic temperament; and through all the gaiety there swept, like Millais' autumn leaves, gusts of melancholy and the psychological pressures of a society restrictive and alien.

This book is an attempt to deal, to some extent, with all the factors that stimulated the revolt, which was not only against

7

conventions in life and art but also against the whole pattern of ideas and society created by the Industrial Revolution. The influences are still with us, in a number of directions.

AUDREY WILLIAMSON

Acknowledgements

It seemed to me that in a book of this nature, covering so many lives and works, references were far better kept to a minimum in the text, and the reader would better be served by a Bibliography, necessarily very selective. The books listed are the ones I myself found particularly useful, and I have indicated their special value in a few cases. I hope I have adequately acknowledged quotations.

I must, of course, thank all the art galleries who have provided illustrations, in particular John Hoole, BA, Assistant Keeper of Art at the City of Southampton Art Gallery, for information on the present whereabouts of the Perseus paintings. I am also indebted to John Gilmartin, Deputy Keeper at the City of Birmingham Art Gallery, G. L. Conran, MA, FMA, Director of the City of Manchester Art Galleries, and J. S. Dearden, Secretary and Editor of the Ruskin Association at Bembridge School, Isle of Wight. The London Library, the City of Westminster Library, the British Museum, the Tate Gallery, the Victoria and Albert Museum, and the William Morris Gallery, Walthamstow, must also be mentioned.

I am specially grateful to those friends who have given support: Joyce Marlow for exchanging Gladstone and Burne-Jones references while writing her own biography of Gladstone and his wife; Jasper Ridley for information on Mazzini, provided before the publication of his biography of Garibaldi; Mollie Hardwick for the loan of books; and Bill Goodman for most interesting

9

particulars of his researches into Bristol medieval craftsmen's records, which confirm that William Morris was apparently correct in seeing a decline in conditions for the artisan from about 1540 onwards.

A small amount of my own material comes from book and television reviews I originally wrote for *Tribune*, and I must thank Douglas Hill, the journal's Literary Editor, for the opportunity to re-use it.

The illustrations in this book are reproduced by kind permission of the following:

National Portrait Gallery (Plates 1, 2, 3, 4, 5, 14)
Tate Gallery (Plates 6, 7, 9)
City of Manchester Art Gallery (Plates 8, 12, 15, 19, 20, 27, 28)
City of Birmingham Museum and Art Gallery (Plates 10, 11, 13, 16, 17, 21, 22)
William Morris Gallery, Walthamstow (Plate 23)
Southampton Art Gallery (Plate 26)

AUDREY WILLIAMSON
London, 1975

I

Industrial Change and the Artist

The eighteenth century witnessed a scientific explosion with multiple effect on the craftsman and small industries. Replacing the hand-tool with the machine, it set in motion a growing 'division of labour', by which the artisan now increasingly had no hand in the end product. Design also became separated from the making of objects, although at the same time the growth of manufacture meant that the designer had a new, wider patronage and appreciative audience. A notable example of this was in pottery, stimulated by Josiah Wedgwood, a manufacturer who was still a radical but moving into the rich new capitalist class. The objects turned out in increasing abundance were also affected by the improvement of techniques made possible by the sifting and mixing of clays, as well as by mechanization, while the new proliferation of canal transport helped to spread the designer's work into all areas of the country. The completion of the Trent and Mersey Canal in 1777 heralded a new transport age.

The romanticism of industry was still possible, for its evil effects on the environment were not yet fully realized. The new industrial age evoked responses from both the poet and the artist. One of its more influential and versatile results was the Lunar Society in the Midlands, so named, with unintentional space-age connotations, because its members met at the time of the full moon. Its membership brought together a varied group of industrialists, scientists and writers, including Dr Erasmus

Darwin (grandfather of Charles Darwin), Matthew Boulton, James Watt and Dr Joseph Priestley, the internationally-famous chemist and Unitarian freethinker. Priestley was also a political radical, who before the end of the century was forced into emigration to America by government oppression, in the wake of Paine's *Rights of Man* and the 'treason' trials of 1794.

There was, in fact, an undercurrent of radicalism in most of these manufacturing idealists, including Josiah Wedgwood, who was actively on the sidelines of the Lunar Society and the friend of many known radicals.* At this time there was still hope that the Industrial Revolution might be used to benefit the workers as well as the management. Priestley was one of those who believed in the interaction of science and the arts. The arts, in his words, favoured 'society and humanity', which in turn stimulated all the sciences. He took from an earlier writer, David Hartley, the belief in the perfectibility of man, and indeed this idea of moral progress through education and social development inspired many of the early radicals, as well as the budding socialist movement later.

The green of the countryside was not yet totally defiled by the smoking chimneys, and science still aroused even poetic enthusiasms. Darwin's *The Botanic Garden* (1789) was written 'to inlist Imagination under the banner of Science'.

> Nymphs! you erewhile on simmering cauldrons play'd
> And call'd delighted Savery† to your aid;
> Bade round the youth explosive steam aspire
> In gathering clouds, and wing'd the wave with fire . . .
> Press'd by the ponderous air the Piston falls,
> Resistless, sliding through its iron walls . . .

* His descendant and namesake, Josiah Wedgwood, early this century became one of the first Labour MPs. 'He began as a Liberal, later joined the Labour Party, but was essentially an independent.' [C. V. Wedgwood: *The Last of the Radicals* (Cape, 1951. Reprint 1974).]

† Thomas Savery, inventor of an early steam engine, modelled on the force pump, used to work the pumps in mines to keep them dry. [Jacob Bronowski: *William Blake and the Age of Revolution* (Routledge & Kegan Paul, 1972).]

12

Darwin's theory of art was contained in the words: 'The further the artist recedes from nature, the greater novelty he is likely to produce ... Reynolds makes even portraits sublime: We admire persons in his portraits whom, in reality, we should have passed by unnoticed.'

It was just this 'sublimity', this recession from nature, that was to produce the revolt of the Pre-Raphaelites in the next century. The Royal Academy remained aloof in its world of aristocratic portraiture, further stimulated by patronage now from the richer manufacturer and tradesman. It ministered to private vanities, and the craving for immortality which had not quenched the genius of a Rembrandt, but in England was beginning to stultify. But outside the Academy there was a sudden surge of industrial awareness. Engines, factories, canals and iron bridges—the insignia of the new age—attracted a new kind of artist, moving out of the salon and studio into what was later to become the 'Black Country'. Joseph Wright of Derby produced a remarkable series of paintings depicting these vistas of quarries and furnaces, experimenting with light as the scientist experimented with the air pump in one of his most famous pictures, exhibited as early as 1768. Even Turner was fascinated by Coalbrookdale, scene of the Darby family's experiments in the application of coal-coke, in place of wood-charcoal, to the smelting of iron. Its famous single-arch cast-iron bridge, erected in 1779 over the Severn at Ironbridge, was the first of its kind in England. While Wright in 1783 used the multilit windows of Arkwright's cotton mill to heighten effects of moonlight and cloud, Turner some fourteen years later was irradiating the Coalbrookdale limekiln and its sylvan background of trees with the furnace glow of the coming century.

In a different direction, William Blake was soon turning the darker eye of the poet on the 'satanic mills' and plight of the boy chimney-sweep, and as an artist drowning the radical symbolism of his verse in a vein of pellucid mysticism and unorthodox biblical decoration, as far removed from the classic style of 'Sir Sloshua' (his name, later adopted by Rossetti, for Reynolds, the founder of the Royal Academy) as human

13

imagination could get. Blake, unique and unfollowable, was nevertheless to be an inspiration to the rebels of the next century. (Rossetti's most valued possession for many years was one of Blake's MS books, to buy which he borrowed ten shillings from his brother William. It was the sketchbook used by Blake for over thirty years, and treasured by him because it had belonged to his dead brother Robert.)

In the meantime, romanticism, the cult of nature, found expression in England in poetry, although even Wordsworth in 1788-9 was writing in *An Evening Walk* of those

> . . . to whom the harmonious doors
> Of Science have unbarred celestial stores . . .

And the indefatigable agriculturalist-traveller and commentator, Arthur Young, was registering on his tours an England bursting with experiment and engineering feats on a scale unknown since Roman Britain.

Great landscape painters and colourists like Constable, John Sell Cotman and Gainsborough were continuing a tradition based on the natural scene (though Cotman, of the thunderous clouds and whiplashed Yarmouth seas, caught steely glimpses of the lurking industrialism too); but the methods, on the whole, were a culmination of past glories. Only Turner leapt ahead to the Impressionists, especially in his later work. But his vast volume of work was little shown in his lifetime. He needed a champion to establish his genius. And that champion, John Ruskin, was to put art criticism on a totally new and revolutionary footing, and bridge the transition from the world of academic art to the world of the Pre-Raphaelites, William Morris and, ultimately, British socialism.

For the first time, art for art's sake and art as an instrument of social change were to become debatable issues, creating a ferment in both literature and painting. And the individuals who created that ferment prevised not only new movements in art, but through the extraordinary diversity of their personalities and

14

interlocking lives forged a sword which ultimately was to cut through the bonds of Victorian prudery, and end in both new social awarenesses and *fin de siècle* decadence.

II

Ruskin:
Art and the Critic

Described as 'the most eloquent and original of all writers upon art', John Ruskin was the fountain-head of the most vital developments of painting up to the time of the Impressionists. He was born on 8 February 1819, the son of a wealthy Edinburgh wine merchant settled in London. There was a possible dark psychological legacy from his grandfather, John Thomas Ruskin, who committed suicide at Bowerswell in 1817, after the death of his wife; and it was the fact that Bowerswell ten years later was bought by George Gray, Writer of the Signet in Perth, that set the scene for one of the great disasters of Ruskin's life, his marriage to George Gray's daughter Effie.

John Ruskin was an only and idolized son, whom both parents, strictly religious, were prepared to indulge in every whim of taste; and this too had its effect in forming the man. He was privately educated but entered Christ Church, Oxford, as a 'gentleman commoner', gaining the Newdigate prize for English poetry in 1839 and taking his degree in 1842.

Ruskin wrote in later life that as a boy he had 'vialfuls, as it were, of Wordsworth's reverence, Shelley's sensitiveness and Turner's accuracy all in one', and it is interesting that he showed in this no apparent knowledge of Shelley's politics, although his own social outlook was eventually to be similar. Shelley, disciple of Thomas Paine, by the mid-nineteenth century had already

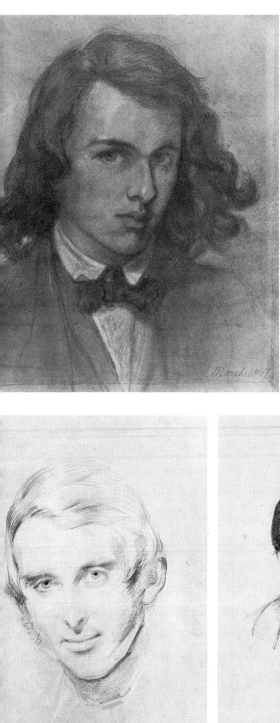

Plate 1 (*left*) Dante Gabriel Rossetti. Drawing by himself, 1847 (aged 19)

Plate 2 (*below left*) John Ruskin by G. Richmond

Plate 3 (*below right*) F. G. Stephens by Millais

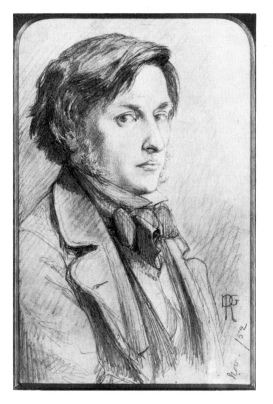

Plate 4 (*left*) Ford Madox
Brown by D. G. Rossetti

Plate 5 (*right*) Thomas
Woolner by D. G. Rossetti

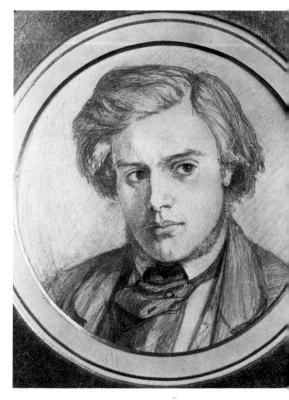

become a legend of romanticism, his best political writing still unpublished and his radicalism swept out of sight by the busy brooms of his conformist family and baronet son. Ruskin, a dutiful son, only towards the end of a long life acknowledged, with bitterness, the stultifying effect of his parents' hold over his life, and religious beliefs.

In artistic matters, however, they left him free and gave him every encouragement. He studied painting under Copley Fielding and Harding, but acknowledged as his real masters Rubens and Rembrandt. His independency of taste was shown more originally in a passion for Turner, an aged recluse whom he enthusiastically courted and of whose Will be became an executor. In 1843 the first volume of his *Modern Painters* was designed to protect Turner, then still alive, from an attack in *Blackwood's Magazine*, and to proclaim the superiority of modern landscape painters, especially Turner, to the Old Masters. In four later volumes, the last published in 1860, this design was expanded into a great treatise on the principles of art, 'interspersed with artistic and symbolical descriptions of nature, more elaborate and imaginative than any writer, prose or poetic, had ever before attempted'. It was in its time a revolutionary work, which helped to inspire a whole generation of young artists; and it set a pattern for descriptive and imaginative criticism, in all branches of the arts, until World War II changed and streamlined literary style into a kind of skeleton of word and image.

It is significant in assessing *Modern Painters* to realize that Ruskin was not only a scholar and linguist of wide classical range, he was also a student of geology, knowledge of which he had deepened on early foreign tours. In 1834 he had published, as a result of one of these tours, a paper in the magazine *Natural History*, 'On the Causes of the Colour of the Water in the Rhine and Facts and Considerations on the Strata of Mont Blanc'. During his second tour the following year he sent geological papers again to the same magazine, this time relative to stone and its changes due to exposure. In the *Architectural Magazine* he published articles on perspective. He was thus equipped in more than one direction to react with sympathetic understanding to the

Turner Exhibition of 1836, which aroused critical abuse on a wide scale, not the least in *Blackwood's Magazine* which categorized Turner's use of sunset-flame and white gamboge as 'all blood and chalk'.

'I was first driven into literature', wrote Ruskin long afterwards in *Fors Clavigera*, 'that I might defend the fame of Turner.' In essence, Part I of *Modern Painters* was this defence. It took him seven years from the time of the Turner Exhibition, and it rocketed him into fame. And this fame was not undeserved, for whatever its misjudgements upon other and especially classic painters, which Ruskin in subsequent tours of Italy came himself to acknowledge, *Modern Painters* was a panegyric of England's greatest and at the time most underrated painter, which drew on an immense range of knowledge and language. This knowledge was drawn on to analyse the very structure and variations of stone and cloud, mountain and valley, sky and chiaroscuro. It enables him to characterize 'Turner's use of one of the facts of nature not hitherto noticed, that the edge of a partially transparent body is often darker than its central surface, because at the edge the light penetrates and passes through, which from the centre is reflected to the eye. The sharp, cutting edge of a wave, if not broken into foam, frequently appears for an instant almost black; and the outlines of these massy clouds, where their projecting forms rise in relief against the light of their bodies, are almost always marked clearly and firmly by very dark edges.'

He is able to perceive with both the geologist's and artist's eye. 'All mountains, in some degree, but especially those which are composed of soft or decomposing substance, are delicately and symmetrically furrowed by the descent of streams. The traces of their action commence at the very summits, fine as threads, and multitudinous, like the uppermost branches of a delicate tree. They unite in groups as they descend, concentrating gradually into dark undulating ravines . . .' He can notice 'the grey passages about the horizon' unperceived by the old masters, and point to the daring of Turner in a still unsurpassed description of *The Fighting Temeraire*.

Take the evening effect with the Temeraire. That picture will not, at the first glance, deceive as a piece of actual sunlight; but this is because there is in it more than sunlight, because under the blazing veil of vaulted fire which lights the vessel on her last path, there is a blue, deep, desolate hollow of darkness, out of which you can hear the voice of the night wind, and the dull boom of the disturbed sea; because the cold, deadly shadows of the twilight are gathering through every sunbeam, and moment by moment as you look, you will fancy some new film and faintness of the night has risen over the vastness of the departing form.

It was a new voice in writing, just as Turner's was a new brushstroke in painting. Charlotte Brontë on reading *Modern Painters* wrote that she felt as if she had hitherto been walking blindfold, that the book seemed to give her eyes. George Eliot later referred to Ruskin as 'one of the great teachers of the day'. And Holman Hunt sat up reading the book all night, feeling as if it had been written expressly for him. It was, in the end, a bell which tolled in the whole Pre-Raphaelite movement.

In 1849 *The Seven Lamps of Architecture*, and in 1853-4 *The Stones of Venice*, extended Ruskin's reputation and influence and posed new conceptions of architecture. Both works were illustrated by Ruskin himself. A chapter in *The Stones of Venice*, 'Of the Nature of the Gothic', was to influence William Morris in his whole attitude to art and craftsmanship, based on Ruskin's belief that the vital roughness of the work of medieval sculptors and carvers was a sign of 'the life and liberty of every workman who struck the stone'—that the splendour of medieval craftsmanship derived from the pleasure of the workman in his work, and his status as an instrument in the creative process. And *The Seven Lamps* equally inspired Morris in his attacks on the artistically disastrous attempts of his time to restore ancient buildings, and indeed reached down to similar resistance to building desecration or destruction in our own age. Ruskin himself in the preface to a later edition of *The Seven Lamps of Architecture* wrote that the book had become 'the most useless I ever wrote: the buildings it describes with so much delight being now either knocked down or scraped and patched up into smugness and smoothness more

tragic than uttermost ruin'. The progress from this to Morris' later Society for the Protection of Ancient Buildings is clear.

In the development and success of another artistic revolution, into which Morris was also drawn, Ruskin had an equally decisive part: and it was a part which was to involve a profound and cathartic experience in his personal life. In 1848, 'the year of revolutions' in a more political sense, several young men, led by the painter-poet Dante Gabriel Rossetti, banded together in a brotherhood which they called 'Pre-Raphaelite', because it was based on a rejection of the now stultified 'classical' school of painting exemplified by the Royal Academy, and supposedly deriving from the Raphael tradition, and turned back to the artists who preceded Raphael in Renaissance Italy. It involved at once a 'return to nature' and a romantic medievalism: a renewed freshness and brightness of colouring achieved partly by abandoning the dark brown base of the current Royal Academy 'antique' school of painting, and the use of a white canvas, or white painted ground. Turner's white gamboge had already to some extent anticipated this, but the Pre-Raphaelites carried the lighter backgrounds to new and dangerous lengths. For the fumes of the white lead they used caused headaches, and perhaps some of the symptoms of psychosomatic illness later shown by so many of the practitioners.

The three young painters who led this new 'school' were Rossetti, William Holman Hunt and Hunt's passionately devoted friend, John Everett Millais, and the members agreed to sign their pictures only with the initials 'PR-B', in an enthusiastic and romantic emulation of the world of secret societies, so much a part of Rossetti's Italian inheritance (his father was a follower of the Italian freedom movement, the Carbonari, and had fled to exile in London). But by the time of the 1850 Academy Exhibition the secret of identity had been leaked, and a storm of critical abuse broke over the heads of the now desperate young revolutionaries. *The Times* described Hunt's *Fugitive Druids* as 'a deplorable example of perverted taste' and the influential *Athenæum* referred to the same picture and Millais' *Christ in the House of his Parents* as 'pictorial blasphemy'. Even Charles

Dickens, for reasons rather obscure (but probably connected with his Academy friends), joined in the attack with a savage misrepresentation of Millais' work in *Household Words*.

Hunt and Millais tended to blame the leak on Rossetti, who had missed the worst brunt of the attack by showing his main picture, not at the Academy, but at the Free Exhibition.* It was therefore into a distracted and slightly dissident group that Ruskin, his attention attracted to the young painters and their plight by a friend, the next year plunged with characteristic generosity. The 1851 Pre-Raphaelite entries to the Academy had provoked even greater savagery of response, what Hunt called a 'hurricane' of attacks. Ruskin went to see the pictures, and in two letters to *The Times* came out in support of a new artistic force which he felt to be of infinite promise. He did not know the artists personally, he wrote, but considered they had shown high fidelity to 'a certain order of truth and should be taken seriously'. He did more: he secured a buyer for Hunt's picture, *The Two Gentlemen of Verona*, made a personal offer for Millais' *Return of the Dove* (which had, however, already been sold), and later added a footnote to a new edition of *Modern Painters* commending the high finish of their work. More fatally to himself, he made a personal call on Millais with his young wife, Effie.

Ruskin at this time was thirty-two years of age, Effie twenty-three. She was certainly not his first love, and it was his parents' fear of a recurrence of the grave depression he had suffered over a previous disappointment in love that had induced them not to oppose his marriage to a young girl whose sociable instincts, and lightness of character, they distrusted. (Their attitude, which Ruskin Senior was unwise enough to pass on to Effie's parents, did not help Effie to settle peacefully into matrimony. And it could not have helped Ruskin, either, if it were true, as he wrote in a letter, that Effie 'does not care for pictures'.) Ruskin was entirely dependent on his father, as his writing did not yet

* So named because there was no selection of exhibits as for the Royal Academy Exhibitions. The painter paid to exhibit his works.

provide him with a living, and Mr Ruskin settled on Effie, at the time of the marriage, £10,000, the interest on which provided their basic income. He also provided an allowance and travelling expenses, on which the young couple had spent a long time in Venice, where Effie sparkled in society while Ruskin collected material for his book, *The Stones of Venice*.

There is no reason at this time to question the genuine affection of the pair; but it was a marriage in name only, some curious inhibition in Ruskin having decided him not to consummate the marriage. There are, in fact, various theories and stories as to his reason for this. One, spread by Mrs George Allen, who had been old Mrs Ruskin's maid, was that Effie had told her mother that she feared she would die if she had children, and Ruskin, hearing of this, vowed he would never be the death of any woman. It was not inconsistent with his basically gentle nature, but its source makes it suspect as a kind of post-divorce 'vindication' (Effie swiftly had a family by Millais). Another story, also not inconsistent with Ruskin's curious vein of romanticism, was that his image of women was innocently founded on the nude paintings of past and present artists, and his discovery of Effie's natural differences physically revolted him (Manet's most famous and reviled nude had not yet burst the bubble of artistic decencies). Effie herself, when passionately seeking her freedom and the annulment of the marriage, claimed that Ruskin had promised that he would 'marry' her in the full sense six years after the wedding: if so, the promise was not met, and by that time Millais' love for her had evoked in her a response that made her need for divorce doubly urgent.

This did not happen by any means at once, although soon after the visit Millais was using Effie as a willing model for several pictures. As for Ruskin, most deeply attached to his work, he was absorbed utterly in writing *The Stones of Venice*, and travelling every morning from his and Effie's new home in Camberwell to the study he still retained in his parents' house at Denmark Hill. The study was lined with the works of his beloved Turner: a collection which was to enrich the nation on his death.

He was still proud of Effie's success in society, which he himself hated, and curiously naïve, in the circumstances, about the type of temptations to which his young wife might be exposed. He seemed also unaware of his wife's critical correspondence with her own parents, concealing of course the sexual situation but showing already an irritation with Ruskin's general attitudes and character. It was based in part on a sense of daily neglect that she did not appear to realize was the lot of every young wife left at home by her working husband, and in part on a blank insensitivity to her husband's fundamental nature. Ruskin's religious questioning (on forms of religion, not yet its basic truth) was the subject of Effie's almost hysterical interpretation. He was, he patiently wrote to Mrs Gray, not contemplating Catholicism but felt he could not write more against Catholics, 'for as I have received my impressions of them from Protestant writers, I have no right to act upon these impressions until I have at least *heard* the other side'. 'He has a number of ideas of this kind which I think most dangerous', wrote Effie, 'as his mind is naturally so imaginative.'

She complained about John's extravagance in buying '£160 of Liber Studiorum' (a now immensely valuable Turner collection) as compared with her own attempts at household economy. And she was completely out of key with her husband's tolerant and already slightly socialistic leanings. He had accepted with unsnobbish kindness her uncle's misalliance with his housekeeper, bitterly resented, with typical Victorian *parvenu* snobbishness, by herself and the Gray family. 'I have been much less shocked than anybody else by the whole affair:' wrote John to her mother: 'but I have long held it for a fixed law of human nature that the best and wisest of men may lose their *heads* as well as their hearts—and what is worst their consciences—to a woman . . .'

Was John Ruskin already weighing up the consequences of losing his own heart, if not his head? Effie in her neurotic later letters, at the climax of the incipient break, was definitely to accuse him of deliberately throwing Millais and herself together in the hope of getting rid of her; but the accusation is at best

25

unproven, and Ruskin not unnaturally denied it. With the course of events in the momentous Scottish journey which John and Effie took with Millais in 1854—partly to rest the exhausted John after the completion of *The Stones of Venice*, partly to enable Millais to paint a picture of Ruskin by a waterfall near Glenfinlas—it is necessary to deal in the chapter on Millais. It was a waterfall which released a maëlstrom of later recriminations, and a situation that heralded the collapse of the Ruskin marriage. But the initial base of that collapse was in Ruskin's character and the marriage itself. He was, he had written to Mrs Gray, 'as cool headed as most men in religion—rather too much so', but this was far more deeply, though not ineradicably, applicable to his general temperament at this time. Millais, before the Scottish episode reached its climax, and perhaps even before he was fully aware of his feelings for Effie, wrote to Holman Hunt: 'Her husband is a good fellow but not of our kind, his soul is always with the clouds and out of reach of ordinary mortals.' How much Ruskin's literary soul was enmeshed in the clouds we know from *Modern Painters*. Millais may have been obliquely referring to this.

That Ruskin was impervious to emotional involvements his later ill-starred passion for Rose La Touche was to disprove; but they were volcanic eruptions in a nature often more akin to a placid, even a little snow-touched, green field in a temperate climate. His truest passion was his work, his world of ideas: 'I have hardly any real *warmth* of feeling, except for pictures and mountains', he wrote to his father. '. . . I have no love of gaiety as people call it . . . whatever I do love I have indulged myself in.'

It was hardly an uncritical self-estimate. In a remarkably candid letter to Rossetti later, Ruskin was to write: 'I am very self-indulgent, very proud, very obstinate, and *very* resentful; on the other side, I am very upright—nearly as just I suppose as it is possible for a man to be in this world—exceedingly fond of making people happy . . .' And he added: 'It seems to me that one man is made one way, and one another—the measure of effort and self-denial can never be known, except by each conscience to itself.' It was a balanced and uncensorious comment

26

on the variations of human nature that not all—least of all, all critics—are capable of making.

His reasoning on the breakdown of his marriage at the time was clear enough:

> Looking back on myself—I find no change in myself from a boy . . . from a child except the natural changes wrought by age. I am exactly the same creature . . . in temper—in likings—in weaknesses: much wiser—knowing more and thinking more: but in character precisely the same—so is Effie. When we married, I expected to change *her* . . . she expected to change *me*. Neither have succeeded, and both are displeased.

Yet Ruskin was not cold: all (including even Millais) stressed his gentleness. His warmth was for pictures as he said, but it was also for a wider spectrum of humanity than the closely personal. It led him in the end to socialism: a caring for humanity as a whole, the nature of social justice and the betterment of conditions: something that, in spite of his own self-indulgences, was of wider benefit to people in the aggregate than any personal sexual attachment could have been. His detachment and apparent frigidity in this were not unlike those of two other humanitarian writers, Thomas Paine and Bernard Shaw, both of whom also appear to have had unconsummated marriages. 'The more I see of the world the more I find the warm-feeling people liable to go wrong in a hundred ways that quiet people don't', he wrote to his father. It was extraordinarily close to a sentiment expressed by Shaw's Dick Dudgeon, in his play *The Devil's Disciple*, when he said he had always been suspicious of the self-sacrifice that sprang from a red-hot emotion.

Whatever the psychological inhibitions or hidden stresses that dictated Ruskin's attitude in his marriage, he showed himself singularly free from the neurotic resentments that wracked Millais and Effie over the affair (could this have been unconscious guilt complex on their part?). Remarkably in a critic, he never apparently allowed personal feelings to influence his artistic judgement, at least with regard to Millais. He had the curious

naïvety of the naturally kind, showing hurt and surprise even when Millais, after Effie's divorce and remarriage, refused to renew the friendship. He continued to admire Millais' work and praise his pictures. It was only in later life, when the whole affair over Effie had receded, that Ruskin attacked Millais' work —the work of a revolutionary artist who had toed the line of success and least resistance, and become an honoured Academician. If he had artistic enthusiasm, the crusading spirit which is behind all the greatest criticism, he also had artistic honesty and detachment, which are among the critic's rarer qualities. His judgements could be unsound: but they were not unsound for the wrong reasons, at least for the major part of his life. In age, with its darkening mental pressures, it was sometimes a different story.

In old age, in spite of this recurring mental breakdown, he kept his passion for his work, and indeed for that of many others, intact. He had one great later love for a woman, Rose La Touche, in which for the first time he showed in his letters real and bitter appreciation of the damage Effie's proclamation of his failure as a husband had done to his chances of happiness. What he may not have known was that Rose's mother had written to Effie and received in reply a letter of such deliberately damaging content to Ruskin that all hope of his marriage to Rose was ended. He denied impotence strenuously, although how much to protect his reputation and how much from real knowledge of his capacity it is difficult, on the evidence, to say.

His reaction to Effie's unexpected flight to her parents and plea for annulment was one of slight shock but greater courage. To Effie's baffled fury (she seemed to take it as a personal affront) he made a point of being seen in society and at exhibitions, and wrote a letter to *The Times* as calmly as if his name were not being bandied about in quite a different context. He left a little later for a Swiss tour with his parents only because this had, in fact, been arranged long before the marital crisis. The even tenor of his life, a life of dedicated work for art and social philosophy, resumed on his return. Whatever Ruskin locked within the recesses of his heart, was never revealed: he threw away the key.

28

Like Swinburne, he turned to the inaccessible Elizabeth Siddal, Rossetti's red-haired, mysterious model, now his ailing wife, for the feminine friendship some dim corner of his nature required. It was a companionship totally without emotional demands, safe and soothing to both sides (Lizzie, too, had her marital problems). Ruskin's gratitude was generous and uncomplaining, even when Lizzie, provided by Ruskin with money to go to Italy for her health, and indulge there in the painting he admired and encouraged, lingered instead in Paris, where she was joined by Rossetti until Ruskin's 'tin' (as Rossetti always called the elusive means of subsistence) ran out.

The story of his violent and all-consuming infatuation with Rose La Touche is strictly outside his involvement in Pre-Raphaelite history; but like his earliest emotional attachment, to Adèle Domecq, it shows a deep and inconsolable self-abandonment that makes clear how little, in comparison, his original affection for Effie Gray meant to him. 'The worst of it for *me* has long been passed' he wrote as early as 1854, when the undertow of the break with Effie had hardly subsided. His immediate reaction, as always, was the basically natural one for him of seeking gentle and entirely asexual female society: Liz Siddal, so soon to die, was only the first of his 'platonics', as Mary Shelley called her husband's more questionable Italian devotions.

In a sense, this was Rose's rôle at first. She was a precocious child of only ten years when Ruskin first became enamoured of her. But it was no ordinary and idle child-complex, for unlike the little-girl friendships of, for example, Lewis Carroll, it continued and indeed grew into an exclusive obsession until the child was a woman in her twenties, herself torn between a growing love for Ruskin and the barriers which Victorian sex morality and religious conformity placed between the two. Parental disapproval, rumours of the Ruskin divorce, a kind of sexual petrification and something which grew, in the end, into religious mania destroyed Rose, burdened with a sense of Ruskin's nameless guilt in the matter of his divorce and his loss of faith: divisions which he became too inhibited and over-sensitive to dispel or justify.

29

The torment of this luckless pair in the self-inflicted inferno of Victorian puritanism and religiosity makes clear the inevitability of the reaction to permissiveness in our own society. Ruskin himself, unable either to deny his religious doubts or to live with them, was almost equally shattered. He could at once see clearly Rose's dilemma, and be appalled by it, while becoming powerless to fight the mental darkness that fitfully accompanied his loss of faith. 'The sky is covered with grey cloud; not rain cloud, but a dry black veil, which no ray of sun can pierce.' Shelley put it another way:

> When the lamp is shattered
> The light in the dust lies dead—
> When the cloud is scattered
> The rainbow's glory is shed.

In the end, this was Ruskin's tragedy, even although he was, nearly to the end of a long life, able to gather together the shattered fragments and for periods light once again the almost burnt-out wick.

To classify him as a psychiatric lover of little girls, as has sometimes been done, does not actually fit Ruskin's case. This was in the end an adult passion, and an adult tragedy. The progressive girls' school, Winnington Hall, Cheshire, run by one of his sturdy admirers, Miss Bell, which Ruskin often visited (as did many others, sometimes with him), was really a part of his educational enthusiasms. He also took an interest in boys' schools. Certainly he was charmed by the girls and gravely danced with the older ones at school balls; but there is no evidence that he looked on them with anything more than the aesthetic pleasure with which he would regard a Cumberland cloud formation or a group of butterflies. His heart remained with Rose. The preference for young girls was and is in any case not a Ruskinian but an English male characteristic. Old men traditionally married (and still marry, in this age of divorce) very young wives, and the Victorian vice (which was also a self-protective device against disease) of seeking little girls of twelve or thirteen years in brothels was something the idealistic Ruskin

would have looked on (if indeed he was aware of it) with revulsion.

In the end, although he travelled with her letters in a rosewood box for many years after her death, he came to some kind of resignation, even about Rose. 'There is no use in trying to keep with us those who are not of this world', he was able to write; 'one might as well try to keep a rainbow.' Essentially, in his socialism as well as his love for at least two women, he was a romantic and an idealist. And like other humanitarians, romantic and the opposite (Shelley, Bernard Shaw, Albert Schweitzer), his reverence for life extended to the animal world. 'I would rather watch a seagull fly than shoot it, and rather hear a thrush sing than eat it . . .' ('Reverence for life' was his own phrase, used first in *The Eagle's Nest* and later adopted by Dr Schweitzer.) In the end, he resigned from the University when it endowed the study of vivisection.

Art has many facets, and Ruskin's interests spread wide. His was the type of wide-ranging mind that was a feature of the eighteenth-century Enlightenment, and still lapped over into the following century, before the division of what C. P. Snow has called 'the two cultures'. But his scientific awareness took a different course: surrounded by the growing, blackening evidences of the Industrial Revolution, with the search for material wealth on the one hand, and appalling squalor and heaviness of labour on the other, Ruskin fought all his life these aspects of political economy and attacked them in particular in *Munera Pulveris*.

True political economy, in his creed, was neither an art nor a science; it was a moral and legislative system, intended to provide happiness and ample provision for the population, the 'multiplication of human life at the highest standard'. By this Ruskin meant beauty, intelligence and moral character, in the rather smug and restrictive moral terms of the Victorian age; but he carried the theme much further than that. It was with him a political philosophy which should deal, as one historian put it, 'with the relation of master to servant, employer to workman, of the state to its subjects, with the province of sanitary and commercial legislation, and with the duty of the state in promoting

31

education, suppressing luxury, regulating the hours and wages of labour'.

It may be a strange ambivalency that some of this should come from a man who had never thought to question his right to live on his parents, so that he could fulfil himself as a writer. Probably Ruskin's crusading instincts, as well as a degree of personal egoism, were far too strong for him to question the means. He committed himself absolutely to the Working Men's College, at which he lectured regularly for the furthering of education and technical skills, and in the middle of his Scottish tour had given a course of four lectures at Edinburgh covering Architecture, Decoration, Turner and his Works, and Pre-Raphaelitism. In one of his most forward-looking if abortive experiments, he devoted much of his inherited fortune to founding the St George's Guild, intended as a form of agricultural community in which we read hints of 'hippie' communities, and the Israeli communes, later.

He continued to pour out books and articles on every aspect of art, architecture, sculpture and social ideas, and although his work was not directly political it formed a kind of yeast in the rise of more committed ideas of social reform and revolution later. His socialism and its influence (particularly on Morris) are the subjects of a later chapter, but it flowed alongside his wider aesthetic interests and never superseded them. These extended to a remarkable range of studies, often originally delivered in lecture form. His lecture on *Modern Manufacture and Design*, given at Bradford in 1859, was an historical spur to Morris and the famous Pre-Raphaelite 'Firm'. 'We have at present no good ornamental design', said Ruskin. His hopes lay in the schools of art then hardly envisaged outside London, and which Burne-Jones among others was very prominently, later, to support.

Even in lecturing, his feeling for the fine phrase did not desert him: 'the names of great painters are like passing bells' is a sentence which rings out from this lecture given among the 'satanic mills' of the north. The year before, he had astonished Tunbridge Wells, in the heart of rural Kent, with an exposition, *The Work of Iron, in Nature, Art and Policy*, in which his geologi-

cal resources were used as a base for a study of post-industrial uses of iron and the advocacy, again, of improvements in design of everything from iron railings to gates and balconies. It pointed out the beauties of Swiss and Italian balconies and referred to 'a rich naturalist school at Fribourg, where a few bell-handles are still left, consisting of rods branched into laurel and other leafage'. It went on, indefatigably, to discuss fetters and ploughs, with a sideline on social policy: 'We buy our liveries, and gild our prayer-books, with pilfered pence out of children's and sick men's wages . . . this is only one form of common oppression of the poor—only one way of taking our hands off the plough-handle, and binding another's upon it.' Cheap labour, and speculation, were already themes which to Ruskin were ineradicably involved with the artistic product. In this he was an heir to the Lunar Society idealists at the birth of the Industrial Revolution.

Unlike many prophets (and especially revolutionary prophets), he was not only honoured in his own country in his lifetime, but honoured on an extensive scale. From 1869 to 1879 he was Slade Professor of Art at Oxford; and in 1871 he was given the degree of LL.D. by Cambridge University. The same year he donated £5,000 for the endowment of a master of drawing at Oxford, and subsequently founded a museum at Walkley, near Sheffield, which in 1890 was transferred to Sheffield itself. Part of his great library and art collection was housed there, and the rest still enrich many galleries and museums.

He died on 20 January 1900, on the very edge of a century which was to reverse many of his artistic ideals and bring others into new and startling focus: a world which was to abandon his gift of literary description for a visual outlook he almost certainly would not have understood, as he failed to understand either Whistler or the French Impressionists—hardly seeming to notice their echo of the experiments with light and image first indulged in by his idol Turner.

In some ways this was not surprising, for in spite of his long and devoted hours cataloguing Turner's works, and his youthful idolization of the painter, Ruskin, like the rest of his world, never

understood Turner's ultimate period; the explosions of sunlight on indefinable objects which so haunted the dying painter's mind that his last words reputedly were 'The sun is God'. Turner himself must have realized this; he accepted the idolatry but never entirely the idolizer, as Ruskin admitted: showing, in fact, very much the same reaction as Rossetti to the critic as at best only a partial evaluer of the artist. In later life, Ruskin's clash with Whistler in a libel action merely emphasized the widening gap between the critical amateur, with a marvellous gift for words, and the artist as creator and innovator, thrusting his brush through the canvas of current taste.

In spite of his sexual neutrality and Protestant morality, and his inability to accept his own atheism without being mentally disturbed by it, Ruskin was, nevertheless, the first link in the chain-reaction that brought together so many of the artistically-inclined young men of his century, in a revolt against Victorianism in its more crushing aspects of art and society.

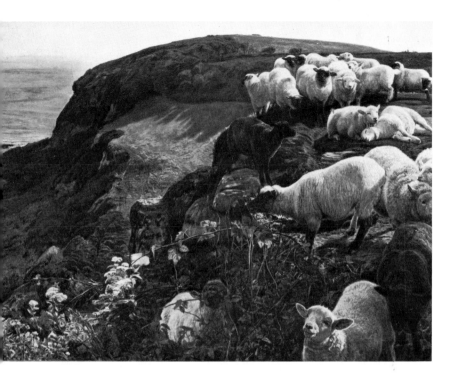

Plate 6 (*above*) Strayed Sheep by W. Holman Hunt
Plate 7 (*below*) Ophelia (Elizabeth Siddal) by J. E. Millais

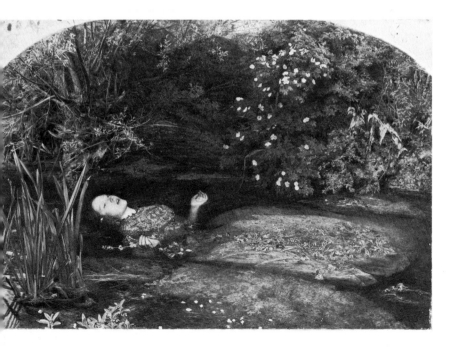

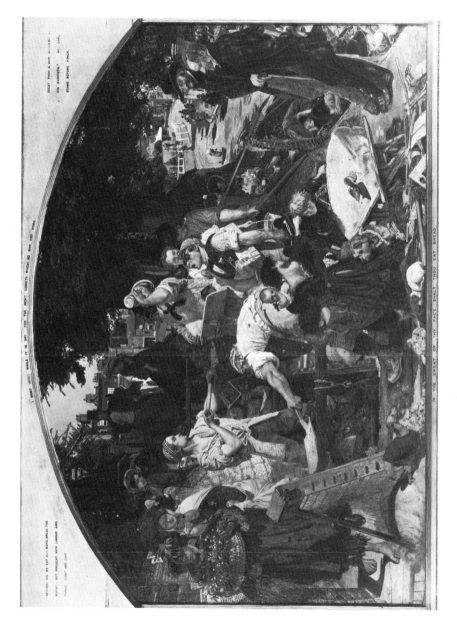

Plate 8 Work by Ford Madox Brown

III

Rossetti and Pre-Raphaelitism

Although Dante Gabriel Rossetti is usually named as the prime inspiration of Pre-Raphaelitism, it was an older painter, Ford Madox Brown, his teacher, who provided the continental links that set the ideas in motion. It was Brown also who preserved the sense of modern industrial life which still ran through the conscious romantic medievalism of the group.

Madox Brown was born at Calais in 1821 and brought up on the Continent. He trained at art school in Antwerp and after a brief period of portrait painting in England returned to Paris for three years. Here his *Parisina's Sleep* shocked patrons of the Salon, but he was still using sombre colouring when he met in Rome the German primitive painters, Overbeck and Cornelius. Known as the Nazarenes, they had founded in 1810 a new school of Catholic Art which used the story picture to point a moral, and at the same time developed a technique founded on bright primary colours and strong outlines. They took pride in presenting themselves as working artists and craftsmen, and Overbeck enhanced the impression by receiving visitors in a monkish costume with a black girdle. By 1845, the movement had begun to fail; but its effect on Pre-Raphaelitism a few years later was electrifying.

In 1848 Brown's *Wycliffe Reading his Translation of the Scriptures to John of Gaunt* showed the new sense of richer colouring he had gathered from his Italian inspiration, and in 1851 his *Chaucer reciting his Poetry at the Court of Edward III* continued

c 37

the style, but now with the glowing lightness which was a feature of early Pre-Raphaelitism. As in his more famous, because more socially stimulating, picture, *Work*, its pyramidal construction and multitude of figures were achieved with a masterly sense of composition and character, and the pastel transparency of the sky was reflected in Chaucer's pearl-grey gown and the yellow of the Court jester in cap and bells.

The young artist who sat for the head of Chaucer was Dante Gabriel Rossetti, born in England on 12 May 1828 of an Italian father and a mother whose maiden name was Polidori, although she was of part-English extraction. Her mother was sister of that Dr John Polidori who was associated with Byron in Italy; and the literary connection was apt, for in the young Gabriel Charles Dante Rossetti there early glowed a passion for verse-making no less than painting. This was stimulated by parental influence, for his father was an authority on the works of Dante.

His awareness of the great Italian poet of the *Inferno* and the *Vita Nuova* was therefore acute, and he quickly made 'Dante' his first name and dropped the more mundane English 'Charles' (although he was always called Gabriel by his friends). A passion for Keats (then hardly known in his native country) soon followed, and was also reflected in his work as a painter. His literary interests were further stimulated by meetings with Browning and Leigh Hunt. Both Browning and his wife became friends, although Hunt, whose journey to Italy to found a journal with Byron had unwittingly led to Shelley's death, advised the boy against a literary career.* But Shelley, too, had insinuated himself lyrically into the young Rossetti's mind, so that when in 1848 he saw Madox Brown's *Wycliffe* at the Free Exhibition, he wrote, much as the young Shelley had done to Godwin, to the painter expressing his passionate admiration, and begging to be taken as his pupil.

It was by a similar method of self-introduction that he had made the acquaintance of Browning, for Rossetti's acute poetic 'ear' had recognized Browning's style in the poem of *Pauline*,

* Shelley had been drowned while sailing back to Leghorn after a visit to Byron and the newly arrived Leigh Hunt.

published at the time anonymously, and he had written, with characteristic enthusiasm, to tell the poet so. Brown (a more modest man, distrusting Italianate excesses of expression) turned up at the Rossetti family's house believing he had been mocked and prepared to give battle. He was almost immediately won over by the charm of the household and accepted Gabriel as a pupil without fee. Brown's wife had died on the way back from Italy and the closely-knit Rossetti family offered him solace and a refuge. Many years later, his daughter Lucy married Gabriel's brother William Michael, himself one of the principal chroniclers of the Pre-Raphaelite movement.

Like many of divided artistic interests, Rossetti in youth had a tendency to by-pass application. He read aloud poetry to the artist while sitting for the head of Chaucer, and when Brown suggested he should attend the Life Class at Heatherley's Art School, his pupil did not remain there long. The result was a certain lack of fundamental technique which Rossetti, in later life, learned to regret, and only slowly to overcome. He took some lessons in perspective from a young contemporary, William Holman Hunt, whose *Eve of St Agnes*, based on Keats' poem, he had admired at the 1848 Royal Academy Exhibition, and when the group was joined by Hunt's devoted friend, John Everett Millais, the scene was set for the new painting ideals which they came to call 'Pre-Raphaelite'. Rossetti had been particularly delighted to find a passage in Monckton Milnes' *Life of Keats* showing that Keats, too, had come across a folio of the first and second schools of Italian painting and concluded 'that some of the early men surpassed even Raphael himself'.

Holman Hunt in an article on Pre-Raphaelitism in Chambers' Encyclopaedia many years later, carefully analysed something of the decadence in the Academy school of painting which had now, in the mid-nineteenth century, become atrophied in mediocrity through attempting merely to repeat the style of its greater eighteenth-century founder, Reynolds, and academicians of his time. He refers with appreciation to the landscapes of Wilson, the brilliant originality and social dramatisations of Hogarth, and animal painters such as Stubbs (now, he writes,

39

surprisingly to us today, 'well-nigh forgotten'). It was Constable, he points out, who in 1821 had prophesied: 'in thirty years English art will cease to exist'. And thirty years later the prophecy was fulfilled at the death of Turner.

'It remained for the young generation', writes Hunt, 'to find out what lay at the root of the decay and also its remedy.' Hunt at nineteen and Millais at seventeen were among that generation already discussing a new 'return to nature', although the meticulous draughtsmanship of leaves and flowers, and translucent brilliancy of emerald and scarlet, shown, for instance, in Millais' *Ophelia* in 1852, make it difficult to imagine why such a technique and paintwork could ever be confused with the altogether softer, more yellowish greens of true English landscape. Hunt's sheep, pink-sheened of fleece and ear, are equally stunning and symbolic, in spite of the deliberate enhancement of the sunset. The very brightness of such early Pre-Raphaelite pictures was an exoticism, hardly less than the Malory- and Keats-inspired subjects which reflected their romantic medieval story-telling. This had arisen partly from a visit to Millais' family home in Gower Street, to study Lasinio's engravings of the Campo Santo frescoes in Pisa. Ruskin did not admire these works, but to the three youths they were an opening door.

It was Rossetti, always the spirited activist, who really framed the whole idea of the Pre-Raphaelite Brotherhood. 'Of course', wrote Madox Brown in old age, 'it was Rossetti who kept things going by his talking, or it wouldn't have lasted as long as it did, and he really talked them into founding it.' Possibly it was a throwback to his Italian origins, with its history of secret societies. His father, as has been stated, had been one of the revolutionary radicals, the Carbonari, which preceded Mazzini's Young Italy movement and Garibaldi's own revolutionary activities in Italy, and he had been forced into exile as a direct result.

Rossetti's personality was itself a kind of international paradox. With the mercurial temperament and passionate blood of the South he combined a Victorian sense of preserving the proprieties and a studied Cockney 'patter' which he used as a kind

of anchor to convince himself of his own 'Englishness'. Women to him were 'stunners', money invariably 'tin'. He never evinced the slightest desire to visit the land of his forefathers—extraordinary enough in any painter—and in fact never did so. What one of his biographers, Rosalie Glynn Grylls, has called illuminatingly the *'chiaroscuro* in his personality' made him a figure of contradictions, and not the least of these was the sense of domestic responsibility which forced him to cling to those models who became his mistresses. He never discarded even the highly self-sufficient and acquisitive Fanny Cornforth, who represented the sensual side of his work, and he married the lovely, more spiritual Elizabeth Siddal too late for their own happiness.

It has been suggested that Lizzie's own rigidly conventional lower-middle-class background and temperament forced Rossetti into the union; but it is true only to a degree. Rossetti himself felt the responsibility keenly as well as genuine concern for her, although by the date of the wedding (1860) there is some indication that he was already in love also with Janey Morris: the wife of one of his younger friends in the group who, with her dark brooding beauty and crinkled hair, became their prototype of Guinevere and Proserpine. Yet Jane Morris too—born Jane Burden, the daughter of an Oxford stable-groom—had her roots in Victorian conventionality. In her whole equivocal relationship with Rossetti the hint of a *ménage-à-trois* was somehow smoothed over with the decencies observed. For Jane, her young daughters, constantly with her, and her uses as a model, were the protective shield. Lizzie had no such defences; and for her the ending was tragedy.

The original Pre-Raphaelite Brotherhood, in addition to Rossetti, Hunt and Millais, included five other friends of the art world: William Michael Rossetti, Gabriel's devoted younger brother; James Collinson; Frederick George Stephens; Alexander Munro and Thomas Woolner. The last two were sculptors; William Rossetti and Stephens became art critics, extremely useful to the fraternity (Holman Hunt's attractive but conventional portrait of Stephens remains in the Tate Gallery); and

41

Collinson early dropped out. He was at one time engaged to Dante's sister, the pious and poetic Christina Rossetti, and he is today one of the most neglected of the original group, although his splendid study for the oil painting, *The Renunciation of Queen Elizabeth of Hungary*, in the City of Birmingham Museum and Art Gallery, is only one of his works which suggests his talent is underestimated. His defection from the group arose through his becoming a Catholic in 1852 and joining a religious community.

Closely associated later, and still highly regarded, were Arthur Hughes (painter of *April Love*) and Walter Howell Deverell, but the official Brotherhood ranks were closed by Holman Hunt before either could be included. Hughes' talent was for a Spring-like tenderness in the painting of tryst and lovers: Ruskin described *April Love* as 'exquisite in every way: lovely in colour, most subtle in the quivering expression of the lips and sweetness of the tender face, shaken, like a leaf by winds upon its dew, and hesitating back into place'. Walter Deverell was American born, the son of a professor at Virginia's new University, which had been designed by Thomas Jefferson. He died tragically young, at twenty-seven, but left several works still in British art galleries including the very Pre-Raphaelite *The Pet*—the figure of a girl with her caged bird—now in the Tate Gallery. Right outside the Brotherhood, yet greatly influenced by it, was Henry Wallis, whose glowing, idealized *Death of Chatterton*, with hair streaming like flame from bed to floor, around a deathly-white face, is also in the Tate.

Stephens, like Madox Brown, whose most famous picture was entitled *Work*, felt social stirrings, the impact of the Industrial Revolution on the artist. As he wrote:

> There is something else we miss: there is the poetry of the things about us: our railways, factories, mines, roaring cities, steam vessels, and the endless novelties and wonders produced every day.

This echo of eighteenth-century romanticism about the machine age was rejected almost wholly by Rossetti, Millais and the later convert, Morris' closest friend, Edward Burne-Jones. But Bell

Scott's *Iron and Coal* and Walter Howell Deverell's striking depiction of the poverty created by industrial and social conditions, *The Irish Beggars* (now in the Johannesburg Art Gallery), no less than Madox Brown's *Work* (with its Pre-Raphaelite insistence on a genuine location, Heath Street, Hampstead) gave a new social dimension to the Joseph Wright and Paul Sandby mills and furnaces. The Pre-Raphaelite concentration was not on the mills and factories themselves, but the people within and outside them. When Woolner and a friend emigrated to Australia to dig for gold, and the 'brothers' went to the docks to bid them farewell, it became the subject of Madox Brown's next picture, *The Last of England,* in which the whole emphasis is on the saddened faces of the husband and wife, pale and drawn by poverty, leaving the English shores. (Woolner later returned to England, without the hoped-for wealth but with a new, and it is said, conceited sense of values. He became extremely popular as a maker of medallions in low relief, and was in 1867 commissioned to sculpt the statue of Lord Palmerston in Palace Yard, Westminster.)

For the rest, 'nature' was supplemented by medieval figures and stories, and scenes and backgrounds in which the leaves and poppies, as in *Ophelia,* often glitter like stars.* It was Walter Deverell who discovered Elizabeth Siddal, the model for Millais' Ophelia, working in a milliner's shop off Leicester Square. She was sixteen years of age; and Deverell had to bring along his mother to persuade her of the rigid respectability of his and his friends' intentions. More than his works, it has become his main claim to immortality. To depict the drowned Ophelia, Lizzie lay all day, for several days, in a bath of water, inadequately warmed by candles, and no one seems to have suggested how much her later ill-health may have owed to this uncomfortable experience. She was to be used as model by several of the group, her red-

* The fame of the Millais work has overshadowed Arthur Hughes' *Ophelia*— a charming and fragile figure sitting on a tree trunk and gazing into the inviting stream—which was exhibited at the same 1852 Academy Exhibition. Neither artist was aware till varnishing day of their identical choice of subject. The Hughes picture is now in the Manchester City Art Gallery, Millais' in the Tate.

gold hair and air of spirituality becoming almost an incarnation of Pre-Raphaelitism, until the dark gypsy melancholy of the full-lipped Jane Morris re-set the image in a subtly different, yet still medieval, tone. 'It's hard to say', wrote Henry James after meeting Janey, 'whether she's a grand synthesis of all the Pre-Raphaelite pictures ever made or they a "keen analysis" of her—whether she's an original or a copy.'

Both women were slim, with that flexible suppleness of contour about which the clothes of a past age cling in elegantly-flowing lines (in a sense, these medieval dresses represented a rebellion by the artist against the increasingly restrictive and bulbous nature of the Victorian crinoline and bodice). Rossetti took immense pains to obtain these clothes, like all the other properties he needed for his pictures. 'There is another thing I want', wrote the older Rossetti in a typical (and oft repeated) style of letter from Kelmscott to his diligent amenuensis at 16 Cheyne Walk, the young Cornish artist Henry Treffry Dunn: '— to wit, a dragon-fly or two to paint in my picture, you know they are quite blue and I want one with his wings spread upwards as they do when they fly . . .' In this fanatical pursuit of 'nature' nothing was left to chance, little to the imagination: the artist was a copyist *par excellence*. The imagination was in the grouping and placing of figures, arrangement of clothes and jewels: for the artist painted strictly what he saw.

If Lizzie Siddal and Jane Morris were the spiritual or romantic figures, Fanny Cornforth of the plumper outlines and ripe-corn hair was the more sexually provocative image. How Rossetti met her is variously recounted, but he retained her through three marriages (two of hers, one of his own) in the position of model and, after Lizzie's death, 'housekeeper', although Victorian convention was observed in that she was set up in a separate 'establishment' in Royal Avenue, Chelsea. She was the model for the early picture, *Found,* on which Rossetti was working in various unfinished forms until the end of his life. It was a reflection of his obsession with prostitution, first encountered in the Cremorne pleasure gardens where Fanny claimed he first met her. The girl of the pictures, crouched in shame and degradation, has

44

been found by her rustic lover, presumably about to rescue and redeem her. He has a cart containing a calf going to market (and the calf across the years created considerably more problems than the malleable Fanny).

It was an off-shoot of the other curious facet of Rossetti's nature, his passion for animals not only as 'pets' but as inhabitants of a rather grotesque menagerie which became notorious among his visitors and neighbours. The raucous cries of peacocks, the inexplicable and much-mourned deaths of dormice and wombats, the burrowings into alarmed neighbouring territories of armadillos, and the talking talents (or otherwise) of hopefully-acquired parrots, punctuate the Rossetti story with a Disney-like riot.

The original Pre-Raphaelites published a journal, which lasted for only four issues, called *The Germ*, in which Rossetti's poem *The Blessed Damozel* was first printed, as well as some anonymous poems by his shy sister Christina. They also issued a manifesto listing their idea of 'Immortals great and good': these included Christ and Shelley from the past, and Mrs Browning and Thackeray among contemporaries.

The Blessed Damozel is still often the only Dante Gabriel Rossetti poem included in modern anthologies. Its gilded picture of the soul of the dead girl wistfully gazing down to earth, unable to throw off sensual longing for her lover, is curiously alien to our modern poetic taste.

> The blessed damozel leaned out
> From the gold bar of Heaven;
> Her eyes were deeper than the depth
> Of waters stilled at even;
> She had three lilies in her hand,
> And the stars in her hair were seven.

Rossetti wrote finer poetry later, yet something in this luminous opening stanza caught the imagination of his time, eager to escape the iron furnaces in a world of medieval-style balladry, with sentiment at the core.

Clashes with the critics notwithstanding, the young Pre-Raphaelites kept their zest. The first real tragedy to quell them was Lizzie's death in 1862, at the age of twenty-eight. There seems no doubt, now, that it was suicide: Madox Brown later admitted to his daughter that he found a note pinned to her nightdress, which he judiciously destroyed after showing it to Rossetti. Its innocent request, he claimed, was 'Please look after Harry' (Lizzie's slightly retarded invalid brother), but nothing was said of this at the time. The Pre-Raphaelite image in Victorian society must be protected, and the verdict was 'accidental death'.

Elizabeth Siddal had talents of her own: her sad ballad-style lyrics and drawings all show sensitivity, and both Rossetti and Ruskin encouraged and admired them. Doubtless she knew of Fanny and she may even have sensed the strengthening cord of Rossetti's feeling for Jane Morris. She stayed for a period, nevertheless, in the Morris' Red House, 'a ghost in the house of the living', wrote a visitor, noting the way she silently glided into the dining-room, and as silently ate and disappeared. It is hard to believe these things disturbed her to the point of suicide: they were part of the pattern of an artist's model's life. But a mystery still hangs about the affair. She had recently lost a baby born dead, and was found by Burne-Jones' young wife Georgie, who cherished her memory, rocking the empty cradle. She had wanted to give the dead baby's layette to the Burne-Jones for their expected child, but Rossetti feared it would seem a bad omen for them all. Lizzie was now once again believed to be pregnant. Always delicate, with that Victorian and possibly psychosomatic propensity to ill-health which Jane Morris also shared, she had taken to laudanum for sleep and died from an overdose of it.

Earlier in the evening she had seemed unusually vivacious and happy again at a party with several of the group and their wives at Swinburne's new 'discovery', the Leicester Square restaurant, the Sablonière, later haunted by Rimbaud. Rossetti took her home and upstairs to bed, then left to go ostensibly to the Working Men's College where he lectured on Monday evenings. No one knows really what passed between them at this last meet-

ing. When he returned at 11.30 she was dying, although he would not believe it and rushed distractedly to and fro bringing a succession of doctors. One of these was a distinguished friend, Dr John Marshall, a principal of the Royal College of Surgeons.

Lizzie lay like a wraith of the dead Ophelia, and kept her secrets. The poem she had last been working on was found by William Michael Rossetti:

> How is it in the unknown land?
> Do the dead wander hand in hand?
> Do we clasp dead hands, and quiver
> With an endless joy for ever?
> Is the air filled with sound
> Of spirits circling round and round?
> Are there lakes of endless song
> To rest our tired eyes upon?
> Do tall white angels gaze and wend
> Along the banks where lilies bend?
> Lord, we know not how this may be:
> Good Lord we put our faith in thee—
> O God, remember me.

And it was Lizzie who noted that haunting verse:

> I wish I were dead, my foe,
> My friend, I wish I were dead,
> With a stone at my tired feet
> And a stone at my tired head.

Under her hair, the hair that always enthralled him—'. . . and round his heart one strangling golden hair', as he had written— Rossetti placed in the coffin his own volume of poems: 'I have often been working at these poems when she was ill and suffering and I might have been attending to her and now they shall go.' They went for only a few years: in October 1869, with the full concurrence and it would seem urging of Swinburne and some of his friends, Rossetti allowed the coffin to be disinterred by Home Office permission and the poems rescued and published. One of those present (Rossetti, it must be emphasized, was not)

claimed that Lizzie's hair was still miraculously fresh and golden
But it was darker tresses now that strangled and enmeshed
Rossetti's heart.

After Lizzie's death, Rossetti could no longer bear the house
by the Thames at Blackfriars, Chatham Place, that he had loved
so much, for all its river smells and its enveloping river mists. He
moved to Cheyne Walk, then also (before the building of
Chelsea Embankment) close to the sights and sounds of the river
Here Dunn joined him in 1867, until, worn out by devoted
service and increasing fretfulness in the last year of Rossetti's
life, he was replaced by the young novelist, Hall Caine.

Dunn promptly fell in love with the new young model,
'Alice' or 'Alexa' Wilding. She had been found in 1865 by
Gabriel in the Strand. He characteristically begged her to come
and sit as his model but she never came. Some time later he
caught sight of her again, in the same part of the Strand: he got
out of a cab and again rushed to overtake her. This time she
really did come. She was a highly respectable girl, not very in-
telligent, with an ambition to become an actress. She sat for
Monna Vanna among other Rossetti pictures.

Rossetti himself, haunted by Lizzie, exorcized her ghost in an
increasing entanglement with Jane Morris. In 1865, the Morrises
had moved from their lovely but remote Red House in Kent to
26 Queen's Square, Bloomsbury, where the whole Pre-Raphae-
lite team, indefatigably marshalled and managed by Morris,
enthusiastically set up their design centre and business, 'The
Firm', which was intended to flood Britain with new sets of
values in decoration, manufacturing a wide variety of goods
from tiles to carpets and from curtains to stained glass. But
Morris, restless in town, still craved the peace and green of the
countryside, and eventually found an Oxfordshire mansion he
called Kelmscott Manor, and of which, by some implicit but
delicate arrangement, he shared the tenancy with Rossetti.

While Morris stayed in London working for 'The Firm', or
fled from what may well have been an emotional crisis to the
land of Icelandic saga, Rossetti and Jane quietly remained at
Kelmscott with her two children, Jenny and May. Rossetti,

48

bereft of Lizzie's dead or unborn babies, lavished genuine affection on the little girls, and May Morris, a golden-haired beauty who was later to captivate the young Bernard Shaw, returned his devotion. In the end, the joint tenancy not unnaturally collapsed, and Rossetti moved back to Tudor House in Cheyne Walk.

He was now increasingly dependent on chloral, a new American drug, for his insomnia. The drug, as modern research has proved, was innocuous in itself, but he washed it down with whisky in dangerously increasing doses. Insomnia had haunted him all his life and was the theme of one of his best poems:

> Thin are the night-skirts left behind
> By daybreak hours that onward creep,
> And think, alas! the shred of sleep
> That wavers with the spirit's wind:
> But in half-dreams that shift and roll
> And still remember and forget,
> My soul this hour has drawn your soul
> A little nearer yet.

Was it Lizzie's soul, or Janey's? Perhaps Rossetti himself was hardly sure. Yet increasing periods of persecution complex (the sensitivity to criticism became almost manic with the years) were interspersed to the end with outbursts of feverish activity on pictures and poems. In states of melancholia his friends accompanied or sent him to Scotland and Bognor for his health. In the journey to Scotland he was accompanied by Hall Caine and a 'nurse' ('nurse' being Caine's euphemism for Fanny). Janey still visited him at Bognor, ostensibly as a model, for he still worked compulsively. She was the recipient of hauntingly unhappy letters to the end. His death came at Birchington-on Sea, on Easter Sunday, 1882. He was only fifty-three.

Rossetti's obsession with the theme of prostitution which recurs in his paintings was not unique among the Pre-Raphaelites or in the Victorian age, when the traffic in young girls from the poorer classes was an almost blatant feature of London life. Many writers saw in it a social evil born of the great cleavage

49

between wealthy society and the squalor of the poor. In 1894 Shaw's *Mrs Warren's Profession* was boldly to dramatize this sociological aspect of life so sedulously swept beneath Victorian carpets, but although privately performed in 1902 by the Stage Society, the play was banned from public performance and did not receive an open London production until 1925. The only picture Victorian society would allow was the sentimental one of the 'fallen woman saved'. Dickens' Little Em'ly was the literary equivalent of the girls in the pictures *Found, Saved* and *The Awakened Conscience*.

Rossetti was a not untypical example of the Victorian male, freethinking enough to take his pleasures where he could find them, yet enough oppressed by the attitudes, in particular the religious attitudes, of his time to suffer the conflicts and complexities set up pyschologically as a result. His Latin heritage made him a particular victim of this conflict: his Italian sensuality had a Dantesque mystic side, and his poetry as well as his painting reflected both. Like Blake, whose work he so passionately admired, he was haunted by Dante's meeting with Beatrice, the *Inferno* and the *Purgatory*, and it was probably from Blake's delicate water-colours as well as the German Nazarenes that the Pre-Raphaelites first acquired their vision of painting which could be based on streams of light, not only a mahogany-like darkness. Rossetti's *The Annunication*, in 1850, a study in white with only a splash of blue sky and bed-hanging in the background, and a slim draped altar-piece of vivid red in the foreground, must have burst on the scene of Academy painting like a snow volley.

Lizzie's probable frigidity attracted Rossetti as fatally as Fanny's more opulent and freely-given charms: sacred and profane love were for him vital and warring parts of the fabric of living. With Janey, who seems to have had much of Lizzie's remoteness as well as her psychosomatic illnesses, the problems continued. The flow of letters between the two, only known and made available after her daughter May Morris' death in 1939, show his passion to have retained these heights of exultation and also these agonies of only half-fulfilment. Were they actually

lovers? It is still impossible to say for certain; although it seems likely she yielded for a period. To the end they certainly remained passionate friends; but for the ageing Rossetti, with all his Latin fire and charm, there was now, as he felt,

> The visible burden of the sun grown cold
> And the moon's labouring gaze.

The chill caught him and would not let him go, although it is not true (as was once maintained) that his work diminished in intensity. In his last year he completed a number of pictures and poems.

He was kind, generous, gay, gregarious and self-indulgent (and like Ruskin the son of indulgent parents, infinitely less rich and therefore infinitely more self-sacrificing than Ruskin's). But there was a Dantesque darkness in his soul and a sensitivity that did not, in the end, withstand two hammer-blows: the death of Lizzie Siddal which continued to haunt him, and the attack—when he was no longer young and carefree enough to throw it off—by Robert Buchanan in an essay, 'The Fleshly School of Poetry', written and published anonymously in the *Contemporary Review* in October 1871.

Buchanan was a minor poet who considered himself slighted by the Brotherhood. The Pre-Raphaelites rushed to the rescue with a countercharge: but in 1872, when Rossetti believed this was forgotten, Buchanan repeated the attack at greater length in *St Paul's Magazine* with a reference to 'an amatory foreigner, ill-acquainted with English'. Rossetti's reaction was much like that of Keats to the review of *Endymion* in *Blackwood's Magazine* which Shelley (who also knew the woundings of critics) always maintained killed the poet. It is the third-rate critic who wounds with a deadly knife: and the bad critics in all periods unfortunately exceed the good. Only the rare great critic, the true essayist who responds to some memorable performance or work of art, survives; but the very sensitivity of the major artist lays him open to melancholia when attacked, especially when there are already sorrows or illness in his personal life. It was Shelley who just before his death, at scarcely thirty years of age,

51

in one of these black depressions at the apparent failure of his work to win response or even publication in some instances, bitterly remarked that if he died now he would have lived to be older than his father: 'I am ninety years of age.' Rossetti had his sorrows too, and his warm Italianate spirit crumbled before a new and icily-projected hail of bullets. The generous in praise of others, the men without unkindness or malice, always feel these things most. The knife wounds not only the soul of the artist, but his faith in human nature. He gazes into the black, unfathomable depths of jealous malignity with startled eyes, and without succour the black hole engulfs him, as the black holes in space are surmised to engulf and suck in whole worlds, not leaving a trace.

In fact, the whole aesthetic movement was under fire, and the attack gave its name to 'Bunthorne, a Fleshly Poet', in W. S. Gilbert's comic opera *Patience* nine years later. Perhaps it was an indication of his already dying spirit that Rossetti took it so much to heart: perhaps it was also prescience. For to all schools of painting and literature there must come an end; and after twenty years the Pre-Raphaelites were in their turn being challenged by a new force, the French Impressionists, to whose genius both Ruskin and Rossetti were blind but whose works were exhibited together in London for the first time in 1874. Monet and Pissarro, in fact, had fled to England from the Siege of Paris, and although their pictures were rejected by the Royal Academy in 1871, they were shown the same year in the French Section of the International Exhibition at South Kensington. Both painted London scenes with a new eye. Did the inevitable criticism and attacks remind the Pre-Raphaelites of their own first reception by the critics, and remind them also that vilification can precede later triumph? If so, Rossetti was the one who did not live to see it: the chill of a new artistic age may have touched his shoulder, like a gust of wind in winter, that is all.

His religious attitude was equivocal, and perhaps did not help to cure his natural melancholy. His brother William Michael was a life-long rationalist (he also, unlike his brother, reflected the movement's more revolutionary tendencies and greatly

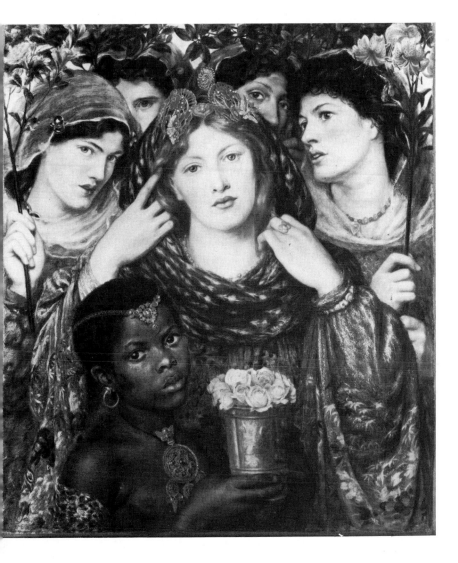

Plate 9 The Beloved, or the Bride (Fanny Cornforth) by D. G. Rossetti

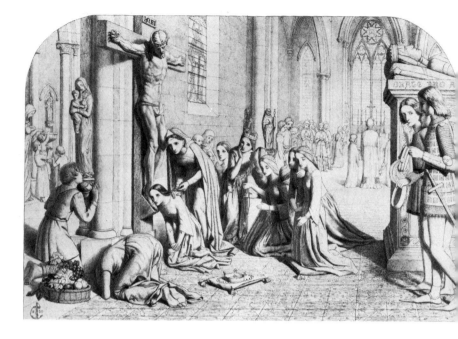

Plate 10 (*above*) The Renunciation of Queen Elizabeth of Hungary by James Collinson. Pen and Ink Study

Plate 11 (*below*) The Young Poet (Self Portrait) by Arthur Hughes

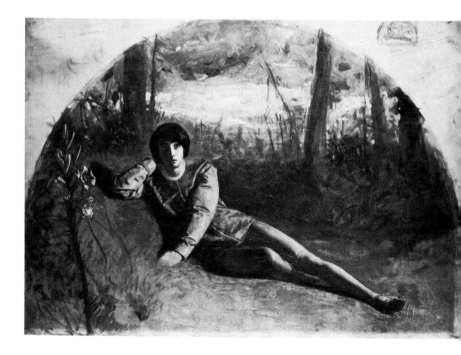

alarmed the family with 'some of his sonnets respecting "tyr-ranicide" ', as Gabriel put it). He wrote after Gabriel's death:

> My brother was unquestionably sceptical as to many alleged facts and he disregarded formulated dogmas and the practices founded upon them . . . On the other hand, his mind was naturally prone to the marvellous and the supernatural, and he had an abiding and very deep reverence for the person of Christ.

Rossetti himself wavered between doubt and a Darwinian feeling of a diffused, perhaps evolutionary, permanency: between

> Would God I knew there were a God to thank
> When thanks rise up in me!

and 'I cannot suppose that any particle of life is extinguished, though its permanent individuality may be more than questionable. Absorption is not annihilation . . .' His more poetic questionings were curiously like Lizzie's:

> Ye who have passed Death's haggard hills; and ye
> Whom trees that knew your sires shall cease to know
> And still stand silent:—is it all a show,—
> A wisp that laughs upon the wall? . . .

His legacy of paintings was not negligible and he conquered his indecisive technique in time, but they are curiously uneven in their appeal today. His *Beata Beatrix*, in which Elizabeth Siddal was modelled after her death, in a halo of red-gold hair and unearthly green light, is an uneasy picture, matching his desperately uneasy soul at the time, and he sometimes captured Lizzie with greater charm and fluency in his drawings of her. Jane Morris as Proserpine is stronger and more sweeping in its linear composition, the curve of the swan-like neck, focused by the raven-dark hair, echoed in the counter-lines and folds of the peacock-blue silken garment that ensheaths her. Where Lizzie was dimly radiant even in death, Jane was brooding, with that distinctive upper lip, too close to the nostrils, that Lizzie also displayed in a paler, less voluptuous way. It was Hunt who remarked that Rossetti painted all his models to look alike, and it

D

may be true, for when Lizzie was photographed he was totally unsatisfied, saying that no photograph caught her real likeness. Perhaps, like many beautiful or charming women, she was unphotogenic, her essence too spiritual and evanescent to be captured by anything but the brush of an imaginative artist. Perhaps Rossetti injected into all his models, especially those he loved, some idealized vision of femininity, elusive, uncapturable, like Dante's vision of Beatrice.

Fanny, whom he also loved in his way, in spite of her obvious acquisitiveness and thickening charms (he nicknamed her affectionately 'the Elephant'), came out in a bolder fashion. She was, in youth, according to Rossetti's brother William, a girl of sweet features with a mass of golden hair; and women's hair was as erotic a symbol to Rossetti as to the eighteenth-century radical painter Fuseli, Blake's friend, whose rather macabre genius undoubtedly had some influence on Rossetti. The sonnet *Body's Beauty* could have been a paean to Fanny's physical charms:

> Of Adam's first wife, Lilith, it is told
> (The witch he loved before the gift of Eve)
> That, ere the snake's, her sweet tongue could deceive,
> And her enchanted hair was the first gold.

It is this poem which ends with the revealing line:

> And round his heart one strangling golden hair.

In the first picture Rossetti did of 'Lady Lilith' Fanny was the model; and she was at her most blooming in *The Beloved*, or *The Bride*, in which her healthy blonde beauty shines in the centre of a cluster of other girls' heads, with the startling and beautifully-painted contrast of a young negress below her, wearing a pendant of lambent rubies.

Some of Rossetti's most striking work, as with many Pre-Raphaelites, was in book illustration. In the *Poems* by Tennyson published by Edward Moxon in 1857, there were illustrations by three of the Brotherhood, Rossetti, Millais and Hunt. The medieval cult, it must be remembered, was fostered in literature

as much as in art, and the selection of Pre-Raphaelite designers for Tennyson was apt.

Some magnetism in Rossetti, both as an artist and a man, won him the admiration and regard of other artists of his time: in the group he was always dominant. He was, like Ruskin (who cheerfully dismembered his precious illuminated MSS in order to give pages to his friends), extraordinarily generous, including in his judgements. 'As for what is said of Swinburne and Morris', he once wrote, 'I know that the volume and *élan* of their genius would always leave me far behind; and if I, as a rather older man, had any influence on them in early years, I feel in my turn that their work has duly reacted on what I have done since.'

Of Millais he wrote: 'I don't believe since painting began there has ever been a man more greatly endowed with the mere painter's power' (although when he heard of his election as an Associate of the Royal Academy he remarked in disgust: 'So now the whole Round Table is dissolved.'). But there remained the younger Burne-Jones: 'He has oceans of imagination and in this respect there has been nobody like him since Botticelli.' Burne-Jones, an equally generous spirit, returned in kind. When Rossetti was dying he said to Hall Caine, at the sight of an unfinished picture on the easel: 'They say Gabriel cannot draw, but look at that hand. There isn't anybody else in the world who can draw a hand like that.' It was Burne-Jones who filled in the sky in *Found*, in the most complete version of Rossetti's often-started and unfinished picture, on which he worked so despairingly all his life.

When, in the shadows that came to envelop him, as different shadows enveloped Ruskin, Rossetti snapped the threads that still bound him to others in the movement, like Burne-Jones and Swinburne, there were always deep regrets on the other side. Persecution mania brings distrust of friends and enemies alike, but it is untrue, as already stated, that with Rossetti it and chloral combined impaired his output. In his final years he seemed, indeed, at last to grasp the full technical essentials of the artist. 'There was no more of the fiddling, rubbing and scraping out, the fretful fumbling with his materials

57

of the Ruskin days', writes the art critic, William Gaunt. 'With competence and certainty he carried out large pictures and handled difficult problems in a workmanlike way that was quite surprising. "I paint by a set of unwritten but clearly-defined rules which I could teach to any man as systematically as you could teach arithmetic", he told Hall Caine, later.'* Painting, he added, was the craft of a superior carpenter; and on Caine's protest he would allow but a minimum to imagination, and that mainly in the conception. At the end, he had reached Ruskin's own belief in the scientific method in art.

He still could not always control a picture's size, and in 1869 *Dante's Dream* turned out so vast that it could only be hung over the staircase in the house of the Member of Parliament, William Graham, who commissioned it. It was eventually bought by the Walker Art Gallery, Liverpool, for the highest sum Rossetti ever earned, £1,575.

It was as a poet, rather than as a painter, that Rossetti in the end tended most to value his artistic achievement, and it could be said that Dante and Blake first set in motion his aesthetic impulses, and continued to nourish them to the end of his life. If the one was a poetic spring, the other was both literary and visual. One of Rossetti's biographers, Rosalie Glynn Grylls, considered his poetry 'much more akin to that of Blake than to any of his contemporaries'. It was to Rossetti that Alexander Gilchrist turned when writing his life of Blake, and it was Rossetti who took on the task of editing his unfinished MS when Gilchrist caught scarlatina from one of his children and died. It is true Rossetti also edited Blake in the same book ('my rather unceremonious shaking up of Blake's rhymes', as he lightly put it), but the influence was a two-way one, symbol and mysticism never moving far outside the perimeter of Rossetti's life and art.

Blake's radical politics, deeply obscured in his verse by symbolism for reasons of government suppression, Rossetti probably never grasped. The works of the English Jacobins had, by the mid-nineteenth century, been driven underground

* *The Pre-Raphaelite Dream* (1943)

too long for even the social criticism of Carlyle and Ruskin to derive anything from them. Socialism was shaping itself from new Christian and moral attitudes, owing little to the Age of Enlightenment and Reason, although Blake's unorthodox visionary style in both art and poetry had always stood outside it, and remained unique. Rossetti, of all the Pre-Raphaelites, was the one most unaffected by social and political ideas and most committed to 'art for art's sake', in Oscar Wilde's later phrase. It was, perhaps, a reaction such as one often finds from his father's earlier commitment, which had led to political exile. Only a few of his poems were political. In Rossetti the cult of aestheticism really had its first disciple, although when the Aesthetic Movement as such began to emerge he repudiated it, disliking both its excesses and its lack of virility.

Dante haunted him to the end, and Dante's Beatrice through both Elizabeth Siddal and Jane Morris.

> Of Florence and of Beatrice
> Servant and singer from of old,
> O'er Dante's heart in youth had toll'd
> The knell that gave his Lady peace;
> And now in manhood flew the dart
> Wherewith his City pierced his heart.
>
> Yet if his Lady's home above
> Was Heaven, on earth she filled his soul;
> And if his City held control
> To cast the body forth to rove,
> The soul could soar from earth's vain throng,
> And Heaven and Hell fulfil the song.
>
> Follow his feet's appointed way;—
> But little light we find that clears
> The darkness of the exiled years.
> Follow his spirit's journey:—nay,
> What fires are blent, what winds are blown
> On paths his feet may tread alone?

Thus the first three verses of *Dante at Verona*, the darkness of exile a mystic journey, and a dead love leaning, like the Blessed

Damozel, from the gates of heaven to fill the soul of the mortal left below. It was a parallel to Rossetti's life (was his self-conscious 'Englishness', after all, a cover for his sense of exile, and did he never visit Italy because he feared to do so, feeling some racial tug at the heart that might never let him go?).

It was the stay at Kelmscott Manor that sent the winds and birdsongs of nature whistling through his verse. The London Cockney who had recoiled from the thought of living in Hampstead, as 'pretty well beyond civilisation', and whose un-Italianate dislike of music had reacted to *The Messiah* at the Crystal Palace as if 'everybody got up and shouted at him as loudly as possible', suddenly found a quieter music in the ripple of a country stream.

> What thing unto mine ear
> Wouldst thou convey,—what secret thing,
> O wandering water ever whispering?
> Surely thy speech shall be of her,
> Thou water, O thou whispering wanderer,
> What message dost thou bring?

It was still a ghost-haunted stream, like so many of Rossetti's poems, ballads and sonnets reflecting back the images of a dead or elusive love. And the music changes with the seasons:

> Stream, when this silver thread
> In flood-time is a torrent brown,
> May any bulwark bind thy foaming crown?
> Shall not the waters surge and spread
> And to the crannied boulders of their bed
> Still shoot the dead leaves down?

The Stream's Secret whispered, perhaps, of Janey, as certainly did *English May*:

> If in my life be breath of Italy,
> Would God that I might yield it all to you!
> So, when such grafted warmth had burgeoned through

The languor of your Maytime's hawthorn-tree,
My spirit at rest should walk unseen and see
The garland of your beauty bloom anew.

The sonnet sequence *The House of Life*, which includes the
one beginning 'Ye who have passed Death's haggard hills',
reaches some of its highest points, as in *Barren Spring*, when
Rossetti's own melancholia vibrates the lyre's string.

Behold, this crocus is a withering flame;
This snowdrop, snow; this apple-blossom's part
To breed the fruit that breeds the serpent's art.
Nay, for these Spring-flowers, turn thy face from them,
Nor gaze till on the year's last lily-stem
The white cup shrivels round the golden heart.

As love poems, they and others introduced into Victorian verse
a new physical explicitness which Swinburne was to develop
with, for his times, even greater daring.

It is doubtful how many people read Rossetti's poetry today,
although it is possibly more limpid and beguiling to the modern
ear than Swinburne's oceanic waves of descriptive sound. His
translations from Dante may too have slipped into semi-
obscurity, although they have been considered among the finest.
It is an irony, perhaps, but a recognition of his own rather
melancholy genius, as well as that of a great medieval poet, that
the one line of Rossetti's constantly quoted is his translation of
François Villon's refrain in *Ballade des Dames du temps jadis*:

Mais où sont les neiges d'antan?

'But where are the snows of yester-year?' has established itself
as the one line of verse by François Villon recognized by every
literate Englishman. Few remember that Villon's original was
refashioned so by Rossetti.

IV

Hunt and Millais:
Retreat to Respectability

The imagination of all artists is coloured to some extent by the social and cultural forces within the society in which they live. The Pre-Raphaelite rebellion was only in part an escape: it was also, as we have seen, a reflection. 1848 was not only 'the year of revolutions', it was the year of the Chartist riots, during which Holman Hunt took his young friend Millais to Kennington Common to see the Chartist petition. The Christian Socialism of F. D. Maurice, who founded the Working Men's College at which Ruskin and Rossetti both lectured, was another symptom of a changing society in which the teachings of Charles Kingsley and Thomas Carlyle influenced many beside Ruskin, whose discipleship of Carlyle was often proclaimed.

It was Kingsley in his novel, *Alton Locke*, who had epitomized the need for class awareness, the roots of working-class socialism (it was the story of a tailor-poet who through his gifts moved into the middle classes, but was urged never to forget or desert the people of his origins). And it was Carlyle, the advocate of Christian socialism, whose moral stance in *Past and Present* influenced Ruskin both before and after his loss of faith, and anticipated William Morris in his denigration of the modern materialistic age, with its attitude to the labourer, as compared with the medieval, pleasurable systems of work within monasteries and craftsmen's guilds. Both Maurice and Carlyle appear

62

on the extreme right of Ford Madox Brown's *Work*, symbolic of the 'brain workers' in a picture in which the dignity and toil of labour are flanked by onlookers from totally different areas of society. In structural composition it remains one of the finest of Pre-Raphaelite paintings, and although often now accused of 'romanticism' it was also a social comment, a reflection on the idlers and rich as well as the mental and physical labourers of society.

Current religious conflicts also had their share in the artists' attitudes, which were by no means a bland echo of Victorian orthodoxy. This 'orthodoxy' in itself was rent by divisions, including the fear and distrust of Popery which had wracked England for nearly two centuries, since the expulsion of the Stuarts. Catholic emancipation, a principle for which George Canning, briefly Prime Minister at the end of his life in 1827, had nearly ruined his career, had not bridged what Ruskin referred to as 'The schism between the so-called Evangelical and High Church Parties in Britain'. 'It seems to me', wrote Ruskin in *Notes on the Construction of Sheepfolds* in 1851, 'one of the most disgraceful scenes in Ecclesiastical history, that Protestantism should be paralysed at its very heart by jealousies, based on little else than mere difference between high and low breeding . . . and I believe that this state of things cannot continue much longer; and that if the Church of England does not forthwith unite with herself the entire Evangelical body, both of England and Scotland, and take her stand with them against the Papacy, her hour has struck. She cannot any longer serve two masters; nor make courtesies alternately to Christ and Anti-Christ. That she *has* done this is visible enough by the state of Europe at this instant . . . Christ's truth [is] still restrained, in narrow dawn, to the white cliffs of England and white crests of the Alps . . .'

This was the Ruskin work which Holman Hunt was reading while painting *The Hireling Shepherd*, and neither this picture, his *Our English Coasts* (also known as *Strayed Sheep*) of 1852, nor Madox Brown's *The Pretty Baa-Lambs* of the same year, can be divorced from it. In 1850 Pius IX had proclaimed the

63

re-establishment of the Roman Catholic hierarchy in England and Cardinal Wiseman had been appointed by him Archbishop of Westminster. Public reaction was such that in 1851 Parliament passed an 'Ecclesiastical Titles Bill' prohibiting Catholic dioceses in England. There was actual fear also of invasion from abroad. This, not some pious New Testament sentimentality, was the significance of Hunt's straying and endangered sheep on the vulnerable white cliffs of England, and his symbol of the hireling shepherd whiling away his time with an attractive shepherdess and neglecting his flock.

The *Strayed Sheep* is by far the better-painted picture, showing the influence of Madox Brown's introduction of pinks and reds into landscape painting, and in the shading of the sheep, which as in so much Pre-Raphaelite work belies the strict claim to 'naturalism' in all except the meticulousness of the detail. But the charm of this new landscaping was in its colour: it was a radiant breakthrough from the muddy browns and greens which had come to characterize Victorian Academy painting, and which had possibly to some extent been based on the assumption that the old masters in the galleries, their uncleaned varnish darkened by the centuries, were painted in this way by their creators. Consciously, the Pre-Raphaelites turned for inspiration not only to the medieval Italian school but also, in landscape particularly, to the Flemish primitives. It was, wrote Eric Newton in *European Painting and Sculpture*, 'from van Eyck and his kind that they had most to learn'; they were 'eye witnesses' in this Flemish tradition.

To this new brilliancy and clarity of the Pre-Raphaelites, modern painting still owes a debt. Constable in his landscapes had, like Turner, begun to experiment further with light, but Constable at this period was less known in England than in France. There had already been occasional Academicians who, painting outside the interior formulae and sometimes in foreign climates, had produced pictures of refreshing basic paleness, with iridescent sky and sea effects. One such was William Daniell, who died in 1837, a full decade before the Pre-Raphaelite revolution, yet whose *Egg Boats Off Macao*, in the Leicester Art

Gallery, does not seem out of place, in its colouring, beside William Dyce's *Meeting of Jacob and Rachel* in the same gallery. Dyce's picture, one of the finest painted in the Pre-Raphaelite style, uses the biblical subject matter with an urgent sense of movement (Jacob thrusting towards a passive Rachel) and both transparency and warmth of colour; and his sharply criticized, bleakly lit cliffs and beaches at Pegwell Bay also showed the extent of his cleavage from Royal Academy style. Their daguerreotype effect, however, was not exactly what Hunt himself regarded as the springboard of the new school, nor was he even certain that that of Madox Brown was a basis of revolt.

The religious subject matter of Hunt's pictures, like that of Brown, was not purely a matter of personal piety: both had their foundation in Ruskin's sheepfold allegory. Nevertheless, Hunt's lamp-eyed Christ in one of his most famous pictures, *The Light of the World*, inevitably fostered the impression of the movement's religious basis. This, too, was a symbolic picture, the eyes and the lantern the focal points and the image reinforced by the crown of thorns (it is curious that his painting of Rossetti had very similar luminous eyes). The theme was from the text in Revelation: 'Behold, I stand at the door and knock', and night, he told his ardent young admirer Millais, was chosen to symbolize the darkness of the times. Christ's lantern gave light to the sinner, and the door (to Paradise) was choked with weeds (Millais in a moment of enthusiasm offered to paint in a symbolic picture of the sinner transformed, in a paradisal garden beyond the opened door, but Hunt still had enough caution left to refuse this by no means foolproof gesture of help). The painting was a more direct scriptural 'morality' companion to *The Awakened Conscience*, Hunt's parallel to Rossetti's unfinished *Found*. Thereafter Hunt's religious bent was to isolate him from the movement in its later phases.

Hunt's visit to Palestine to paint the actual biblical backgrounds was the fulfilment of a long dream. But in his early days he was a gay enough member of the Brotherhood. 'All the fun of these fellows', wrote the staid but indulgent Ruskin to Val Prinsep, an aristocratic scion of Little Holland House who

65

also began to paint in the new style, 'goes straight into their work—one can't get them to be quiet at it—or resist a fancy if it strikes them ever so little a stroke on the bells of their soul . . .' If the bells of Hunt's soul tolled rather sombrely later, it was not always the case. Before he left for Palestine he had become enamoured of a girl named Annie Miller, whom he used as model for the fallen girl in *The Awakened Conscience*. Fearing for her future, he paid for her education and a good doctor, as she seemed ailing and possibly consumptive, and planned to make her his wife. It was not helpful to his association with Rossetti that on his return he heard rumours that she had been seen walking down Regent Street (the centre of Victorian prostitution and courtesanship) with a 'swell whore', and in St James's with Lord Ranelagh, notorious as a rake. Rossetti had used her in Hunt's absence as a model and had encouraged her to sit for other artists. ('They all seem mad about Annie', wrote the sober Madox Brown in his Diary.) Later, when hoping to marry someone else, Hunt begged Stephens to try and get back his letters to Annie, offering a £5 note and a sovereign for them. Indiscretion on an impious scale seems certainly indicated.

Hunt, born in 1827, was a year older than Rossetti. His father had wanted him to go into business and Hunt had tried this; but by 1845, against parental wishes, he had become a student at the Academy and the next year, at only nineteen, exhibited his first picture, of a child holding a watch to its ear. True to the literary traditions, he was soon painting scenes from Dickens and Scott; but the most momentous event of his life proved to be the showing of *The Eve of St Agnes* at the 1848 Royal Academy Exhibition, for it attracted the attention of the Keats-worshipper Rossetti, who now introduced himself as enthusiastically to Hunt as he had earlier done to Madox Brown.

For a time Rossetti shared Hunt's studio at 7 Cleveland Street, near Fitzroy Square, where they worked together on their pictures for the Academy—Rossetti having trouble with his infant model for *The Girlhood of Mary Virgin* and punctuating painting progress with outbursts of Italianate temper. It was Hunt who soothed the child angel and restored some kind

of peace. It is interesting that thus early in the association, and long before the advent of William Morris, both young painters found time for snatches of interest in the furnishing of their studio, and discussion of the possibility of furniture and textile designs free from Victorian over-fussiness. Even vegetable-dyed, handmade materials, and their use also for women's clothes falling about the body in natural lines, were discussed.

This arrangement did not last long (Hunt fell into arrears with his rent) and Rossetti, at last leaving the Rossetti family home where he had always slept at night, was soon sharing a studio at 72 Newman Street with Henry Wells and Lowes Dickinson. This also had to be evacuated in haste, and the furniture carried over to the long-suffering and stable Madox Brown, when the landlord (himself only a tenant of the premises) suddenly did a 'moonlight flit', leaving his tenants' property at the mercy of the true landlord, who could seize it under the then law.

By now the Pre-Raphaelite Brotherhood had been formed and Hunt had become most attached to John Everett Millais, of whom he was to be a lifelong and absolutely loyal friend. It was he and Millais who bore the brunt of the critical attack on the Pre-Raphaelite pictures in the Academy of 1850, when Millais' *Christ in the House of His Parents* was so particularly marked out for 'blasphemy'. It is a measure of the extinction of the Age of Reason and Enlightenment, after only thirteen years of Victorian rule, that the outrage at Millais' picture was based on his attempt to depict the boy Christ and his family as ordinary human beings in a carpenter's workshop, without any bituminous background or creation of the dim holy light (not to count halos) that had come to be expected in religious paintings.

Yet for all its revolutionary realism in the human figures, and sepia-paleness of background, the picture also has the new Pre-Raphaelite style of symbolism—the flock of (almost obligatory) sheep crowding to look into the workshop, and the wounds on the hand and foot of the boy Christ who has turned for comfort to his mother. (Few critics seem still to notice this glance forward to the nail-pierced hands and feet on the cross.)

67

Splashes of Pre-Raphaelite colour are in the red of the carpenter's shirt and dark blue skirt of the madonna, who is comforting the red-haired child Christ, and the tools on the wall and wood-shavings on the floor emphasize the basic realism of the setting. The exquisite painting of these shavings alone should have alerted critics to the young artist's technical accomplishment.

Rossetti in his *Girlhood of Mary Virgin*, shown at the 1849 Free Exhibition, had more conventionally supplied the halos, and he had chosen the Free Exhibition again in 1850 for his *Annunciation*, though not totally avoiding the critical onslaught (*Blackwood's* described him as 'one of the high priests of this retrograde school . . . they delight in ugliness and revel in diseased aspects').

The immediate reaction of Millais and Hunt (both of whom needed to sell pictures) was despair: it has sometimes been said that it was from this moment that Millais decided on a less revolutionary, more Academic future, but in fact it was several years before he took this plunge. Hunt, even more dependent financially on his work, was the most embittered, and departed for Oxford where he had secured the job of restoring Rigaud's frescoes at Trinity House. The engagement had, however, a happy outcome for the Brotherhood: at Oxford Hunt enjoyed the hospitality of Thomas Combe of the Clarendon Press, who became the first and one of the most valued patrons of Pre-Raphaelite artists. The rift certainly quickly healed, for it was Hunt who in 1852 recommended to Combe Rossetti's *Dante Drawing an Angel*, writing him that the artist was better acquainted with Dante's works and life 'than *any man in the world*'.

Nevertheless, it was after the 1850 outburst of virulence that Rossetti ceased to show his pictures except on rare occasions: the man who was to be devastated by *The Fleshly School* late in life was already sensitive enough to attack to withdraw into his own world of Dantesque mystery and romanticism. He had not at his call the brilliant and unassailable draughtsmanship of Millais, and already he knew it, and his vulnerability.

Millais was born in 1829 of an ancient Jersey family, who

68

moved to London as soon as they discovered his talent as a child. In technical mastery and precocity he was the most academically dazzling of the Pre-Raphaelites, having studied with Henry Sass at the age of nine and been admitted to the schools of the Royal Academy at the unprecedented age of eleven. Here he won every prize and honour available, and at seventeen he exhibited at the Academy a picture, *Pizarro Seizing the Inca of Peru*, which was thought already to put him in the forefront of historical artists. But almost immediately he came under the spell of Hunt and Rossetti, and he was still only nineteen years old when the Brotherhood was formed.

Millais was six feet tall and unusually slight: in his own description, 'a specimen of a living paper knife'. He was exceptionally good-looking with a mass of fair curly hair: nervously excitable, insomniac, emotionally immature. His attachment to Hunt was highly emotional, although in the spirit of the time without any apparent conscious suspicion of homosexuality (Holman Hunt, characteristically, called it 'a sacred friendship' and described him as 'an utterly dedicated and superbly trained artist'). *Ophelia* was painted at the age of twenty-three, two years after *Christ in the House of His Parents*, and he was twenty-two when in 1851 Ruskin wrote his letters to *The Times* and made his fateful drive with his wife Effie to see Millais.

By March 1853 he was painting Effie for his Academy exhibit, *The Order of Release*, subtitled '1746' and showing the return of a Scottish soldier after Culloden to his wife and child. It was certainly darker and more Academic in style than *Christ in the House of His Parents* or *Ophelia*. It was tentatively at this stage called *The Ransom* and Effie's auburn hair he painted dark in order to contrast it with that of the blond child in her arms. Effie on 20 March wrote to her mother:

> He found my head like every one who has tried it immensely diffi-
> cult and he was greatly delighted last night when he said he had quite
> got it. The features are at once so curious and the Expression so
> difficult to catch that he wanted—half a smile. He says he is to do me

for another picture next year for another kind of expression. He paints so slowly and finely that no man working as he does can paint faster... He says nobody has painted me at all yet, that the others have cheated themselves into making me look pensive in order to escape the difficulties of colour and expression.

(G. F. Watts had done two drawings of Effie in 1851, and Thomas Richmond had painted her the same year. Ruskin had done a drawing of her at Verona in March 1850: it is now in the Ashmolean Museum, Oxford.)

There seems no indication as yet that he and Effie had an interest in each other apart from the painting, although this cannot be ruled out. Ruskin was immersed in work on the second and third volumes of his *Stones of Venice* (published in July and October) and the indexing of the October volume had cost him particular exhaustion. It was this that led to the party that travelled to the Highlands of Scotland, and it included not only Effie and Ruskin but Millais and Millais' two brothers. It was intended to be both a revivifier of Ruskin's flagging vitality and an opportunity for the young Millais, in whose work Ruskin was now taking particular interest, to paint a portrait of Ruskin against the rocks and waterfall of Glenfinlas: although this exact background, of course, was not yet chosen.

It had been intended that Holman Hunt should also be of the party, and had he gone with his friend it is possible the consequences of that momentous tour would have been very different. But Hunt was finishing *The Light of the World* and only waiting to sell it before sailing for Syria to paint there on the proceeds. It was the parting from Hunt about which Millais seemed mainly grieving during most of this six-month tour, and his emotional state and hysteria were such that Ruskin actually wrote to Hunt begging him to put off leaving England (it may be because of this that Hunt actually did not sail until the following year). There is no doubt both Millais and Effie were showing signs of ill-health, in particular Millais who suffered especially from the bites of midges. His frailty and obvious mental distress gave him an adolescent charm to which

70

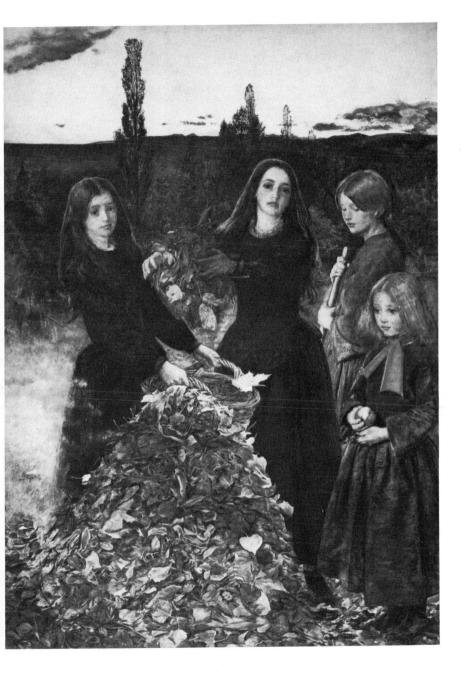

Plate 12 Autumn Leaves by J. E. Millais

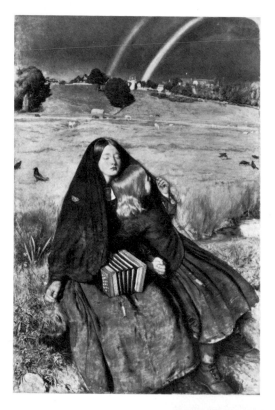

Plate 13 (*left*) The Blind Girl
(Effie Gray) by J. E. Millais

Plate 14 (*right*) Millais by
C. R. Leslie

Effie seems to have responded with the maternal instincts that had been frustrated by her marriage to Ruskin.

'Today I have been drawing Mrs. R. who is the sweetest creature that ever lived', wrote Millais to Holman Hunt early in the tour. 'Ruskin is benign and kind. I wish you were here with us . . .' On 3 July 1854, he wrote again to Hunt of a trip with Effie and his brother William to the ruined fort of Doune from New Trossachs Inn, Stirlingshire:

> Although this place is so beautiful and William is with me I feel very lonely and miserable; there is something depressing about these far stretching mountains, everything looks wild and melancholy and one cannot help feeling you are very far from your other friends. The Ruskins are *most perfect people*, always anxious and ready to sacrifice their interest in our behalf. She is the most delightful unselfish kind hearted creature I ever knew, it is impossible to help liking her—he is gentle and forbearing.

Whatever Millais' inner feelings, the façade of Ruskin's kindness and goodness was being kept up, even to his most intimate friend. On the 6th, Ruskin wrote to his father:

> I shall soon be able to give you a more accurate address for M. has fixed on his place—a lovely piece of worn rock, with foaming water, and weeds, and moss, and a noble overhanging bank of dark crag—and I am to be standing looking quietly down the stream—just the sort of thing I used to do for hours together . . . and we shall have the two most wonderful torrents in the world, Turner's St Godhard— and Millais' Glenfinlas.

He adds: 'I am sure the foam of the torrent will be something quite new in art.' The scientific basis of painting as a reflection of nature was always one of Ruskin's most insistent themes.

Millais on his side wrote to the artist Charles Collins (who would have been one of the original Pre-Raphaelites but for Hunt's over-hasty closing of the books): 'He is such a good fellow and pleasant companion . . . I am going to paint him looking over the edge of a steep waterfall—he looks so sweet

E

and benign standing calmly looking into the turbulent sluice beneath.' But on 17 July he wrote to Hunt that Ruskin was not of their kind, and proclaiming his intention of painting 'a companion of his wife at Doune Castle . . . at a window overlooking a river and distant mountains with a view of Stirling Castle'. By 3 September, still from the inn at New Trossachs, he was mysteriously adding: 'Like you I have much that I could tell you but cannot in a letter. I destroy your letters, at least most of them I have received here that I think you would not wish to be seen': a thought-provoking comment in the circumstances.

On 20 October he was claiming distraction not by Effie but by his devotion to Hunt:

> . . . scarcely a night passes but what I cry like an infant over the thought that I may never see you again—I wish I had something to remember you by . . . It is wonderful how with all the suffering I endure in thinking of your leaving, Deverell's illness*, and the other calamities, how I still go on with my work, sitting numbed in the biting cold . . . I should like to go to sleep for a year and awake and find everything as it was when you lived in Cleveland Street when you were straitened for food, and we all went nightly to disclaim against Rubens and the Antique—Those were happy times to these.

The nostalgia is alone indication of his deep unhappiness, and it was on the same date that Ruskin also wrote to Hunt trying to dissuade him from leaving England (using, among others, the argument that his talent needed further maturing before this foreign venture). How much of this was smokescreen thrown up by both over the real cause of Millais' condition? It is strange, in our eyes, how the more shocking implications of Millais' apparently violent attachment to Hunt never seem to have crossed anyone's mind: the *fin de siècle* decadence, in the mid-nineteenth century, was an unimagined feature of the future.

On the surface, Ruskin's bland calm remained undisturbed, and there is every outward indication that he was unaware of

* Deverell was at point of death, a grievous blow to them all.

the growing situation. Yet Millais' immense charm—crybaby or not—seems to have been felt and commented on by nearly everyone, and Effie had already written to her mother of Millais before their departure: 'He is so extremely handsome, beside his talents, that you may fancy how he is run after.' That Ruskin had noticed Millais' change towards himself, his additional comment in the 20 October letter to Hunt shows:

> *I* can be of no use to him—he has no sympathy with me or my ways
> . . . he has nobody to take your place—his health is wretched—and
> he is always miserable about something or other.

Not, in fact, a gay companion, and it is not surprising Ruskin showed slight impatience and the work on the portrait progressed slowly. But its geological background was peculiarly suited to Ruskin's own temperament, and he himself did a pen, wash and bodycolour of the same scene, *Study of Gneiss Rock, Glenfinlas.*

By 1856, after the explosion of the whole Millais–Effie affair in his face, he was to write in the fourth volume of *Modern Painters* of the idea that 'beauty is continually mingled with the shadow of death', and by 1875 he had reached the nadir of melancholy in feeling that 'everything that has happened to me . . . is *little* in comparison to the crushing and depressing effect on me, of what I learn day by day as I work on, of the cruelty and ghastliness of the *Nature* I used to think so divine'. The Wordsworthian romance of Nature that moved a whole generation of artists and poets had evaporated in the bleak vistas of the Victorian industrial slum, and the Darwinian theory of evolution. When William Dyce, one of the older artists who sympathized with the Pre-Raphaelite movement (it was he who had persuaded Ruskin to go and see their pictures at the 1851 Exhibition), painted in 1859–60 his *Pegwell Bay, Kent—a Recollection of October 5th 1858*, it was in the chill silver-greys and creams of a wintry beach and cliffs, an 'end', wrote Charles Aitken, 'of all things feeling'. It is still often described as 'Ruskinian', although this marvellous picture in some ways

75

looks forward to the more misty, indeterminate greys of the Whistler Nocturnes.

At the end of 1854 Ruskin gave his famous four lectures at Edinburgh, and when he and Effie returned to Camberwell there was a new tension in the house. When Effie's ten-year-old sister Sophie stayed with them, she was sharply aware of Effie's unhappiness, although too much note has been made of the comments of this intelligent small girl, primed very much by her sister's neurotic feelings about Ruskin's indifference and deliberate attempt (as she now saw or imagined it) to throw her and Millais together. Millais painted the child and was enthusiastic about her beauty, of which he said she was as yet completely unaware. He later used her with Effie's other sister in his masterpiece, *Autumn Leaves*. There is a mystery about his subsequent relationship with Sophie: the girl never married and died quite young, and there are indications that she may have replaced, in later life, the now rather dull, less magically-endowed Effie in his heart. Her own devotion to her handsome brother-in-law was apparent.

What is clear from Millais' letters to Mrs Gray is that Effie, on one of their Scottish walks, confided to him the nature of her marriage to Ruskin. She also later confided in Lady Eastlake (wife of the Royal Academy President), who certainly pressed on her the enormities of Ruskin's behaviour and her need to get an annulment. Was it Effie's confidence that suddenly released Millais' desire and opened up for him the vista and possibility of their marriage? And did Effie make this confidence totally without calculation of such an effect? In any case, the vituperation of Effie, Millais and her friends about Ruskin's 'wicked' behaviour reads astonishingly when we remember how much the Victorians deplored sex outside marriage and indeed veiled the sexual implications within it. The store they pretended to set by chastity here takes on a strangely grotesque aspect. Had Ruskin committed murder he could hardly have been more desecrated. That he was aware of the implications of the attack on his virility he did quickly show, although outside these particular social circles the scandal of the divorce was soon

76

forgotten and his moral reputation remained especially high as a writer to his death.

Obviously Effie's flight, when it was finally settled, had to be unsuspected by him, for if he had attempted, even at this late date, to assert his conjugal rights she would have had no grounds for annulment of the marriage and (by Victorian standards) a comparatively honourable divorce. To Ruskin she was merely setting out on a visit to her parents in Scotland; and all contact with Millais had to be discontinued until some time after the divorce. Nevertheless, when they married in 1855 there was a fairly general assumption, outside their own circles, that Millais had stolen Ruskin's wife. Long afterwards, when Millais had become Sir John Millais and perhaps the most famous Academy painter of his time, Queen Victoria refused to allow him to paint her because she understood 'he had seduced his future wife while painting her'.*

The effect of the marriage to Effie on Millais as a painter was, in the long run, stultifying. Like his friend Hunt, whose religious puritanism grew as the years passed, he became, in self-defence, increasingly conventional in behaviour, dress and painting outlook. Millais, who had been the first to show a picture with the magic and mysterious initials PR-B (the scene from the *Isabella* of Keats), became in the end the prop of Academy standards and portraiture: ultimately earning over £25,000 a year, a wonderful support to Effie's social pretensions. When in 1879 they moved from 7 Cromwell Place to 2 Palace Gate, near to Kensington Gardens, the house contained a marble hall and staircase and a forty-foot studio on the first floor. According to Hunt, Millais came to declare that a painter 'should hold up the mirror to his own times' and the only way to do this was to find 'people willing to give him money for his productions' and 'win honours from his contemporaries'. 'What good would my labours hundreds of years hence do to me?' was his infinitely practical (and in some ways not unsympathetic) outlook.

What his labours, alas, in the general public's mind did most

* Elizabeth Longford: *Victoria, R.I.*

for him in posterity was to perpetuate the fame of *Bubbles*: although there is an irony here, in that Millais certainly did not paint this rather sentimental picture of an angelic, fair-haired boy (his grandson) blowing bubbles for advertising purposes. He had sold the copyright and the painting was later acquired (to his frustrated indignation) by the manufacturers of Pears Soap, who reproduced it on posters throughout the land for many years afterwards.

It was, of course, an accomplished painting, in particular with regard to the bubbles, whose evanescent mobility Millais stilled by the practical expedient of using a crystal globe specially made for the purpose. So were the series of pictures of pretty children, including the almost equally famous *Cherry Ripe*, with which he stated, unrepentently, that he met the public's taste, as he would willingly continue to meet any change in it. His portraits of notabilities, including Gladstone, were similarly academic. It was only when the Grosvenor Gallery staged a comprehensive exhibition of his works in 1886 that he experienced qualms of artistic conscience. The preliminary placing of his later paintings beside his earlier ones showed too grimly the deterioration, of which he was too good an artist to be unaware. The Pre-Raphaelite pictures were separated from the rest and diplomatically hung in a small room on their own.

For a few years after the marriage to Effie his revolutionary principles remained, as the fine *Autumn Leaves* of 1856 shows. According to Hunt, the picture arose from something Millais said to him in 1851 about the delicious odour of burning leaves, but his addition that Millais also then remarked on the autumnal conviction that 'Time puts a peaceful seal on all that has gone' sounds far more likely to be a later comment, made when the painting was actually conceived, and the emotion of the affair with Effie had at last become recollected in tranquillity. In any case, *Autumn Leaves* has some genuine claim to be the masterpiece of Pre-Raphaelite art: the two Gray girls in their black dresses (the two other little girls were local country children) looming sadly, gravely, out of a seasonal twilight, the pyramid

of rust-brown leaves painted in the full maturity of the brilliant and meticulous talent that had, some years before, given the shimmer of high summer to the foliage around the drowning Ophelia, and the rose, poppy and cornflower escaped from her dying hand.

It remains a tragi-comic fact that Millais' later reputation never quite survived the stingingly witty comment that 'if Ruskin had remained married to Effie he would have ended up by writing *Bubbles*'.

He remained an immensely handsome man. Beatrix Potter, meeting him when he was nearing his death from throat cancer in 1896, when he was sixty-seven, remembered his pointing to his throat and saying huskily: 'How is my little friend? Can't speak, can't speak.' She adds: 'He looked as handsome and well as ever, he was one of the handsomest men I ever saw . . .' He had taken to fox-hunting soon after marrying Effie, and thus acquired a reputation for virility as well as social eminence. He had been created a Baronet by Gladstone in 1885 and President of the Royal Academy in 1896, on the death of Lord Leighton. He died on 13 August the same year, and was buried with supreme irony in the crypt of St Paul's Cathedral, beside Ruskin's god, Turner. His coroneted pall-bearers included the Earl of Rosebery, the Earl of Carlisle, and the Marquis of Granby. Only Sir Henry Irving and his oldest friend, Holman Hunt, represented the arts.

Effie survived him only sixteen months, dying nearly blind in her seventieth year. It was a strange echo of one of her husband's last Pre-Raphaelite pictures, *The Blind Girl*, with its Winchelsea-painted background of golden grass and two rainbows arched against a lowering blue sky, and the seated figure of red-haired Effie as a blind girl impervious to this luminous beauty, towards which her small sighted companion turns in rapt wonder. Once again, symbol was allied to a painterly study of natural phenomena. The figures were painted in Perthshire, where Millais had taken his bride soon after the Ruskin scandal.

It is worth noting that child models had often been a prominent feature of Millais' pictures (the early *Return of the Dove*

to the Ark showed two little girls greeting the bird). It was in later life that the subject became a stereotyped sentimental formula. Effie did not share the sentimentality. She ruled her children with a touch of Victorian strictness, and retained her vivacity in society almost to the end.

Ruskin outlived them until the turn of the century. There is some indication that towards the end Millais felt more kindly towards him, although they never met after the completion of the Ruskin Glenfinlas portrait in London at the height of the Effie scandal, when Millais found it necessary to finish the work on Ruskin's hands and complained in a letter: 'Surely such a quiet scoundrel as this man never existed, he comes here sitting as blandly as ever, talking the whole time in apparently a most interested way.'*

Ruskin may have been bland and reticent on his private feelings, but he was not inhuman. If he meticulously refrained from attacking Millais, whose work he had always greatly admired, he was not so forgiving towards Millais' unshakeably loyal friend in the affair, Holman Hunt. When Hunt's symbolic *The Scapegoat*, painted in Palestine on the shores of the Dead Sea, was exhibited in 1856, Ruskin wrote: 'it was a mere goat, with no more interest for us, than the sheep which furnished yesterday's dinner'. Hunt's subject was based on the Talmud ritual whereby a goat was driven from the Temple into the Wilderness on the Day of Atonement, carrying with it symbolically the sins of the people. Perhaps Ruskin himself was still feeling, in the wake of the Effie divorce and remarriage, too much in the position of a sacrificial sheep.

Hunt's goat (and he wore out more than one, as relentlessly as his friend Millais shot pheasants and pursued foxes) had an understandably depressed air, and it is only in black-and-white reproductions that one can appreciate the minutely detailed

* This gives the lie to the oft-quoted story in Sir William Rothenstein's *Men and Memories* to the effect that Henry Acland (the Gray doctor) told him that no word passed between the two men at these sittings. Mary Lutyens' valuable book based on the Millais and Ruskin correspondence has scotched a number of such legends.

painting of the animal's long hair. At close range deep purple and rust tones seem to diffuse both figure and landscape, and are too overwhelming for the picture to register at all.

The Pre-Raphaelite movement at the beginning was closely allied to literature. Keats and Shelley, Blake and Wordsworth, Dante and Tennyson, as well as Malory and Shakespeare, were founts of inspiration long before Morris discovered, some time after Wagner, the world of Icelandic saga. The fact that writing no less than painting was a vital strand in the Pre-Raphaelite tapestry was early acknowledged by Rossetti, who in fact years later, in 1870, told Dr Hake: 'My own belief is that I am a poet (within the limits of my powers) primarily and that it is my poetic tendencies that chiefly give value to my pictures.'

Hunt himself at the beginning followed the trend of painting dramatic scenes from literature. His *Eve of St Agnes* in 1848 first attracted Rossetti, as we have seen, and the picture has a theatrical quality of composition in addition to the ponderous moralizing which even the youthful Hunt could not resist expounding. He had interpreted Keats' poem, he pointed out, as 'the sacredness of honest responsible love and the weakness of proud intemperance'. This last presumably refers to the Morrisian figure stretched dead-drunk on the floor clutching an empty wine-jar, and another slumped in a chair beside the triple Norman-arched windows, through which some sort of orgy can also be glimpsed. It was perhaps this use of three arches, with their finely-painted light reflection, that inspired the Pre-Raphaelite follower, Arthur Hughes, in his own *Eve of St Agnes* eight years later, which took the form of a triptych depicting three scenes from the poem. All three scenes had a night setting, a difficult task for a painter, as Whistler and his admirers pointed out. Hughes' painting is masterly of its kind and probably underrated.

In 1851, Hunt turned to Shakespeare, with a scene from *Two Gentlemen of Verona*, and it was *The Times'* abuse of this painting in particular that inspired Ruskin's defence of the Brotherhood in the same paper. It had all the Pre-Raphaelite qualities of glowing colour in both clothes and landscape, and it seems

81

generally overlooked that the painting of the autumn leaves on the ground anticipated, on a smaller scale, that in his friend Millais' more famous and mature painting five years later, in which the pile of leaves has become the centrepiece of the whole picture. The same detail in leaf-painting is observable in Millais' early *Ophelia*, and again in Hunt's own *Strayed Sheep*, with its cluster of tangled foliage, blossoms and red admiral butterflies in one corner of the cliff-top.

Interchange of subject and ideas continued throughout Pre-Raphaelite history, but Hunt, the lonely bachelor of the group (he did not marry until 1865), alone dredged the depths of religious and moral feeling, obsessed with the idea that the Bible scenes could only be realized through travel to Palestine and the East. His first visit at the time of the Ruskin–Millais explosion was followed by several others, and all helped to sever him from the main line (and also the prizes) of the more rational-minded Brotherhood.

He never lost his loyalty to Millais, defending him for his pursuit of success on the grounds of 'provocation' (Woolner, equally successful in other directions on his return to England from Australia, was not similarly excused). Time and tragedy blunted the edge of his resentment of Ruskin in the affair. In 1866, after the death of his young wife in Italy, Hunt ran into Ruskin in the square of St Mark's, Venice, and together they visited the churches, sculptures and paintings described in Ruskin's *Modern Painters*, comparing their reactions with what the young critic had written of them twenty years before. The general verdict of both men was that young Ruskin had been right. It was a ballast, perhaps, against the slings and arrows of fortune that had darkened their individual lives. They compared notes, too, on religion, and here a cleft in time had to be acknowledged: Ruskin was now a reluctant atheist, seeing man himself as the only arbiter of his own fate. Hunt, like most Victorians, could not ignore the discoveries of science, but he ingeniously bent them to religious purposes, including a triumphant explanation of the Ascension: 'since we are told that a condensation of gases in the atmosphere can make a solid body

like a thunderbolt, it is competent for us to imagine that His body was resolved into its original elements, to be reorganized at a later time'. The prevision of some modern science fiction is almost startling.

Hunt stayed again in Jerusalem from 1869 to 1874, pulled by the Englishman's traditional fascination with the Arab world as well as biblical history, and only briefly revisiting England, where he remarried in 1873. He was in Port Said travelling back from one of these visits when the Suez Canal was opened, and at the time of the Franco-Prussian War he noted the disconsolate French in the orient and thought the Prussians (with whose moral attributes he was generally much more in sympathy) 'Machiavellian-led'. Politically, as well as in religion, he was more attuned to the Establishment than other Pre-Raphaelites and he was shocked by Madox Brown's expression of sympathy for the Paris Commune. The visit with young Millais to see the Chartist demonstration had long been forgotten by both men.

In 1871 Richard Burton, the great traveller, author and orientalist, reported seeing Hunt in Jerusalem looking very 'worn'—'like a veritable denizen of the Holy City'. Hunt lived in a large decrepit house overlooking the Temple area, with a shed he had built on the roof so that he could paint with protection from the sun. His picture of Christ in the Carpenter's Shop—*The Shadow of the Cross*—with raised arms foreshadowing the Crucifixion, dates from this time, and like other Pre-Raphaelites, notably Rossetti, he succumbed even in exile to the Victorian obsession with spiritualism. Probably with both men bereavement, the loss of a young wife, was the spur to attempted communication with the spirit world. (Rossetti once startled a companion, when a wild bird alighted tamely on his hand, by claiming, apparently in all seriousness, that it was the soul of Lizzie Siddal, come back to him.)

Hunt's obsession took, in the end, a different form: a conflict with the Devil himself over *The Triumph of the Innocents*, a painting dogged by ill-luck in transit and in composition, which it took him as a result many years to complete. Because of this, Hunt (the last of the true Pre-Raphaelites, as he came to regard

83

himself) had little substantial to offer the newly-opened Grosvenor Gallery. In the end a new start was made on the ill-fated picture, helped by Millais who was perhaps responsible for some of the painting. Hunt finally (in his own mind, at least) defeated his Satanic Majesty on Christmas Eve 1879, in his studios in Manresa Road, Chelsea.

The Innocents' triumph was complete. Hunt was careful to explain that the nimbus surrounding the heads of these remarkably sturdy little victims of Herodian massacre, accompanying Joseph and Mary on the flight into Egypt, indicated that they were dead spirits, not (as was suggested to some unwary minds) living children who had somehow attached themselves to the Holy Family. He was rewarded, as in the case of *The Light of the World*, with immense fees for reproduction rights throughout the Christian world.

Yet it is unfair to judge Hunt only by his religious pictures, simply because they are the most reproduced. *The Lady of Shalott* with its elaborate and mirrored background is a notable example of Pre-Raphaelite inspiration from literature; *Strayed Sheep* is a beautiful piece of painting, warmed by sunset radiance; and another unusual study of *Sunset*, with trees reflected in sunlit water, is almost Whistler-like in its impressionistic effect. He and Millais, locked in friendship and influencing each other, both in the end knew monetary success. But both, too, did their best work in the first impact of Pre-Raphaelite ideas.

V

Morris:
Craft and Saga

William Morris, unlike most of the Pre-Raphaelites, did not need the constant services of self-sacrificing parents. He was born in Walthamstow, in the environs of Epping Forest, of extremely wealthy parents, and was educated at Marlborough Public School and Exeter College, Oxford, where he formed his lasting friendship with the painter, Edward ('Ned') Burne-Jones.

The story of Morris is as inseparable from that of Burne-Jones as that of Holman Hunt from Millais. In both cases a friendship forged in youth became an iron bond that could not be severed, either by time or by differences of opinion. Physically, the contrast between Morris and Burne-Jones was striking, and even in temperament they were at polar extremes: the one solidly handsome, with a basic coolness shattered only by sudden bursts of flaming temper, a craftsman and poet with a social conscience and a mop of curly hair which gave him the lifelong nickname of 'Topsy'; the other delicate in frame and health, hyper-sensitive, the typical romantic prototype of the young painter of genius. What bound them was the romantic spirit, expressed in different ways, and an early shared passion for brass-rubbing, medieval Gothic, Dürer drawings and stained glass which Morris was to adapt to modern design, while Burne-Jones brought it also as an enrichening influence into Pre-Raphaelite painting.

Morris' hair, like Morris' rages, had a leonine ebullience. 'Morris's rages', recalled Bernard Shaw in *The Observer* in 1949, 'were eclampsias.* His lack of physical control when crossed or annoyed was congenital and not quite sane.' His hair, in youth dark and curling 'like exquisite wrought metal', as it was described by his biographer J. W. Mackail, was so strong that he later amused his children by letting them clasp it to lift themselves from the ground. (Shaw's Hesione is said to do the same in *Heartbreak House*.)

Several years younger than Rossetti, the two friends first caught the Pre-Raphaelite fever at Oxford, when in 1854 Morris bought Ruskin's new book founded on his Edinburgh lectures. 'I was reading in my room', writes Burne-Jones, 'when Morris ran in one morning bringing the newly published book with him: so everything was put aside until he read it all through to me. And there we first saw about the Pre-Raphaelites, and there I first saw the name of Rossetti. So many a day after that we talked of little else but paintings which we had never seen.' Soon after this they saw a print of Millais' *Return of the Dove to the Ark* on view in Oxford High Street: 'and then', explains Burne-Jones with dramatic and succinct mysticism, 'we knew'.

Morris studied drawing in which he showed a natural aptitude, but he never produced more than one completed painting. This, of his later wife Jane, as Guinevere, remains in the Tate Gallery and allows an interesting comparison with one of Rossetti's portraits of her as Proserpine, hanging on an adjacent wall. The distinctive mouth and dark, crinkled hair strongly feature in both pictures, but Morris' is a full-length, slighter and younger figure, in ivory medieval gown with long red sleeves, in which the patterns of the materials and the pages of the illuminated book open on the dressing-table are characteristic, already, of his interest in textile and book design. It is by no means an unaccomplished piece of work, showing Morris'

* This is a condition of epileptic seizure usually observed in pregnant women. It was one of the great sorrows of Morris' life that his daughter Jenny developed epilepsy, and he may have suspected that it was hereditary.

innate facility in any branch of art or craft that he undertook.

Being strongly-built and athletic, with immense vitality, Morris at Oxford already showed a passionate interest in sailing and rowing. He also began to write poetry, proclaiming at his first effort in rhyme that if that was poetry then it was an easy thing to do. A flow of ballad and saga-style work throughout his life was to reveal, indeed, the charm and fluency which Morris, the versatile, found so easy to attain.

In March 1855 he came of age and inherited £900 a year. He wrote his first story, showing the influence of Shelley's *Ode to the West Wind*, this year, and founded at his own expense the *Oxford and Cambridge Magazine*, which enjoyed the short but influential life of most undergraduate magazines. In July, in the summer break, he travelled to France with Burne-Jones, viewing cathedrals. His reaction was predictably buoyant: 'I think I felt inclined to shout when I first entered Amiens Cathedral', he wrote in the *Magazine*. The young men found the sculptures of Notre-Dame 'half taken down and lying in careless wreck under the porches'. This cathartic experience marked the beginning of Morris' lifelong campaign against vandalism and debilitating contemporary 'restorations', which often attempted to iron out the divergencies of style and period which in fact were part of the architectural value of many English cathedrals, built over a span of centuries. They found seven Pre-Raphaelite pictures at the Paris exhibition, the Beaux Arts, including Hunt's *Light of the World* and three by Millais (*The Order of Release* was attracting the most attention, less probably on its merits than because of the Ruskin–Millais scandal). The travellers then visited Chârtres and Mont St Michel. Morris' response to the ride from Louviers to Rouen was characteristic: 'the railways are ABOMINATIONS: and I think I have never fairly realized this fact till this our tour . . .'

Reaction from the Wright of Derby and even Turner excitement at industrial invention helped to drive Morris into the Pre-Raphaelite camp. The group formed a phalanx against the modern extension of that early romanticism, felt by many of their contemporaries to be expressed in the soaring glass and

iron architecture of the Crystal Palace and new railway stations throughout the country. The Crystal Palace was first erected to house the impressive display of commerce in the Hyde Park Exhibition of 1850, but early shifted, on the pre-fabrication principle, to a site in South London, where it remained, with its new two towers, in permanent use as the centrepiece of pleasure gardens with weekly firework displays until burned down in 1936. It was in some ways the most prophetic and forward-looking building achievement in Victorian England, a fore-runner of the great glass-and-steel skyscrapers of New York's Park Avenue. A whole era of London life vanished in the 1936 conflagration; but Morris would have rejoiced with Viking fervour, seeing a menacing Valhalla engulfed in the flames, as at the end of Wagner's *Götterdämmerung*.

If Morris' politics looked always to the future, his artistic spirit, like that of the whole Pre-Raphaelite group, was also embedded in the romanticism of the past. It was Rossetti who told both his young admirers that the two greatest books in the world were the Bible and the *Morte d'Arthur*. And it was Malory who inspired not only Burne-Jones but Morris' first book, *The Defence of Guenevere*, a dramatic poem showing a furnace heat and brightness of imagination many thought he rarely attained again. By 1857 he was, according to Rossetti, working on his first picture, *Sir Tristram after his illness in the Garden of King Mark's Palace Recognized by the Dog he had given Iseult*, a Malory subject which (perhaps exhausted by writing out its title) Morris never appears to have finished, as all trace of it has disappeared. He returned to the theme later, however, many times, including in water-colour and pencil drawing.

In December 1854, three years before, Wagner too had been musing on the subject of Tristan and Isolde, and first wrote to Liszt of his ideas for the project of an opera. It is perhaps not coincidental that both men also became passionately and creatively involved in the world of the Icelandic saga and Nibelungen myth, in which in fact Wagner first showed an interest as early as 1848, when he wrote the dramatic poem

88

Plate 15 Study: Sunset by W. Holman Hunt

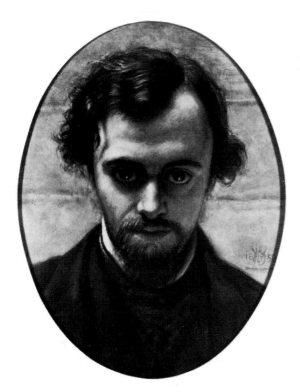

Plate 16 (*left*) D. G. Rossetti
by Holman Hunt

Plate 17 (*right*) Holman Hunt.
Self Portrait

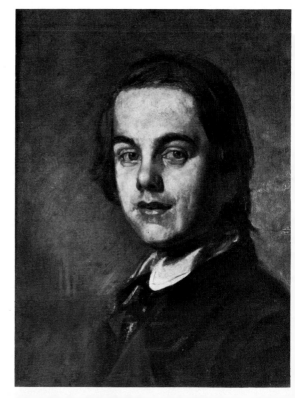

Siegfried's Death. Walter Deverell, too, before his death, had proposed to translate the *Nibelungen Lied*. The reaction against the Iron and Steel Age was spreading among romantics through-out Europe. And with Wagner, who had fled from the police in Dresden in 1849 after the revolution there, in which he had taken an active part, the whole *Ring* cycle of music dramas, based on the *Nibelungen Lied*, was to take a slightly political flavour, becoming an overt indictment of the new capitalistic greed for gold and the saving of the world by man himself, from the outmoded rule of the old gods.

In socialistic principles Morris was to go far beyond Wagner; but in this we see the contrast between the craftsman of genius that Morris essentially was, both in design and in poetry, and the artist and musician of creative genius, like Wagner, whose imagination transforms ideas into the immortal fabric of a new form of art.

In London, Burne-Jones and Morris were soon sharing rooms at 17 Red Lion Square, which Rossetti had once inhabited with Deverell, and Rossetti had 'adopted' these young admirers, took them to theatres (and out again if the play bored him) and to his house on the river at Chatham Place where they 'tired the sun with talking' over coffee. 'Both are men of real genius', wrote Rossetti, with his usual easily-excited generosity, to Bell Scott.

One of the first communal activities in which young Morris and Burne-Jones joined with Rossetti was the painting of frescoes on the walls of the hall of the new Union Society at Oxford. This octagonal hall was part of the thirteenth-century Venetian Gothic dreams of the architect Benjamin Woodward, who had recently designed the Union debating hall and the Oxford Museum. Rossetti had already admired his design for the Fire Station in Chatham Place, and was soon busily gather-ing together a whole team of young enthusiasts to paint scenes from the *Morte d'Arthur* in the bays between the windows above the gallery of the new hall. Woolner (returned from Australia) and Munro had been engaged to do statues of Bacon and Galileo in the Museum; and now during the Long Vacation

Rossetti persuaded Munro, Arthur Hughes, Val Prinsep and Spencer Stanhope, as well as Morris and Burne-Jones, to join him in decorating the hall. He brushed aside Prinsep's alarmed protest about inexperience with his characteristic generosity— after all, he pointed out with his own brand of irrefutable logic, Morris had never painted anything, but he had undertaken one of the panels and would certainly 'do something very good'.

Buoyed up by this dazzling Rossetti optimism, the young artists set to work in August amid a great deal of chaff and animal spirits. The hall rang with their laughter and the clatter of paint-buckets. And Morris, the indefatigable, had soon finished his picture—from the Tristram–Iseult story—and while the others continued toiling on theirs, he added a burst of sun-flowers in the foreground. The aesthetic cult of the sunflower later was a curious echo from the most robust of all Pre-Raphaelites, William Morris.

According to Burne-Jones (whose panegyrics of Morris could no more be trusted than Morris' panegyrics of Burne-Jones), Morris' design for the roof decoration 'was a wonder to us for its originality and fitness'. As models the young artists simply sat for each other; and indeed this had always been a Pre-Raphaelite characteristic, since the time when young Rossetti sat to Madox Brown for the head of Chaucer. Soon Morris, with his splendid knight-like presence and halo of curly hair, was to appear as Lancelot in Rossetti's illustration to *The Lady of Shalott* in the Moxon Tennyson, and a few years later he was to model as St George for Rossetti in the water-colour, *St George and Princess Sabra*, for which Elizabeth Siddal modelled the Princess a few days before her death. At the Oxford Union, small sturdy caricatures of him began to appear among the *Morte d'Arthur* pictures (Rossetti also added a plethora of his favourite wombats), and the high spirits and fun reached their zenith when Morris, trying to meet their need for armour to copy, produced a basinet and surcoat of ringed mail made to his own design by the local blacksmith. In trying on the helmet Morris got stuck firmly inside it, 'embedded in iron, dancing with rage and roaring inside'.

Unfortunately, nothing of this interesting youthful example of group art has survived. The mortar on Woodward's building was not fully dry, and no one thought to prepare the walls thoroughly before painting. The distemper flew off the brick surface, only thinly whitewashed, and as William Gaunt put it, 'The vision of an age that never was disappeared almost at once.' In any case the light from the windows made the work difficult to see, and even to compose. Only the echo of ghostly laughter, of young voices long stilled, remains.

Val Prinsep, a young giant of nineteen, was to achieve perhaps his greatest fame as the inspiration for the character of 'Taffy' in George du Maurier's *Trilby*, a connecting link across the Channel between the Pre-Raphaelites and the young artists soon to forge a new revolution of style in Paris. Whistler, later a close neighbour of Rossetti on the Chelsea Embankment, was to be another link.

It was after a visit to Manchester in 1857 to see the Art Treasures Exhibition that Morris wrote his *Praise of My Lady*, included the following year in *The Defence of Guenevere*:

> My Lady seems of ivory
> Forehead, straight nose and cheeks that be
> Hollow'd a little mournfully.
> *Beata mea Domina!*

It was a description of Jane Burden, whom he had met at Oxford in the Long Vacation. It was when Rossetti and Morris were working together on the mural decorations of the Science Museum in Park Road that they first saw Jane and were equally struck with her unusual beauty, gypsy-like yet medievally '*spirituelle*', with 'eyes so deep-set that she seemed to come from a different race'. She was immediately urged to become their model, and Morris characteristically undertook her education (it was as a result of this that she remained a great and fastidious reader all her life). They were married two years later, on 26 April 1859, at St Michael's, Oxford.

Where did Rossetti stand? The question is unresolved but it

93

would seem he was already fascinated by Jane, and she perhaps by him. Both these young men had opened for her a new life, had given her new eyes with which to see the surrounding world. But Rossetti was still hopelessly entangled with the ailing Elizabeth Siddal, of the languid beauty and red-gold hair he so loved, and perhaps against his inner better judgement he married her the next year.

Morris has been accused of coldness as a husband, and he was a man at the opposite geographical Pole to Rossetti, loving the North and its art with the almost mystic fervour that Rossetti gave to Dante and the South. But although he was a man of vast energy whose volume of work in several simultaneous directions was prodigious, he was also a romanticist, and although his verse may have lacked the 'hotness' Rossetti once admitted to the slightly disapproving Holman Hunt, it was not without deep-running currents of feeling, expressed in ballad-like rhythm and contour:

> Her full lips being made to kiss,
> Curl'd up and pensive each one is;
> This makes me faint to stand and see.
>
> *Beata mea Domina!*

The friendships apparently thrived. Rossetti and Lizzie joined Morris and Jane in decorating the Morris' new home, The Red House at Upton in Kent. It was a house of beauty and original design, for which Philip Webb, long to be associated with the Pre-Raphaelites, was the chosen architect; 'more a poem than a house', wrote Rossetti. The Brotherhood instantly named it 'The Towers of Topsy'. It was here that the idea for 'The Firm' was developed. This was the famous association of the Pre-Raphaelite group, with business partners, as a company for the designing of textiles, furniture, carpets (made at Kidderminster), wallpapers, tiles, stained glass, and indeed every form of decorative work. Its full title was Morris, Marshall, Faulkner and Company. It was aimed to revolutionize the heavy Victorian taste in house decoration and furnishings, but although

its original prospectus, written by Rossetti, expressed the hope that this would prove also to be cheaper and extend to the less wealthy sections of society, the hope proved over-optimistic. Commercially The Firm could only run if its expenses were covered, and its expenses proved high.

Although all the Pre-Raphaelites, in particular Rossetti and Burne-Jones, produced designs, it was Morris in the end who virtually ran the business and did all the major part not only of the creative work but its actual technical process. It became a standing joke, when The Firm outgrew the Red House in faraway Kent and shifted to Queen Square in London, that Morris greeted visitors with his arms bright blue to the elbow from the dye vat. His own particular genius proved to be for textile design, curtains and wallpapers, and his work, with its flowing lines and sense of continuous natural plant and flower-growth, remains highly admired. His designs, in fact, were still used in recent years by the firm of Sanderson's for curtain material. At 26 Queen Square, from 1865 to 1871, Morris was genuinely happy, with living quarters 'above the shop', much like the medieval craftsmen. Simultaneously he worked on the proofs of his poem *The Earthly Paradise*, and illuminated book design, and also began the leather-tool work which later became a feature of his book production activities at the Kelmscott Press.

It was in 1871 that he found the manor house of Kelmscott, in a small village in Oxfordshire, and took it at a shared rent with Rossetti of £60 a year. The implications of the *ménage-à-trois* were unspoken yet always uneasily present, for Lizzie was now dead and Rossetti's reliance on Jane was growing. Morris' journey to Iceland under the influence of his new passion for the sagas and their language, which had been stimulated by a meeting with Eirikr Magnusson, was at least in one sense an escape; although it is also true that it was a land to which some strain in his northern-looking nature deeply responded. Soon he was translating and rewriting the sagas in a tumultuous outburst of energy. Nevertheless, Professor Mackail, the biographer of Morris and son-in-law of Burne-Jones, wrote with

possible perceptiveness that the importance of this trip to Iceland was 'not wholly intelligible'. It cannot, in fact, be divorced from the situation at Kelmscott and Morris' ambiguous comment in a letter to Aglaia Coronio on 'what horrors it saved me from'.

Was he truly the complaisant husband or did he find the other two literally taking the initiative out of his hands? It is significant that later Morris affirmed that partners in any marriage should remain 'free' individuals. Rossetti papered and painted the house busily, moved his furniture in from Cheyne Walk, and brought in three dogs (one called 'Dizzy' after Disraeli), to which animal Morris had a curious antipathy. He even, which may have hurt Morris more, began to take over the affections of his young daughter May.

Rossetti was by instinct a London Cockney, normally out of his element in the country, but a new sensitivity to nature now appeared in his verses. He noticed in *Sunset Wings*:

> And clouds of starlings, 'ere they rest with day
> Sink clamorous like mill waters, at wild play
> By turns in every copse.

The house was near Lechlade, where Shelley, sitting in the churchyard, had written his verses *Summer Evening*. And Rossetti's mind was still, too, on dragonflies:

> Deep in the sun-searched growths the dragon-fly
> Hangs like a blue thread loosened from the sky . . .

Soon the attack of *The Fleshly School* and perhaps different inner conflicts over Jane had triggered off his first mental collapse. In 1870, after she had modelled for him in London, he had written to Janey: 'The sight of you going down the dark steps for the cab all alone has plagued me ever since—you looked so lonely . . . Now everything will be dark for me till I can see you again——' She always drew him back. From 1872 to 1874 he was back often at Kelmscott: '. . . here is all happiness again, and I feel completely myself.' His mother and sisters visited him (when Jane was away) and decencies were observed.
96

The unhappy Morris snatched tours abroad with Jane for her health, and she took the two girls to London to him. He had brought them a tiny pony from Iceland named 'Mouse', with which when at Kelmscott they all met visitors at Lechlade Station. But The Firm now took all his time, apart from the verses into which some of his heartache spilled, and the growing volume of letters to Georgiana Burne-Jones, a sympathetic listener, with whom he may have been falling in love.

In April 1874, something snapped in Morris: he wrote to Rossetti asking to relinquish his own share in the tenancy, 'since you have fairly taken to living at Kelmscott, which I suppose neither of us thought the other would do when we first began the joint possession of the house'. His plea was poverty, and it is true The Firm was costing him a good deal, but he probably knew that Rossetti, unwilling to relinquish the Cheyne Walk house in London, could not afford to continue the tenancy alone. Morris, when Rossetti left, shared the tenancy with a comparative stranger.

While, in July, Jane and Morris went to Belgium, Rossetti fell once again into his particular mental disorder, the persecution complex (in a walk by the river he maintained that some anglers had given him an insulting look, and physically attacked them). He never saw Kelmscott again, nor did Morris ever see Rossetti. Jane continued to write to him. In August 1874 Morris took the final step: he dissolved the partnerships in The Firm and took over the business himself. There was some resentment at this and a feeling that the pay-off was too small, but it was Morris' money and work which had always largely sustained the business. Madox Brown was the one who protested effectively, and Rossetti made over his share, quietly, to be invested for Janey. She continued to visit him during his illnesses at Bognor and in London, ostensibly for modelling, although when Rossetti went to Scotland with Hall Caine they were accompanied by Fanny, primly referred to by Caine in his Memoirs of Rossetti as 'the nurse', as already recounted. Probably in many ways she was: an invigorating antidote, with her rude health and now amplifying proportions, to the remoter,

97

more illusive contacts Rossetti now had with the more spiritual Jane.

Morris was the victor, but a victor, as he knew, amid the ashes. In 1879 he took over The Retreat on Hammersmith Mall by the river, hastily renaming it Kelmscott House both in nostalgia for Lechlade and because The Retreat sounded like a private asylum for the insane. Here he buried himself once more in the work of The Firm, although a visit to Italy with Jane proved miserable for the writer of sagas, now putting on weight and with the ice of the North in his veins. In August 1880, with Jane and several others he made the 130-mile journey by water along the Thames from Hammersmith to Kelmscott (it formed the basis of charming chapters in *News from Nowhere*, written ten years later). Merton Abbey had now become the home of his carpet looms, and among May Morris' most vivid memories of her father were those of him sitting weaving his beautiful medieval-style tapestries at his great loom in an upstairs room at the Hammersmith house. After his death, she preserved it zealously, exactly as during his lifetime. Ceramic design had also now come into The Firm's schedule, and W. S. Gilbert's quip in *Patience*, 'Such a judge of blue-and-white and other kinds of pottery', may have been at the expense of Morris, although Rossetti and Whistler, close neighbours by the river at Chelsea, were also fervent rivals in the collection of Nankin china. Whistler, with his single white lock of hair, carefully cultivated, has always been the physical model for players of Bunthorne on the stage.

By 1883, a year after Rossetti's death, Morris was an active member of the radical organization, the Democratic Federation, formed by Henry Myers Hyndman, and from that time until three years from his death Morris was as militant and absorbed in socialist activities as he had once been in saga and design. Jane, uninterested, moved like a Malory wraith among the new brotherhood of social reformers who now thronged the house. Among them was the young red-haired critic and Fabian, George Bernard Shaw, who half fell in love with her daughter May and noticed May's mother as a singularly 'silent' woman. Rossetti

was dead, and perhaps part of Janey had died with him. Guinevere had lost her Launcelot. She had little place in the brave new world of revolution against working-class oppression and the Victorian slum.

Yet her extraordinary decorative presence remained. 'Rossetti's pictures, of which I had seen a collection at the Burlington Fine Arts Club', wrote Shaw, 'had driven her into my consciousness as an imaginary figure. When she came into the room in her strangely beautiful garments, looking at least eight feet high, the effect was as if she had walked out of an Egyptian tomb at Luxor. Not until she had disposed herself very comfortably on the long couch opposite the settle did I compose myself into an acceptance of her as a real woman, and note that the wonderful curtain of hair was touched with grey, and the Rossetti face ten years older than it was in his pictures.'*

The impression she made on Morris' young Scottish socialist disciple, J. Bruce Glasier, had the same effect of unreality, as of a being of another world and period, when he first saw her.

> I had, of course, heard of her great beauty, and had seen her portrait in some of the reproductions of Rossetti's pictures, but I confess I felt rather awed as she stood up tall before me, draped in one simple white gown which fell from her shoulders down to her feet. She looked a veritable Astarte—a being, as I thought, who did not quite belong to our common mortal mould.†

It was Shaw, the art critic, who could appreciate the setting Morris had devised for this Astarte:

> Everything that was necessary was clean and handsome: everything else was beautiful and beautifully presented. There was an oriental carpet so lovely that it would have been a sin to walk on it; consequently it was not on the floor but on the wall and half way across the ceiling.

*Morris as I knew him. Reprinted as Introduction to Vol. II of May Morris' *William Morris: Artist, Writer, Socialist* ('Morris as a Socialist') (1936)
† *William Morris and the Early Days of the Socialist Movement* (1921)

'An artistic taste of extraordinary integrity' was Shaw's description: integrity being the word perhaps most pertinent to the whole of Morris' life, in work and social outlook as well as artistic taste. The beauty he created around him was uncluttered, just as his mind, though so richly-furnished, was uncluttered by what to him were irrelevancies.

Morris when Shaw knew him was primarily active as a fellow-socialist, but it was as a writer that Shaw also appreciated him, claiming his *Sigurd the Volsung* to be 'the greatest epic since Homer'. 'Morris', he wrote, 'was a very great literary artist: his stories and essays and letters no less than his poems are tissues of words as fine as the carpet on the ceiling.' A mass of Morris writing, as well as design and practical craftsmanship, in fact remained which was quite outside the range of his socialist lecturing and pamphleteering. Only *News from Nowhere*, his pastoral contribution to Utopian literature, is now regularly read and in print of these intended harbingers of Marxist revolution, while his poems and ballads still creep into collections of prose and verse, and his fantasy novels have reappeared in paperback in the wake of the successful works of J. R. R. Tolkien, whose *Lord of the Rings* carries on the tradition of Morrisian romance and saga: yet another efflorescence of creative imagination to emerge from the hot springs of Icelandic legend and the dwarf-infested caverns of the Nibelungen. Morris' *Sigurd the Volsung*, illustrated by Burne-Jones, was a contribution to the epic literature of which both Wagner and Tolkien made ample use, and his fascination with the Tristan and Isolde story, as we have seen, was displayed in almost every one of his many forms of artistic expression. His study of *Iseult on the Ship*, a beautiful, graceful drawing of Janey in pen, ink and pencil, could be used by any stage designer for the first act of Wagner's great music drama.

His founts of inspiration were so many and luminous that some of them dried before he had exhausted them, turning away to play, as he did, with so many glittering jets of fancy. He probed not only into Icelandic and Teutonic but also into Hellenic literature. There was an unfinished *Scenes from the Fall*

of Troy as well as a *Life and Death of Jason*. Helen's is a chill, haunting and prescient strain:

> Shall I say, Paris, that my heart is faint,
> And my head sick? I grow afraid of death.
> The gods are all against us, and some day
> The long black ships rowed equal on each side
> Shall throng the Trojan bay, and I shall walk
> From off the green earth to the straining ship;
> Cold Agamemnon with his sickly smile
> Shall go before me, and behind shall go
> My old chain Menelaus; we shall sit
> Under the deck amid the oars, and hear
> From day to day their wretched measured beat
> Against the washing surges; they shall sit
> There in that twilight, with their faces turned
> Away from mine, and we shall say no word . . .

And in *Jason* one can hear, perhaps, the sad echo of Jane vanishing from his life and some garden, probably the Red House garden, they had shared:

> And though within it no birds sing
> And though no pillared house is there,
> And though the apple-boughs are bare
> Of fruit and blossom, would to God
> Her feet upon the green grass trod,
> And I beheld them as before . . .
>
> Dark hills whose heath-bloom feeds no bee,
> Dark shore no ship has ever seen . . .

This was the darkened scenery of Morris' marriage, as he concealed his bruised heart in webs of tapestry and revived his wounded mind in the glow of legend and fantastic worlds of romance, where the women were gentle and loving, and the kingdoms strange ones in which mistress and female servant were locked in enmity, with evil in some unexplained dominance over the good (the influence of Morris' socialism was perhaps dimly reflected in these relationships).

Morris' novels do not represent a Hobbit-inhabited world, but a world in which creatures recognizably human are yet not quite human, but touched with witchery in both its black and white forms. They have a curious poetic streak in spite of their deliberately archaic language, but the structure is leisurely and the tension slack. They still have their admirers, but have been superseded by the more vigorous strain of the best science fiction: by H. G. Wells, in particular, and John Wyndham, both of whom made the world of their time the basis of invasions from space, or new extensions in telepathic communication, and showed the impact of these things on an otherwise normal human society. Even in the farflung future of *The Time Machine*, Wells' Eloi and Morlocks are both variations of human genetics, two human strains divided by time and conditions of life. In some ways the futuristic worlds of the cyberites are closer to Morris' green-grass summer worlds of strange beings in human form; but the whole imaginative process has been transformed by a century of invention and hardware of which Morris had no conception. His world of romance was far nearer the world of *The Faerie Queene* than of *2001: A Space Odyssey*.

It was only when he turned to socialism that Morris found something that satisfied both the practical and the visionary sides of his mind. If the revolution of society was a vision of the future, it was also something concrete that could be worked for here and now. The Firm had not transformed decorative taste, except among a small and comparatively wealthy section of society. Even the Kelmscott Press and its masterpiece, the Chaucer superbly planned by Morris and Burne-Jones to incorporate printing and illustration on each page, was a throwback to Caxton's development of the illuminated medieval manuscript, and so costly to produce that no working man could hope to possess a copy. Socialism offered hopes of a far wider transformation of values, and one which would benefit the toiling masses of the poor, giving them new dignity and enough money to live well and acquire taste. This was the revolution which Morris now stirred all his massive creative energies to promote.

VI

Ruskin and Morris:
The Socialist Legacy

ﾟﾞﾟﾞﾟﾞﾟﾞﾟﾞﾟﾞﾟﾞﾟﾞﾟﾞﾟﾞﾟﾞﾟﾞﾟﾞ

When Morris took up socialism as an active creed, it had already been diverted into new channels of political and economic theory by the publication of Karl Marx's *Capital* in 1867. But in other forms it had penetrated the century's thought through the works of Carlyle and Ruskin, who were both initial inspirations of Morris. They were among those first writers, in fact, to rebel against the threatened obliteration of human values and justice under the grinding mills of the new capitalism.

The romantic hopes of the Lunar Society and Wordsworthian poets had been wiped out by the smoke belching from factory chimneys, and a feverish pursuit of wealth by the classes controlling industry. This had resulted in an appalling increase in hours of labour, low pay and slum housing in grossly overcrowded conditions. The adulterated Reform Bill of 1832 had still kept the franchise geared to property rights, and the Chartist rebellion had been crushed from the very weakness, in state and monetary terms, of the labouring classes who supported it. In Chartism the traditions of Thomas Paine's *Rights of Man*, and of Shelley's *Queen Mab*, lived on; but the deism (miscalled 'atheism') and social welfare theories of the one, and the genuine atheism and political concern of the other, had been suppressed in educated society. Although Paine's works con-

tinued to be printed and read 'underground', in labouring and radical circles, they were long banned by government censorship, and publishers of them, like Richard Carlile, when discovered were subjected to savage terms of imprisonment. *Queen Mab*, like *Rights of Man* often called the 'Bible' of the Chartists, slipped through to the middle classes (as Blake slipped through) as romantic poetic symbolism, but it was 1920, almost one hundred years after his death, before Shelley's penetrating and dangerous *A Philosophical View of Reform* was published.

A further factor in the suppression and distortion of Paine's ideas in middle-class minds was, curiously enough, Thomas Carlyle's quarrel with the British Museum and founding of the London Library as a rival to the Reading Room. When researching his monumental and still-vivid *French Revolution* in the 1830s, he had access only to two works on Paine in the London Library and both were deliberate anti-Paine propaganda, one of them by a British government official, commissioned to counteract the prolific early sales of *Rights of Man*.*

When Carlyle published his *Past and Present* in 1843, therefore, he showed no appreciation at all of the nature of Paine's political writings, so influential in the working-class movement, and his reference to Paine's 'atheism' makes it clear he had never read *The Age of Reason* ('I believe in one God, and no more; and I hope for happiness beyond this life,' Paine had written. 'I believe in the equality of man, and I believe that religious duties consist in doing justice, loving mercy, and endeavouring to make our fellow-creatures happy'). Paine's influence remained only among a totally different class of men; the reading members of the working class, and the artisan-craftsmen, who had formed the backbone of the Chartist movement. One of them, W. J. Linton, a Chartist poet and engraver, wrote a Life of

* They were still the only works on Paine in the London Library towards the end of the nineteenth century, and accounted for the scholar Leslie Stephen's own early denigration of Paine. It was Stephen who discovered the tainted nature of the sources and introduced more valuable works on Paine into the London Library. He also then wrote the very just entry on Paine in the Dictionary of National Biography.

Paine which was published anonymously in 1842, only a year before Carlyle's *Past and Present*. Like the National Charter Association's collection of Paine's writings, published the same year, it would never have reached the bulk of the educated middle classes, to which philosophers such as Carlyle and Ruskin belonged. Only Morris, although he gave no special indication of it, may have gathered some idea of the nature of Paine's work, because it was an apprentice in Linton's workshop, Walter Crane, who later became deeply associated with Morris not only in his engraving and Kelmscott Press activities, but also in his militant socialism.

This, however, was late in the century, and Morris, in his early Pre-Raphaelite days, was as far removed from the world of underground agitation and the Chartists as were Carlyle and Ruskin. Like Ruskin, he was first influenced by *Past and Present*, and then absorbed Ruskin's own works of social criticism with characteristic enthusiasm. Lines of thought common to all three men can be traced right through their works, until Morris, a convert to Marxist communism, shot into a new political orbit.

In parenthesis, it is interesting to note that in 1871, when Ruskin went to live in the Lake District, the house he acquired near the crags of Coniston was Linton's house. 'There certainly *is* a special fate in my getting this house', he wrote. 'The man from whom I buy it—Linton—wanted to found a "republic", printed a certain number of the *Republic* like my *Fors Clavigera*, and his printing press is still in one of the outhouses, and "God and the People" scratched deep in the whitewash outside . . .' Tenuously, the heritage of the Chartists and *Rights of Man* had at last filtered through to the hermit of Coniston Water.

It was not of Republics, but of Heroes, that Carlyle wrote in 1843. His 'Aristocracy of the Wisest' was hardly more than a dream of good government, and he knew it: we must, he wrote, 'learn to do our Hero-worship better; that to do it better and better, means the awakening of the Nation's soul from its asphyxia, and the return of blessed life to us,—Heaven's blessed life, not Mammon's galvanic accursed one'. We should

be a world of heroes, not flunkies, and by Reform Bills, Anti-Corn-Law Bills, and 'thousand other bills and methods', demand that our Governors cease to be quacks, or depart.

It was Bernard Shaw, prefacing his *Caesar and Cleopatra* in the first year of the next century—the year of Ruskin's death—who most strongly appreciated this aspect of Carlyle, who 'with his vein of peasant inspiration', wrote Shaw, 'apprehended the sort of greatness that places the true hero of history so far beyond the *preux chevalier*, whose fanatical personal honor, gallantry, and self-sacrifice, are founded on a passion for death born of inability to bear the weight of a life that will not grant ideal conditions to the liver. This one ray of perception became Carlyle's whole stock-in-trade; and it sufficed to make a master of him.'

But Carlyle did not, like Shaw, recreate a Caesar in a new image: he attacked the God Mammon direct, because it seemed to him the God which had replaced the Christian God in the wealthy manufacturing classes of his time, and in Government too. 'Industrial work, still under bondage to Mammon, the rational soul of it not yet awakened, is a tragic spectacle . . .' The question of work and wages was a crucial one. 'Life was never a May-game for men', he admitted, but never, 'since the beginnings of Society, was the lot of those same dumb millions of toilers so entirely unbearable as it is even in the days now passing over us. It is not to die, or even to die of hunger, that makes a man wretched . . . But it is to live miserable we know not why; to work sore and yet gain nothing; to be heart-worn, weary, yet isolated, unrelated, girt-in with a cold universal Laissez-faire: it is to die slowly all our life long, imprisoned in a deaf, dead, Infinite Injustice . . . Do we wonder at French Revolutions, Chartisms, Revolts of Three Days?'

Basically, it was putting into words the deep disquiet many compassionate people of the time were beginning to feel as industry took over the lives of human beings: a disquiet many also acquired through the novels of Charles Dickens. 'Liberty, I am told, is a divine thing', wrote Carlyle. 'Liberty when it becomes the "Liberty to die by starvation" is not so divine!'

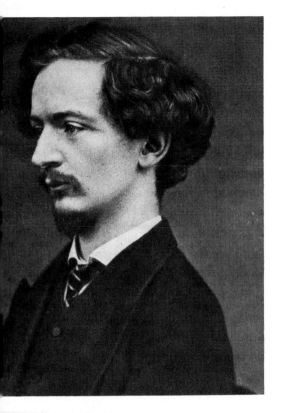

Plate 18 (*left*) Swinburne, aged *c* 28. Photo by Elliott and Fry

Plate 19 (*right*) Study for Pandora (Jane Morris) by D. G. Rossetti

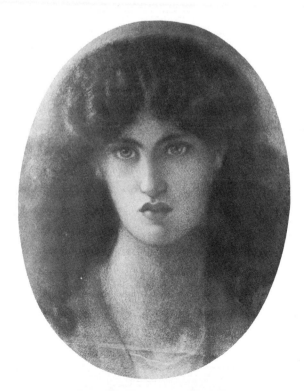

Plate 20 Glen Birnam by J. E. Millais

No revolutionary ('When the very Tailor verges towards Sansculottism, is it not ominous?'), he was concerned with a juster relationship of Master and Man, not with destroying it. Discipline—'brass collars' as he put it—was good for the human being: Carlyle's iron Christianity, though, was less for breaking chains, than easing them. In his ideal society, 'To be a noble Master, among noble Workers, will again be the first ambition with some few; to be a rich Master only the second ...'

The immense problem 'of Organising Labour, and Managing the Working Classes, will, it is very clear, have to be solved by those who stand practically in the middle of it; by those who themselves work and preside over work'. It was a problem, as he saw it, of co-operation of workers and management which we are still discussing today, although without the Carlylean ethics. 'The leaders of Industry, if Industry is ever to be led, are virtually the Captains of the World; if there be no nobleness in them, there will never be an Aristocracy more.' He could not see the possibility of the democratisation of the Captains; but he did see that love of men could not be bought by cash-payment alone, much though that cash payment, a new balance of work and wages, was needed. The secret was the instillation of a sense of the spiritual value of work. 'Idleness alone is without hope.'

It was to be the gospel of John Ruskin, and the personal life-line of the indefatigable, versatile genius Morris. 'I do not mean work in the sense of bread', Ruskin once wrote, '—I mean work in the sense of mental interest.' But the wage-earners of Victorian society were not Pre-Raphaelites and artists, and the division of labour, as Ruskin well knew and pointed out, was taking even the craftsman's interest from the ill-paid labourer in the factories. 'The more the great civilised invention known as the division of labour is perfected, the more each individual man is broken into small fragments and crumbs of life; so that all the little piece of intelligence that is left in a man is not enough to make a pin, or a nail, but exhausts itself in making the point of a pin or the head of a nail.' Mary Wollstonecraft had seen the same problem even in the previous century, when

the Industrial Revolution was in its infancy, and we are still discussing it today.

Ruskin, brought up with stern Christian principles but in the shelter of wealth and self-indulgence, felt the disquiet of his time. In France in 1848 he wrote back in horror of the 'vagabonds and ruffians' who filled the streets, yet whose expressions of malice and brutality would vanish if a few words of humanity were spoken to them. It was a jolt followed by another, when in Venice in 1851 he was struck by three adjacent columns of incompatible news in a newspaper: the first detailing the death from exposure of a homeless young girl, who had just given birth to a child on the bank of an English canal; the second, a fashion account of satin skirts; the third, the death of a burned child, because a surgeon had refused to treat it without a special order from the Parish. Thenceforth the social criticism of Carlyle, whom he came to know and visit, began to enter his very bones, and both his writing and his life reflected his disturbed conscience to his death.

Ruskin was a thinker, but like Morris he was also practical. In 1854 he threw himself eagerly into the Working Men's College project at 31 Red Lion Square, knowing well it was not meant to turn working men into professional artists, but rather to awake their dormant faculties and interests, particularly artistic but also botanical and geological. Lichen and fungi from Anerley Woods were brought to favourite pupils; pebbles were placed in jars of water to show their 'tangled veins of crimson and amethyst'; even West Indian birds were brought as examples of natural colour, 'all rubies and emerald'. It was Morris' arts and crafts obsession in a different direction. Education was essential, but its aim should be to advance all men only to the full extent of their capacities; never 'art for art's sake'. He became a patron of Octavia Hill when she was secretary of the Working Women's College, also established by F. D. Maurice, and later gave money towards her school in Nottingham Place. On her persuasion, he bought a row of cottages to be reclaimed from slums to a decent standard of housing, and supported her campaigns for smoke abatement, open spaces and the National Trust.

In *Sesame and Lilies* (translated into French by an admirer, Proust), he dealt with women's education, emphasizing that girls should be given exactly the same education as boys, although he tacitly implied that while stretching and improving their minds, it might be put later to different uses. He respected career-women such as Miss Bell of the Winnington Hall Girls' School and Octavia Hill, although later showing himself antagonistic to women's suffrage. 'So far from giving the vote to women,' he wrote in Letter 95 of *Fors Clavigera*, 'I would willingly take it away from most men.'

There is sometimes, with Ruskin as with Carlyle, a curious streak of dictatorship for the workers' (or state's) own good. Ruskin suggested the registration of male workers according to their abilities, and subsequent direction to work where they were most needed. This reversion to the feudal system of villein, if not serf, inevitably involved in the direction of labour, still has occasional supporters among politicians.

Work, in Ruskin's theory, should not be mental only, but manual. (This greatly influenced another admirer, Tolstoy.) While Rossetti and his young friends threw themselves with gay impracticability into the task of decorating the Union Hall, Ruskin was brick-laying at Woodward's new Oxford Museum, and thus providing a full brickwork column as well as designing an ogival window. Years later, in 1874, he was sponsoring an elegantly designed but unsuccessful 'Mr Ruskin's Tea Shop' in shabby, uninterested Paddington Street, and setting a whole bevy of enthusiastic undergraduates to the task of building a new road: an ideal country road, flower-bordered, 'along the foot of the hills past Ferry Hinksey'. Among the willing road-makers, surprisingly, was Oscar Wilde, 'a talkative Irish youth', as Peter Quennell put it, 'who boasted that he had frequently been allowed to trundle Professor Ruskin's private barrow'. News of the project spread, and the scene became a centre of tourist interest not unlike that shown, so long ago, in Madox Brown's painting *Work*. Nevertheless, unskilled youthful energy and enthusiasm alone proved not enough to make a good road: the

III

unfinished work was abandoned and left for the philosophical owner of the land to dismantle.

Ruskin College, Oxford, is Ruskin's most lasting memorial, outside his writing and art collections. And if his immense output (thirty-nine volumes) of written work is largely unread today, a great deal of it does not deserve that fate. Shaw referred to the splendour of Ruskin's prose, founded on his biblical training at his parents' home, and many of his ideas are still pertinent. He set himself strongly against political economy as a 'science', especially when it treated the worker as an 'engine', pointing out the fallacy of any easy deductions on this basis; for the worker was 'an engine whose motive power is a soul'. Human beings were not machines, although Ruskin did not echo those political pamphleteers who, from the time of the Levellers to the Chartists, had been calling for universal suffrage. The inequality of man made this unreasonable; by inequality meaning of age, intelligence, wealth, possessions and education. Ruskin, like so many of his class, did not pause to ask why inequality in these things unfitted a voter for deciding which election candidate might best serve his interests in Parliament. Nor did he explain why intelligence must be presumed a prerogative of those with wealth, education or a vote (which he well knew not to be true). In this he was a creature of his time and society, for all his resistance to the capitalists' treatment of labour.

Nevertheless, Ruskin was concerned with economics and much extended Carlyle's arguments. He discussed taxation of income and property (suggesting a ten per cent tax on all fortunes exceeding £1,000 a year, diminishing in scale); wrote in 1858 that he was 'engaged in an investigation, on independent principles, of the Natures of Money, Rent and Taxes, in an abstract form, which keeps me awake all night'; advocated the housing and distribution of works of art so they could be seen by the greatest number of people (Morris had a similar idea); suggested, in The Political Economy of Art, state control of the arts (which was dismissed in the press as 'arrant nonsense'); and also suggested that the true political economy was only in the

wellbeing of the individual with reference to *all* individuals, that is the corporate body of the state (it was perhaps the nearest Ruskin ever came to glimpsing the essence of Morris' Marxist philosophy).

When in 1862 he crystallized his social criticism in four articles, they were soon curtailed by the publisher (of *Cornhill Magazine*) as 'papers too deeply tainted with socialistic heresy to conciliate subscribers'. Ruskin published them the same year as *Unto This Last*, which he maintained to his death to be his most valuable work, the one for which he would sacrifice all the others. Internationally, it had the greatest influence of any of his books, in particular on Tolstoy and Gandhi, who considered it his political bible.

Its flashpoint was the blunt statement that 'the art of making yourself rich, in the ordinary mercantile economists' sense', was 'equally and necessarily the art of keeping your neighbour poor'. '*All* labour should be paid by an invariable standard', good and bad workmen alike—although Ruskin drew back, like Carlyle, from the suggestion that poor workmen should be used as a form of cheap labour to keep the good workmen out of employment. 'Political economy (the economy of a State, or of citizens) consists simply in the production, preservation, and distribution, at fittest time and place, of useful or pleasurable things . . .'

> But mercantile economy, the economy of 'merces' or of 'pay' signifies the accumulation, in the hands of individuals, of legal or moral claim upon, or power over, the labour of others; every such claim implying precisely as much poverty or debt on one side, as it implies riches or right on the other.
>
> It does not, therefore, necessarily involve an addition to the actual property, or well-being, of the State in which it exists.

This was hard hitting in an age in which the industrialist ruled, and ruled by cheap labour; and who, when the Ten Hour Bill was passed, tried to maintain his profits by putting the workman to work at more machines, so that many collapsed from the strain. As Ruskin shrewdly noted, 'an accumulation of real

property is of little use to its owner, unless, together with it, he has commercial power over labour', so that 'the art of becoming "rich", in the common sense, is not absolutely nor finally the art of accumulating much money for ourselves, but also of contriving that our neighbours shall have less'.

The regulation of wages so as not to destroy industry, but develop it to the benefit of both manufacturer and worker (both being also consumers) was one of his main themes, which he termed 'balances of justice'; and he discusses value and usefulness in consumer goods on a wide scale. But Ruskin does not leave out artistic goods, for their usefulness is, after all, measurable only by the need for pleasure of each individual. Nor does he ignore the armament industry, but criticizes its values when writing: 'The real science of political economy is that which teaches nations to desire and labour for the things that lead to life; and which teaches them to scorn and destroy the things that lead to destruction.'

He had written, as he points out, in the last volume of *Modern Painters*: 'Government and co-operation are in all things the Laws of Life; Anarchy and competition the Laws of Death.' And he summed up: 'That country is the richest which nourishes the greatest number of noble and happy human beings.' Once again, he was hovering, without realizing it, on the idea of the corporate state, of Morris' new Earthly Paradise and Marxist Utopia.

While Ruskin wrote, Morris wrote and acted. When in January 1883, he joined H. M. Hyndman's Democratic Federation, which was also Bernard Shaw's introduction into active socialism, he was merely fulfilling a destiny implicit in his own character and social conscience. The Crimean War and *The Times* despatches, the tales of industrial squalor brought to Oxford by Cormell Price and Charles Faulkner (later a partner in The Firm), had early stirred the feelings of a rich young man who never, during the whole of his life, took his social background to be any sort of dividing wall between himself and other human beings, whatever their rank in society. In his own lifetime Morris saw the apparently defeated Chartist movement

114

re-emerge in a new and more legally-knit form, in which the National Association of United Trades for the Protection of Labour advocated the peaceful settlement of trade disputes without strikes, and organized political support. From 1852 to 1889 the Amalgamated Society of Engineers 'served as a model', wrote the Webbs, 'for all new national trade societies'. There was a catharsis in 1859–60 when there was a great lock-out in the London building trades. 'This struggle in which the employers were definitely waging war against Trade Unionism', wrote Morris' daughter May, 'resulted in a drawn battle.' Thereafter agitation for the legal status of trade unions was supported by the new London Trades Council, which was active, in 1867, in the movement for urban franchise. By 1875, fifty years of struggle for collective bargaining was at last recognized, and indeed the year before two representatives of the Miners' National Union were successful in the General Election. There was no Labour Party as such; but workers' representatives were moving into Parliament.

Hyndman himself, the classic top-hatted socialist, had been converted by Marx's *Capital* (having, like Shaw, read it in French, the only language in which it was then available). Two men more different than he and Morris it would be difficult to find. Hyndman's authoritarian personality split movements like a piccaninny with a knife splits melons: Shaw, the intellectual, rapidly decamped to the Fabian Society, while Morris in 1885 joined the Socialist League. His Hammersmith branch had already been active in the Social Democratic Federation, as Hyndman's society had been renamed, and Morris was already a practised political lecturer in London and all parts of the country.

He now turned Kelmscott House on the Mall into a vibrant socialist centre, editing its magazine *The Commonweal* with all the fervency that the young Pre-Raphaelites had poured into *The Germ*. The same year, 1885, his activity in the Free Speech Demonstration at Dod Street, Limehouse, ended in an appearance in Court: soon a regular experience for socialists, although the protection of his middle-class status kept Morris out of jail, where his less affluent working-class allies frequently ended up.

Morris, no supporter of privilege, was only too bitterly aware of the discrepancy and assuaged his sense of guilt and injustice as best he could by bailing out his comrades; the more feckless of whom had a habit of demanding this service in the middle of the night.

In 1886 (8 February) there occurred 'Black Monday', a disastrous demonstration of the unemployed, in which the windows of the Clubs of the wealthy in Pall Mall were broken and at which Hyndman and the fiery young John Burns (later a Liberal Cabinet Minister) were arrested. They were tried for sedition and acquitted in April. 'We are not responsible for the riots', flashed Burns in his own defence. 'It is Society that is responsible . . .' And Society, vociferously deprecating the violence, prepared its police for the next occasion. Morris, who was not present, thought it looked like 'the first skirmish of the Revolution', and published *A Dream of John Ball* in *Commonweal*, lauding the great preacher of the 1381 Peasants' Revolt who was author of two lines that have run like rivers of fire through the whole of British working-class history:

> When Adam delved and Eve span
> Who was then the gentleman?

In 1887, the Kelmscott Press published his translation of *The Odyssey* of Homer, and Morris and the rising socialist movement went through the traumatic experience of 'Bloody Sunday', when a great demonstration converging from several directions on Trafalgar Square, for a meeting, was broken up by the police (fully ready this time) *en route*, resulting in the death of one of the demonstrators, Alfred Linnell. Morris and the well-known traveller, fine prose writer and socialist MP, R. B. Cunninghame Graham, were pall-bearers at the martyr's funeral.

It was, according to Shaw, the beginning of the end for Morris' active socialism.

Morris joined one of the processions in Clerkenwell Green, where he made a speech, urging the processionists to keep steadily together

and press on if they were attacked. It was the speech of a man who still saw in a London trades procession a John Ball fellowship. He then placed himself at the head of the column, and presently witnessed the attack on it by a handful of policemen, who must have been outnumbered fifty to one at least. The frantic stampede that followed made a deep inpression on Morris. He understood at once how far his imagination had duped him. The translation of ten Odysseys would only have deepened the illusion that was dispelled in that moment. From that time he paid no more serious attention to the prospects of the Socialist bodies as militant organizations.

It was never an abandonment of his basic beliefs in any sense; and if Shaw is right, which seems on the evidence highly disputable, it was a very slow and gradual relinquishment of revolutionary activity as a way of life. It was, in fact, six years later, in 1893, that Morris began to abandon the fight, coming to realize, according to Glasier, that revolutionary socialism was impossible in England, where the working class were too deeply attached by temperament as well as by tradition to compromise. A sensitive man, as Shaw saw him, wracked by his experience of working-class timidity in confrontation, and his own exposed nerves and ideals in the police courts, Morris turned back to the Kelmscott Press and the fantastic romances, to the *Nibelungen Lied* (*The House of the Wolfings*) and, even earlier, the Utopian pastoral which he called *News from Nowhere*.

In 1890 Morris left the Socialist League to the rising Anarchists (under whom, with their element of foreign revolutionaries in exile, it soon foundered) and formed the Hammersmith Socialist Society. It was a haven for his followers of the purest socialist ideals, and Shaw often spoke in the coaching house which Morris had turned into a meeting hall. There was an attempt in 1893 to draw together the sundered movement by a Joint Manifesto of English Socialists, drawn up mainly by Morris, with Shaw and Hyndman giving their names.* It was,

* The naming of Sidney Webb as one of the drafters was a mistake of Morris' biographer, J. W. Mackail, as pointed out by Shaw in his review of Mackail's book in 1899.

in Shaw's word, 'futile': 'he finally got us to sign a document which avoided expressing any of our views . . . It fell flat, and neither is nor was of the slightest importance. The manifesto of the Hammersmith Socialist Society is a far better exposition of Morris's later attitude towards Socialism.'

In fact, the socialist movement was turning into a nascent parliamentary labour party, which as the Independent Labour Party first emerged in 1893, with the Scottish miners' champion, Keir Hardie, as its chief spokesman (the Labour Party now in Parliament was formed in 1900 and named in 1906, ten years after Morris' death). Hardie at Morris' invitation lectured on the party's aims at Hammersmith, and soon would be the first of Labour's official representatives in Parliament. The famous British characteristic of compromise was manifesting itself in a new phase of parliamentary history. But Morris, where socialism was concerned, was not a man for all seasons. He had stood out solidly for Marxist revolution, a totally new form of government and a new doctrine of equality. As the *Manifesto of English Socialists* of 1893 put it:

> Our aim, one and all, is to obtain for the whole community complete ownership and control of the means of transport, the means of manufacture, the mines and the land. Thus we look to put an end for ever to the wage system, to sweep away all distinctions of class, and eventually to establish national and international Communism.

If futile and unimportant, as Shaw claimed, it was hardly equivocal in its expression of an uncompromising Marxist ideal. Indeed, in the same year Morris and Belfort Bax published *Socialism: Its Growth and Outcome*, which gave a central place to the ideas of Marx and Engels.

Morris was disillusioned not with the ideal, but with the idealists. At the age of fifty-three, according to Shaw, he had looked sixty-five, and declining health played a large part in the restriction of his socialist activities. By 1896, at the age of sixty-two, he was dead.

There was a great deal of truth in Shaw's estimate that one of the anomalies of Morris' position, which he never completely

overcame, was the fact that while among the Pre-Raphaelites he was still the ageless young eccentric, 'Topsy', among the social reformers and workers he was looked on as a patriarch, and expected to give a lead. Temperamentally this was never his true rôle; for Topsy, unlike St Paul, had never totally out-grown childish things, or at least child-like enthusiasms. Yet among the new young socialists, as among the Pre-Raphaelites, he inspired devotion and warm enthusiasm, as Bruce Glasier in his book, *William Morris and the Early Days of the Socialist Movement*, makes clear. 'His Socialism', wrote Glasier, 'was integral with his genius; it was born and bred in his flesh and bone.' But he adds, and this is crucial to Morris' ideas, 'He derived his Socialist impulse from no theory or philosophy or reasoning of his intellect, but from his very being.' When taxed, Morris confessed outright, 'I do not know what Marx's theory of value is, and I'm damned if I want to know . . . But I am, I hope, a Socialist none the less. It is enough political economy for me to know that the idle class is rich and the working class is poor, and that the rich are rich because they rob the poor. That I know because I see it with my eyes. I need no books to con-vince me of it. And it does not matter a rap, it seems to me, whether the robbery is accomplished by what is termed surplus value, or by means of serfage or open brigandage.'

If this seems simplistic, it was not simple-minded. Morris, as reported here by Glasier, was extemporizing in answer to a question at a lecture. His lectures and writings had often im-mense force and penetration: like Paine, nearly a century before, he spoke in terms the common man could understand but also assuming the common man to have a reasonably-developed intelligence and grasp of fundamentals. And there was some basis for his distrust of elaborate theories of political economy, 'algebraics' as he called them; they had been tried before in Parliament and outside it, earlier in the century, when Ricardo, Hume and James and John Stuart Mill had in turn wrestled with Malthus' *Essay on the Principle of Population*, and the cir-cumstances in which, as the elder Mill put it, wages must be 'reduced so low that a portion of the population will regularly

die of want'. Francis Place, the radical tailor and 'political manipulator', and Robert Owen, with his co-operative ideals and experiment in housing his workers, and educating their children, at New Lanark, had both made little headway against the worsening conditions of capitalist exploitation in the still-expanding industrial age, and Coleridge as early as 1817 was blaming political economy for the condition of the poor.

'What the economists and the utilitarians had unwittingly done', writes Brian Inglis in his masterly *Poverty and the Industrial Revolution*, 'was to cater for the owners of property. They had taken for granted, John Stuart Mill was later to recall, that the policies they were advocating were in the interest of the community as a whole. But they had really been in the interest of a class.' The selfishness of the members of that class had effectually overridden the principles of those members of it with a social conscience, who quite unintentionally had yielded to the demands of 'common interest'.

Morris, therefore, swept political economy aside and delved down to the basic roots of that communism of which Marx was now the recognized prophet. It was the optimism of James Mill that he echoed. 'In the great struggle between the two orders, the rich and the poor, the people must in the end prevail', Mill had written; and Morris believed in this for a long time with all the passion of which his generous and hopeful nature was capable. The paternalism of Carlyle and Ruskin, and of the renegade 'Parson Lot' of the Chartist movement, Charles Kingsley, was totally outside that nature.* His programme was not amelioration but revolution. He told the Oldham weavers that there was 'no hope save revolution'. And by revolution, as Shaw who knew him wrote, 'he meant armed insurrection as much as his hero John Ball did'. This was why he failed to support any of the efforts of his colleagues to stand for Parliament (they were in any case lugubriously disastrous, John Burns

* Kingsley had back-pedalled not only into the Deanery of Westminster, but even into Balmoral, where he became royal chaplain, a hard-boned racialist and supporter of Governor Eyre's mass murders in Jamaica.

at this time doing best with some 500 votes). 'I think that Socialists', he wrote in *Commonweal* in 1885, 'ought not to hesitate to choose between Parliamentarianism and revolutionary agitation, and that it is a mistake to try and sit on the two stools at once.' 'I do not aim at reforming the present system', he said at Glasgow, 'but at abolishing it.'

To the agitated Lady Burne-Jones, torn as her husband was between love of Morris and only the most timid, bird-like flutterings in the direction of social reform,* he wrote: 'I am sure it is right, whatever the consequences may be, to stir up the lower class (damn the word) to demand a higher standard of life for themselves, not merely for the sake of themselves and the material comfort it will bring, but for the good of the whole world and the regeneration of the conscience of man; and this stirring up is part of the necessary education which must in truth go before the reconstruction of society.'

In fact, Glasier claims, this education had been little stimulated, outside a few serious-minded working-class readers, by Mill, Ruskin and Carlyle, whose works were not often accessible in libraries used by the working class. Morris' lecturing was therefore an illuminating force. He did not advocate the more extreme ideas of the Anarchists, believing indeed that the Commonweal needs laws; nor was he against the use of machinery, although his views on this have been much misinterpreted. 'Morris's target is not industry as such, not the machine as such, but what capitalism does with them', as Anthony Arblaster, a lecturer in politics at Sheffield University, has written.† He believed that all merely monotonous and laborious work should be done by machinery, but that there should still be opportunities for all men to engage in crafts and skills and occupy their hands and minds. It was 'the allowing machines to be our masters and not our servants that so injures

* Later, whether through Morris' original influence or her own maturing political outlook, she became active in Rottingdean committee work and eventually a Suffragette.

† *People for the People* (Ed. David Rubinstein). Article on William Morris.

the beauty of life nowadays'—a direct echo of Ruskin's own statement on the subject.

He had, in this connection, a remarkable foreknowledge of the direction to which this development of machinery was leading. The method of manufacture, he saw clearly, now 'alters not merely from decade to decade, but from year to year . . . This system is still short of its full development, . . . and when the process is complete, the skilled workman will no longer exist, and his place will be filled by machines directed by a few highly-trained and very intelligent experts, and tended by a multitude of people, men, women and children, of whom neither skill nor intelligence is required.' The age he foresaw in *Art Under Plutocracy* was the age of the computer.

What he also saw very clearly was that in fact the machine did not lighten labour, it had added to it. It was 'by no means invented with the aim of saving the pain of labour. The phrase labour-saving machinery is elliptical, and means machinery which saves the *cost* of labour, not the labour itself, which will be expended when "saved" on tending other machines.' Under the capitalist society this was inevitable, simply forming what he called 'a slave society'.

Art and the environment were for Morris integral parts of social reform, the new craze for allotments was no alternative to the state ownership of land, and the building of the People's Palace in the East End was irrelevant for many East Enders 'whose poverty will prevent them from using it'. Housing reform comes before civil magnificence: 'Until their private houses are roomy, comfortable and pleasant, they cannot really enjoy splendid public buildings.' In the art education of the poor Morris was a realist; squalor cannot breed decorative taste. 'The shoddy is king.' The disappearance of 'all pleasure in their labour, or hope of distinction or excellence in it', as he wrote in *Art Under Plutocracy*, 'has welded them into a great class, and has by its very oppression and compulsion of the monotony of life driven them into feeling the solidarity of their interests and the antagonism of those interests to those of the capitalist class'. 'Remember', he warned, 'we have but one

weapon against that terrible organization of selfishness which we attack, and that weapon is Union.'

Unfortunately, union was just the thing that was lacking in the organizations of the socialist middle class. The Hyndman-Morris split was echoed among individuals throughout the movement, Fabian, Federation and Socialist League. In the end it wore down Morris, and helped to lead to his retirement as an activist. Before this retirement he had written *News from Nowhere*, which remains his only truly socialist fantasy—and it is essential to stress the word 'fantasy', for as Glasier, who knew him so well, pointed out:

> Morris never intended . . . *News from Nowhere* to be regarded as a serious plan or conspectus of Socialism, and was both surprised and amused when he found the little volume solemnly discussed as a text-book of Socialist politics, economics, and morality. The story was meant to be a sort of Socialist *jeu d'esprit*—a fancy picture, or idyll, or romance . . .
>
> Yet one meets with readers of *News from Nowhere* who appear to be possessed with the idea that such whimsicalities in the story as the conversion of the present buildings of the Houses of Parliament into a manure depot, the free provision of all manner of fancifully carved tobacco pipes, and the going about of road-dustmen in gorgeous medieval raiment, constitute prime factors in Morris' conception of the Socialist Commonwealth!

Morris had been startled when a referendum among Glasgow members of the Socialist League had revealed that the principal reading that had turned them into socialists was of works by Burns, Shelley, Carlyle and Ruskin, followed by Henry George's *Progress and Poverty*, Disraeli's *Sybil: or the Two Nations*, Kingsley's *Alton Locke*, and Victor Hugo's *Les Misérables*. There was no mention of Owen, St Simon, Louis Blanc or even Marx, nor (most surprising of all to Morris) of Sir Thomas More's *Utopia*, which was Morris' own inspiration for *News from Nowhere* (Utopia, literally, means No-Place).

It is significant that More's Utopia was a communist state, with a six-hour working day for its people, no money (except

to trade with neighbouring states), and an equal share in the land and the produce under a benevolent, peace-loving system of government. There were slaves (in a touch of Tudor casuistry) to do the most disagreeable tasks, but they were mainly convicts used in this way under the penal system, in preference to their stagnating uselessly in prison. Farming is 'a part of every child's education. They learn the principles of agriculture at school, and they're taken for regular outings into the fields near the town, where they not only watch farm-work being done, but also do some themselves, as a form of exercise.'* Everyone is taught a trade, but according (as in Ruskin's ideal) to his capacity and needs, whether these be intellectual or manual; and (with equal shades of Mao Tse-tung and twentieth-century China) there are no tailors, because everyone wears the same clothes, and the fashion never changes. There is religious tolerance for all creeds except atheism; and no death penalty for theft or indeed anything but the most serious crime ('To my mind no amount of property is equivalent to a human life', wrote More).

More's was only one of the first of a series of authors' Utopias, being itself influenced by Plato's *Republic*, in which Socrates is made to state: 'Our purpose in founding our ideal State is not to promote the particular happiness of a single class, but, so far as possible, of the whole community.' More's Utopia in its turn has influenced literature and ideas of equality and justice into the present century. Godwin's *Political Justice* in 1793 echoed its disapproval of the manufacture of unnecessary luxuries, and belief that a few hours' work a day, in Godwin's words, 'would be amply sufficient to supply all the necessities and comforts of life'. Ruskin and Morris both touched on the same idea. The variations on the theme have proved endless, though not all with More's classic scholarship and serious probing into the art of government; nor the necessity, as in his case, to veil the

*This system is followed in Cuba under the Castro régime. The translation of More's *Utopia* I am using is that of Paul Turner in the Penguin Books edition, first published in 1965.

Plate 21 (*left*) Sculpture: Paolo and Francesca by Alexander Munro

Plate 22 (*right*) St Timothy and Eunice. Stained glass panel, Vyner Memorial Window, Christ Church, Oxford, by Edward Burne-Jones

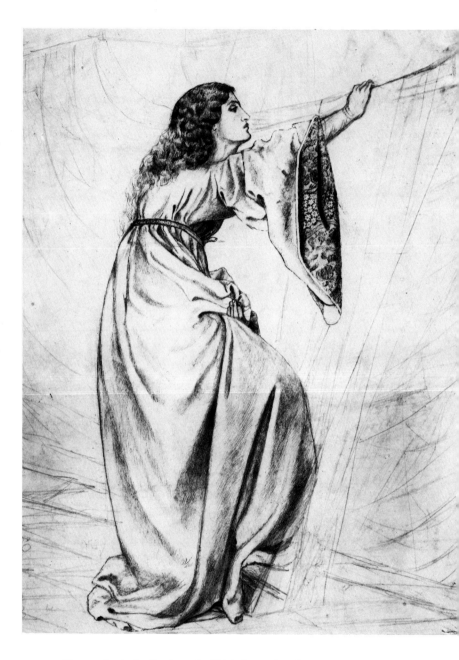

Plate 23 Study for 'Iseult on the Ship'. Pen, Ink and Pencil by William Morris

seriousness of the political implications by use of the classical 'dialogue' form, which can be made rather ingeniously to shift emphasis to a 'querying' character, identified hopefully as More himself. The man for all seasons was expert in the art of diplomatic cover.

Morris' book has little of the intellectual depth and diversity of More's. It is meadow-sweet and pastoral, a futuristic 'dream' where the protagonist awakens to a transformed Hammersmith, with a new society in which industry has been so carefully disseminated throughout the whole land that smoking towns and indeed all traces of industrial squalor have vanished. Its people are gentle and happy and without resentments, an idealized race in an idealized land, who look on the historic past as an age of civil war, social slavery and revolution—that revolution for which Morris had longed and worked and which is here narrated in retrospect (with a rather astonishing prevision of the 1926 General Strike, as well as obvious reference to 'Bloody Sunday'). In Chapter XI, 'Concerning Government', he adopts the Thomas More method of discussion by dialogue, in this case between the 'dreamer' (Morris) and an aged inhabitant. From this emerges a description, highly critical, of the form of government of Morris' own time, including the class system ('which proclaimed inequality and poverty as the law of God'), the 'rights of property', and Parliament (a 'Watch Committee' for the interests of the upper classes). Nineteenth-century science was 'in the main an appendage to the commercial system', and the law an instrument for suppressing any attempt of the people 'to deal with the *cause* of their grievances'. Government 'was the Law-Courts, backed up by the executive, which handled the brute force that the deluded people allowed them to use for their own purposes; I mean the army, navy and police'.

Now all is changed: 'we are very well off as to politics—because we have none', explains the aged inhabitant in a succinct Chapter XIII, and in the following chapter he expands on a system in which, naturally, differences of individual opinion cannot be entirely eliminated but these no longer 'crystallize

H 127

people into parties permanently hostile to one another'. Moreover, 'the whole system of rival and contending nations which played so great a part in the "government" of the world of civilization has disappeared along with the inequality betwixt man and man in society'.

It is, in fact, a less complex Utopia than More's (which did allow for war and military training, although only as a defence against less idyllic rival and contending nations). More's Utopian method of preventing war and saving lives by political assassination, if necessary, Morris does not touch on, although it was an idea that filtered right through to the Carbonari of which Rossetti's father was a member. But Morris' Nowhere had some similar basic principles and brought them into a world of pastoral fantasy, in which the most charming rural scenes appeared in a journey the length of the Thames, based on Morris' recollections of his own tranquil boating excursion to Lechlade ten years before. It was not an imaginary country, but England in some brightly imagined future, when the social slate covered with so many abuses was wiped clean, shining-new in the golden light of an English (equally idealized) summer. In this, rather than any special political message, has lain its charm for several generations of readers. It was one of the last romantic examples of the *genre* before the more horrific twists given to it by Huxley's *Brave New World* and Orwell's *1984.**

It was not, however, as has been said, romanticism presented as serious possibility. Morris was by no means the idealist of human nature that he is sometimes presented as being. His socialism in fact was based on the contrary view. 'He had no patience with the idea that men, apart from the environment of society—its education, customs, and co-operation—were naturally unselfish, amiable or God-like creatures; nor that "free" from organized society they could attain any human

* It is, however, worth noting that Shaw proclaimed he was himself influenced by Samuel Butler, and Morris may well have derived some ideas from *Erewhon*, in particular that alien civilization's distrust of, and elimination of, machines.

eminence of happiness', wrote Glasier. And in his writing on the status of the craftsman in the Middle Ages, and his protection under the guilds, Morris was far more knowledgeable than is often realized. He never denied that there were 'dreadful' conditions for some in these early periods, but his general accuracy about the medieval 'Golden Age' of craftsmanship and artisan labour relations is confirmed by a modern expert on medieval tools, W. L. Goodman, whose researches into the Bristol Apprentice records have shown that it was the custom for the medieval master-craftsman to provide the apprentice, on completion of his training, with tools, clothing, a sum of money for setting up in business and the fee for his admission to the liberties or freedom of the City.

These benefits were gradually eroded during the sixteenth century and in Bristol, at any rate, completely eliminated by about 1660. All the expenses now became transferred to the boy's parents, so that the ordinary workman had small chance of becoming a master himself, which had regularly happened in medieval times. 'The point is that all this was cut and dried about a century before the usual date of the Industrial Revolution', writes Goodman. There had, in fact, been a steady decline for the artisan from Morris' 'Golden Age' of medievalism, beginning in Elizabethan times and reaching its *nadir* in the Victorian factory.

More's *Utopia* was published by the Kelmscott Press in 1893, the year the Press also published Morris' own companion to it, *News from Nowhere*, which had first been serialized in *Commonweal* in 1890. Exquisitely printed and designed, they marked Morris' farewell to active socialism and return to the Pre-Raphaelite world of art and design, the pursuit of beauty through craft and imagination. Swinburne's *Atalanta in Calydon*, Keats' *Poems* and Rossetti's *Sonnets and Lyrical Poems* all poured from the Press, re-establishing the links with the past that had never really been severed, least of all with the devoted Burne-Jones. The ebullient, still-youthful Morris, in soft blue shirt and dark blue suit, who in 1884 had stood outside the Law Courts in the Strand selling copies of the Democratic Federation's journal,

129

crying '*Justice!* Twopence!', was now aged and drained, but the toil did not cease, except that it was a labour of love, not the 'toil to live' he so hated in contemporary society.

'I have never known what I fear many of you unfortunately have known—actual poverty', he had told his Glasgow disciples in a lecture: '—the pain of today's hunger and cold, and the fear of to-morrow's, or the dread of a master's voice, or the hopeless despair of unemployment. I have, I truly believe, lived as happy a life as anyone could wish to live, save for the misery of seeing so much cruel wrong and needless suffering around me. Yet I am no more entitled to that happiness than any of my fellows.'

Perhaps he re-felt that happiness now, working at his press and loom, letting go the dreams of revolution and accepting at last the parliamentary alternative, opening up for younger men than himself. He was no renegade, still capable, as late as 1895, of a paper on *Communism* declaring that any other state of society 'is grievous and disgraceful to all belonging to it'. But 'the tone', writes Shaw, 'is cheerful and humorous; he is even disposed to chuckle at his favorite butt, the politically fussy Fabian, as having hit on a stupendously prosaic solution of the problem that was once so tragically difficult'. In fact, he spoke in Hyde Park on May Day 1895 on the Social Democratic Federation platform, and gave large subscriptions to the fighting funds of Hyndman (with whom he had become reconciled) and George Lansbury, who were candidates in the general election. But when called on by Robert Blatchford in *The Clarion* to become leader of the Federation, he declined. It was not only a matter of health; his reconciliation to the method of infiltrating, rather than revolutionizing, Parliament was a gesture of defeat, not of acceptance in principle.

One desire, as he well knew, poring over his beautiful and costly illustrated volumes, had never been fulfilled. 'I don't want art for a few, any more than education for a few, or freedom for a few', he had written. The education and the freedom would come more easily than the art, proliferating after his death in 1896 into new vulgarities of commercial

advertising and *media* of which he could have little conception. Yet in design, ever-surprising, he suddenly stared in the face of the twentieth century, switching from his intricate and flowering wallpaper designs to a preference for plain whitewash. The Pre-Raphaelite revolt against Victorian mahogany, fussiness and overcrowding was complete.

VII

Burne-Jones:
The Stained-glass Influence

≈◗≈◗≈◗≈◗≈◗≈◗≈◗≈◗≈◗≈◗≈◗≈◗≈◗≈

'Remarkable as Morris's judgment was on all questions of art', wrote Shaw, in assessing the family influence on Burne-Jones' son-in-law's biography of Morris, 'his opinion was not worth having when its value depended, however subtly or indirectly, on an impartial estimate of Burne-Jones' work. He smelt a rival to his friend at forty removes, and was probably jealous of even his own share in the tapestries and windows which they produced together, Burne-Jones as designer, Morris as colorist.'*

This deep and unshakeable friendship and mutual loyalty began at Oxford, and survived until death: indeed Burne-Jones outlived his friend by under two years. Yet their backgrounds were entirely different. Burne-Jones (he was originally plain Jones, and took the name of a relative by marriage) was born in Birmingham on 28 August 1833, and never knew his mother who died within a week. He was brought up by a Miss Sampson who was utterly devoted to him, although having, according to his wife, Georgiana, only a slight clue to his nature. His father was a carver and gilder, and the frail child suffered from nightmares, some of which in later life he exorcised by drawing little devils and demons with tails, and slightly horrific pictures of childish terrors, prolifically across his letters and papers.

There was humour and perhaps a psychological outlet in

* *Pen Portraits and Reviews.*

these little black satanic figures, dancing or playing cricket, and a sense of fun was Burne-Jones' defensive wall, like that built by many melancholic and sensitive men, against the enveloping dark. 'All through his life', wrote Georgiana, 'he was a dreamer of dreams, by night as well as by day': something that he inherited from Celtic forefathers, along with the impenetrable sadness that was embedded deep in his nature. Perhaps he needed both the fun and the dreams, for Birmingham in those days was no Earthly Paradise. 'The whole town reeked with oil and smoke and sweat and drunkenness', wrote a fellow-townsman. It was perhaps partly through Burne-Jones' eyes that Morris, the child of the sunlit south, of Epping Forest and of Exeter College, Oxford, got his first dark glimpses of the industrial Midlands, and what the revolution of the machines had done to cities and men.

Young Burne-Jones grew tall but willowy, a victim of recurrent physical collapses and the common cold, contrasted with bursts of nervous energy: 'a shy, fair young man', as Prinsep first saw and described him, 'with mild grey-blue eyes and straight light hair which was apt to straggle over his well-developed forehead . . . who spoke in an earnest impressive manner when he did speak, which was not often . . . he was almost painfully shy'. This shyness and silence were noted throughout his life, except in the company of very close friends, and particularly when, many years later, he moved into society, where he was never completely at ease, as Gladstone's daughter Mary and others noticed at the Prime Minister's celebrated breakfasts. Alone with Gladstone, that rather solemn and statuesque elder statesman, he was more inclined to indulge his impish sense of fun. When Gladstone came to the Burne-Jones' last London home, The Grange in Fulham, 'Edward told him, as they walked in the garden', wrote Georgie, 'that in the branches of a fine old hawthorn growing there, 801,926 birds nightly roosted.' Gladstone took this with the utmost seriousness. 'How many birds did you say?' was his courteous and interested response.

Burne-Jones' early interest was theology, and he also collected

a highly personal museum of fossils, coins and supposed historical relics, which included a stone worn round the neck of one of the sailors at Trafalgar and another stone, alleged to be part of that erected at Bosworth Field, on the spot where Richard III was reputed to have been slain. Without serious intentions, he went three evenings a week to a school of design and made notes on the principles of light and shade and on water colouring. His first Pre-Raphaelite link was an odd one, and quite unconscious: when staying with an aunt in London he accompanied her to Evangelical services at Beresford Chapel, Walworth Road, where Ruskin had been taken by his parents, long before Edward was born.

Religion was to forge a more momentous connection for Edward Burne-Jones. In 1852, when he was nineteen, he first met the young daughter of a Wesleyan minister recently appointed to the Birmingham circuit, Georgiana Browne Macdonald. It was a number of years before they became engaged, and still more before poverty lifted enough for them to venture to marry, almost alongside Rossetti and Elizabeth Siddal, on 9 June 1860 (it was Dante's Day, carefully chosen, and the day also of their engagement). The bridegroom had £30 ready cash, of which £25 was provided by a helpful patron for two pen-and-ink drawings, and the new home in Russell Place contained no chairs, only an oak table which had been made specially at the Boys' Home in Euston Road to a design of Philip Webb (the boys were still working on the chairs and a sofa, which belatedly arrived). But this, in 1852, was not even a dream of the future, although the child Georgie noticed Edward's mouth 'large and well-moulded, the lips meeting with absolute sweetness and repose', the domed head of colourless hair, and the light-grey eyes from which 'power simply radiated', so that 'as he talked and listened, if anything moved him, not only his eyes but his whole face seemed lit up from within'.

Reading, with Burne-Jones, was already a passion. He was absorbed in 'logic, metaphysics, philosophy, and religious polemics . . . and books of poetry, romance, and devotion'. There was no art gallery in Birmingham (a lack which many

years later was to be remedied partly by his efforts) and painting hardly entered into his scheme of life. 'Until I saw Rossetti's work and Fra Angelico's', he was to write, 'I never supposed that I liked painting. I hated the kind of stuff that was going on then.' He was ripe for Pre-Raphaelite conversion.

It came, as nearly everything in his life was to come, in conjunction with Morris. They met at Oxford in 1853, and Morris transformed the lonely life of the shy young student from Birmingham. It was a union of spirit almost without divergencies, and a contrast of physical vitality that gave both a necessary supplement of gentleness or strength. Soon Morris was reading aloud from Volume I of Ruskin's *Modern Painters*, and Burne-Jones, rapt in Ruskin's chapters on 'Clouds', was proclaiming: 'he is the most profound investigator of the objective that I know of'. 'There never was', he added when the second volume of *Stones of Venice* appeared, 'such mind and soul so fused through language yet . . .'

It was three years, in 1856, before Burne-Jones plucked up courage to write to Ruskin, and was as startled and enchanted to receive a reply as if it were a missive from Merlin. 'I'm not Ted any longer, I'm not E.C.B. Jones now—I've dropped my personality—I'm a correspondent with RUSKIN, and my future title is "the man who wrote to Ruskin and got an answer by return".' Below this dazzled proclamation he drew a small Burne-Jones prostrate before an aureoled Ruskin.

In the meantime Morris and Burne-Jones worshipped from a distance, read avidly, and gravely considered plans to enter the Church or a Monastery. Ecclesiastical controversies, as has been seen, were in the air in mid-century England, and 'the Christian Socialists', wrote Edward, 'if Maurice and Kingsley are fair examples, must be glorious fellows'.* Morris took his new friend to his home in Walthamstow, and the impecunious, motherless carver's son was understandably impressed. After the reading of Ruskin's Edinburgh lectures, including the one on

* In 1854, F. D. Maurice, later founder of the Working Men's College, was forced to resign from King's College, London, for denying the doctrine of Eternal Punishment.

the Pre-Raphaelites, and the first sight of the Millais reproduction, *The Return of the Dove*, in Oxford, Burne-Jones took a tentative step towards his future career, with a series of pen-and-ink designs for the *Ballads Upon the Fairy Mythology of Egypt*, by a friend named MacLaren.

A visit to the 1854 Royal Academy Exhibition, showing Holman Hunt's *Awakened Conscience* and *Light of the World*, sparked off an anti-Academy diatribe which showed how far on the Pre-Raphaelite road he and Morris had travelled: 'Landseer', wrote Burne-Jones, 'has drivelled his time away on another group of the Royal family in Highland costume . . . Maclise has managed to cover an acre of canvas with mangled bodies, and a host of meaningless faces in steel helmets—and all to illustrate a fact in history about which the less said the better.'

Morris was now reading Chaucer aloud, and both of them were absorbed in the old chronicles in the Bodleian. The *Morte d'Arthur* and *Nibelungen Lied* they only later discovered. 'Slowly, and almost insensibly, without ever talking about it', wrote Edward, 'I think we were both settling in our minds that the clerical life was not for us.' But it was not until their first tour of France in 1855 that, walking on the quay of Le Havre one night on their way home, the two friends came to their final decision: Morris should be an architect and Burne-Jones a painter. 'That', wrote Burne-Jones without hyperbole, 'was the most memorable night of my life.' They had only found one division of taste in France, when Burne-Jones, unlike Rossetti and Morris a lover of music, had thrilled to Meyerbeer's *La Prophète* at the Paris Opéra. (It is strange that no chord in Morris vibrated to this tale of a great sixteenth-century revolutionary-turned-tyrant, John of Leyden.)

What they both shared was a world of imagination. 'Of course imagining doesn't end with my work:' wrote Edward. 'I go on always in that strange land that is more true than real.' Unlike Morris, he never put his strange land into literary romances, yet he was a natural writer who has left us pictures in his letters more lasting than some of those he tried to put into paint. It was in design that Burne-Jones as well as Morris most

136

excelled, and in the stained-glass compositions they later created together Morris, the non-painter, was the colourist. Edward's colours, in his once-admired, now half-forgotten, paintings, were often drab in comparison, suffused in blue-green darkness that perhaps explained his later acceptance as an Associate of the Royal Academy.

The discovery of the *Morte d'Arthur* and, for Edward particularly, of Rossetti's illustration to *The Maids of Elfenmere* in Allingham's *Day and Night Songs*, set their joint imagination working; and 1856 which saw Burne-Jones' first contact with Ruskin was also the year in which, greatly daring, he ventured timorously into the Working Men's College, to try and get a glimpse of Rossetti at one of his classes. This idol, too, responded with unexpected warmth. Rossetti, so easily wounded by the arrows of criticism, opened like an Italian flower to the sun of this hero-worship. Soon Edward was invited to the studio at Blackfriars, and was not slow in introducing his friend to Rossetti's generous attention.

Rossetti was charmed and scented genius in both directions; and Ruskin, too, became a frequent visitor. To Miss Sampson, Edward wrote in ecstasy (and not a little boastfully, a rarity with him): 'Just come back from being with our hero for four hours—so happy we've been: he is so kind to us—makes us feel like such old friends. Tonight he comes to our rooms to carry off my drawing and show it to lots of people.' Georgiana, now transferred with her family to London and the subject of Edward's romantic attachment, was taken to visit Rossetti but (her eyes perhaps drawn elsewhere) remembered little except that Rossetti went on painting while they were there, 'and that I noticed the sensitive look of his hand as well as the beautiful olive colour of his skin, so different from that of a dark Englishman'.

Burne-Jones was now twenty-three, a late age to start as a painter; but in spite of techniques still to learn Rossetti was encouraging. With his sharp eye for the direction of a talent he had noticed Burne-Jones' facility in design, but the problem of how Ned (as they now all called him) could earn a living was an urgent one. and it remained so for a number of years. Neverthe-

137

less this year, 1856, Ned became engaged to Georgiana, and in a gesture of generosity as great as Ruskin's own he gave her every treasured work of Ruskin's that he possessed, as an engagement gift. He and Ruskin shared a curious physical likeness, particularly in colouring. It was a delight to the hero-worshipping Burne-Jones when Ruskin was ushered in by a servant with the words, 'Your father, sir.'

In the meantime, he shared the studio at 17 Red Lion Square with Morris. 'Topsy has made some furniture (chairs and a table)', he wrote to Miss Sampson, 'made after his own design; they are as beautiful as medieval work, and when we have painted designs of knights and ladies upon them they will be perfect marvels.' In fact, Rossetti also painted a picture on one of the chairs: the first tentative birth-pangs of The Firm were manifesting themselves.

Apparently Rossetti's studio was equally open to them, for it was here that they were working when 'the greatest genius that is on earth' came in and they had their first dazzled sight of the famous Holman Hunt: 'such a grand-looking fellow', enthused Ned, 'such a splendour of a man, with a great wiry gold beard, and faithful violet eyes—oh, such a man. And Rossetti sat by him and played with his golden beard passing his paint-brush through the hair of it. And all evening through Rossetti talked most gloriously, such talk as I do not believe any man could talk beside him.' The Rossettian magic in full flood had once again enlarged the circle of the Brotherhood.

The same year, 1856, Rossetti took his two new young friends to see Madox Brown and Ned to see the Brownings in Devonshire Place. 'There was a year', wrote Burne-Jones later, 'in which I think it never rained nor clouded, but was blue summer from Christmas to Christmas, and London streets glittered, and it was always morning, and the air sweet and full of bells.'

He was totally without economic sense and his idea of keeping money safely was to 'put it in a box and sit upon it'. A client wishing (unusually) to pay in advance by cheque was met with incomprehension. It was some years before the Burne-Jones

finances became respectable enough for a bank balance, and when the mysteries of cheque-drawing were explained to him, he complained of the term 'drawing'.

By 1857 he was already making cartoons for stained glass, and attempting to meet the Pre-Raphaelite demand that nature should be painted from life, by seeking apple blossom in Warwickshire and Worcestershire orchards for the background of a picture based on Rossetti's *Blessed Damozel*. The bitter wind of an English May blew the petals to the ground before they were painted, and Burne-Jones, never physically partial to outdoor life, in future painted his backgrounds from memory, indoors. (He made an exception of the apple tree in the garden of his dear friend Morris' mother.)

In the days of the Oxford Union murals, Rossetti, Morris and Burne-Jones lodged together, at first in the High Street opposite Queen's, and after October in George Street. Prinsep after forty years still carried in his mind the picture of the three that long-ago autumn: 'Rossetti on the sofa with large melancholy eyes fixed on Morris, the poet at the table reading and ever fidgetting with his watch chain, and Burne-Jones working at a pen-and-ink drawing' (Ned was long hesitant about painting in oils).

> 'Gold on her head, and gold on her feet,
> And gold where the hems of her kirtle meet,
> And a golden girdle round my sweet;
>> *Ah! qu'elle est belle La Marguerite.*

still seems to haunt me . . .'

'We sank our individuality', wrote Burne-Jones, 'in the strong personality of our adored Gabriel.' No one, recalled Georgiana, 'could reproduce the peculiar charm of his voice with its sonorous roll and beautiful cadences'.

The domestic picture was broken up when Rossetti was called away to Matlock, where the ailing Lizzie Siddal had been sent for her health. But a new arrival with sun-bright hair had now for the first time joined the group. It was the twenty-year-old poet Algernon Swinburne, a student at Balliol, a remarkable scholar, and a budding revolutionary follower of the Italian

political exile, Mazzini, and the French novelist Victor Hugo. 'Now we were four in company, and not three', wrote Ned, his reaction to the intrusion a little ambiguous.

Swinburne's voice, pitched higher than Gabriel's but often described as beautiful when reading poetry (which he was passionately fond of doing), now replaced Rossetti's among the chattering music of the gay young painters. He was small, dapper, with tiny feet and nervous, convulsive movements. Lizzie was to laugh when she first saw him, for they had exactly the same shade of red-gold hair and could easily have been taken as brother and sister. In fact, their devotion was to have something of this nature, for Swinburne could be tender and generous as a companion, and invincibly loyal. In the meantime, his burnished thatch of hair and eager mind brought a new shimmer into the Pre-Raphaelite group, and psychological problems to come did not yet intrude into the artists' circle.

It is out of period and character to suggest that the Pre-Raphaelites were sexually promiscuous or even openly defied convention in their affairs, which were normally based on a deep romantic attachment and limited in number. Not all models were as compliant and easy-going as Fanny Cornforth, and it is certainly not true that even Rossetti and Lizzie lived together openly at Chatham Place before their marriage. Decencies were observed for the sake of families if nothing else, and whatever the rather equivocal situation Lizzie for most of the time still lived officially with her respectable suburban parents. Alexa Wilding modelled but clung tightly to her virtue, Madox Brown married a second time into warm and dependable domesticity, there is no evidence of Morris straying even for a short while from his (more divided) Janey, and when Holman Hunt lifted the pretty Annie Miller from her slum it was from a respectable poverty, and he was genuinely concerned for her possible contamination by sitting as a model in his absence. The fact that this occurred, and that his response to the tales he heard on his return from Palestine was both shocked and angry, showed that she was originally a girl on whose loyalty and respectability he hoped he could rely. It is to underrate

Hunt's intelligence to suggest otherwise; and although he blamed Rossetti for Annie's fall there is no real indication that it was because he thought Rossetti himself had seduced her; only that he knew it was Rossetti who had found her modelling opportunities and thus indirectly led her to quite different associations.

Hunt had left money not only for her education but doctoring, and quite probably the girl found it insufficient to keep her and did not see why she should not supplement it by earning more in the way Hunt himself had taught her. Hunt was away in the Middle East a very long time, and the education as well as the modelling raised the girl to a higher, if dissolute, branch of society: the courtesan rather than the prostitute, it would seem from her associations. Hunt, so innately religious and respectable, was unlucky in trying to maintain these qualities in his love life. When his first wife, Fanny Waugh, died so tragically of cholera on the way to the Middle East, he brought their baby son back to England and eventually married (abroad) Fanny's sister Edith, who had taken care of the child. In England such a marriage with deceased wife's sister was still illegal, but Hunt seems to have made up in common sense and affection for any 'indiscretions' that Victorian society most irrationally prohibited.

Any young man as attractive, mercurial in mood, sensitive and aesthetically susceptible as Edward Burne-Jones could hardly escape responding to the beauty of women, sometimes off as well as on the artist's canvas; yet his love for his charming and understanding Georgiana was firmly enough based for the marriage to survive with strength and affection, even although Georgie, like her sympathetic correspondent William Morris, must have had her inevitable periods of trial and even fear, so discreetly passed over in her generous and intelligent book about her husband and his friends.

The most serious and perhaps dangerous eruption of a sleeping volcano within Ned came in 1868, eight years after their marriage. Georgie hid the memory of a trying period in a single uninformative sentence. They had had, she wrote, 'the pleasure of meeting the beautiful Miss Spartali and her sister, daughters

of the Greek consul, but now, I forget in what way, we became acquainted with one or two other families of her nation'. It was one of these descendants of Grecian Helen who was to cause especial heartache for Georgie; for Ned became for the next four years inextricably entangled with Mrs Marie Zambaco, cultivated by several of the Pre-Raphaelites as a model of grace, and herself a practising artist. On 23 January 1869, Rossetti, who had drawn her, wrote to Madox Brown:

> Poor Ned's affairs have come to a smash altogether, and he and Topsy, after the most dreadful to-do, started for Rome suddenly, leaving the Greek damsel beating up the quarters of all his friends for him and howling like Cassandra. Georgie stayed behind. I hear to-day however that Top and Ned got no further than Dover, Ned being now so dreadfully ill that they will probably have to return to London.

The distraught Cassandra, doubtless desperate at the fragile Burne-Jones' struggles in the toils, was said to have tried to persuade him into a suicide pact and got him at least as far as the edge of the Serpentine, where entertained *raconteurs* (more concerned with wit than truth) soon had Ned drawing back at the brink, for fear of catching one of his devastating colds in the water. She then attempted to drown herself in the Paddington canal, at a spot poetically chosen outside the house of the Brownings. Rossetti was again informative about 'bobbies collaring Ned who was rolling on the stones with her to prevent it, and God knows what else'.

The affair, basically serious on both sides, dragged on explosively and indecisively until at least 1872. 'I had thought M.Z. was all over by that time', wrote J. W. Mackail, on receiving a letter dated 1872 when gathering material for his life of Morris. He was human enough to add wistfully: 'How extraordinarily interesting one could make the story, if one were going to die the day before it was published.' (His father-in-law was still alive, and almost certainly never knew of this disconcerting discovery of an episode of his past by the husband of his dearly-loved daughter Margaret.) Burne-Jones' tendency to psychoso-

142

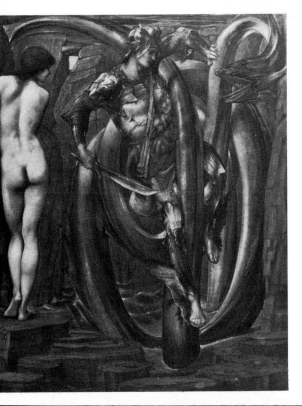

Plate 24 (*above left*) Edward Burne-Jones, aged 51. Photograph by F. Hollyer

Plate 25 (*above right*) William Morris, aged 23. Photograph

Plate 26 (*left*) Design for 'Perseus Slaying the Sea Serpent'. Gouache. By Edward Burne-Jones

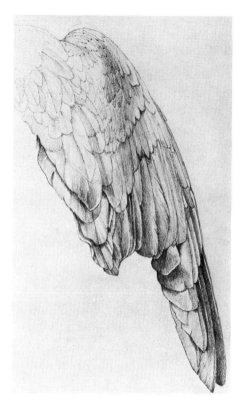

Plate 27 (*left*) Study of a Wing, by Edward Burne-Jones

Plate 28 (*right*) Study for the drapery for the Beggar Maid ('King Cophetua and the Beggar Maid') by Edward Burne-Jones

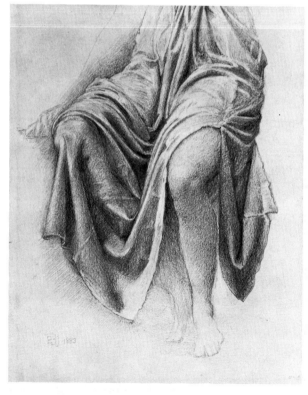

matically-timed ill-health, like that of at least two of the
Pre-Raphaelite women, saved him in the end from the worst
results of his artistic temperament.

His permanent scar from this affair was carried on his fore-
head. The most disreputable but entertaining of the Pre-
Raphaelite hangers-on, the adventurer Charles Augustus
Howell, whether from devilment or innocence is not entirely
clear, brought Marie to the Burne-Jones' home and introduced
her to Georgiana. When Burne-Jones entered the room and
found them together he promptly evaded a scene by fainting,
and hitting his head in his fall on the mantelpiece. Whether the
effect of two nurses showing feminine concern was soothing to
the invalid, or the opposite, history does not record.

Howell, reputedly half-Portuguese, made quite a good living
acting as agent in Pre-Raphaelite business affairs and sifting
away some of their best works, which were never seen again
until they mysteriously appeared for sale at obscure auctions.
Rossetti, who was perfectly aware of the process, only laughed,
and thought Howell's company and business acumen in getting
good prices for his pictures worth the loss. Howell came to a
bizarre end, in 1890, when he was found outside a Chelsea
public house with his throat cut, and a ten-shilling piece be-
tween his clenched teeth. He died a few days later. 'Howell is
really dead *this* time', wrote Ellen Terry to a friend: '—do go to
Christie's and see what turns up.' What turned up were a
number of missing items, many of which Whistler recognized
as Rossetti's, Swinburne's or his own. It was Whistler who,
with his talent for the apt phrase, had described Howell as 'the
Gil-Blas-Robinson-Crusoe hero out of his proper time, the
creature of top boots and plumes, splendidly flamboyant'.

Another of the strong personalities that attached themselves
to the Pre-Raphaelites was 'Red Lion Mary', the girl who
looked after Morris and Burne-Jones at Red Lion Square and
whose inexhaustible resourcefulness provided bedding for the
night for their friends (when mattresses on the floor ran out, she
was rumoured to have built up beds with boots and port-
manteaux), hand-sewn drapes for the models, and embroidery

I

of Morris' designs for the hangings. The fact that her respectability as a feature of the household was inviolable was another instance of Pre-Raphaelite ability to respect women who expected it and to observe the Victorian conventions in this. Red Lion Mary was too short to make a good model, but offered to stand on a stool to help out even in this direction. Rossetti was so touched by this that she was put into one of his pictures—as one of the ladies accompanying Beatrice in his *Meeting of Dante and Beatrice in Florence*. When she eventually married, he made a pencil drawing of her head and gave it to her as a wedding present.

There was, shortly before the Burne-Jones' marriage, a nebulous plan of taking a large house where all the Pre-Raphaelite families could live together. The Madox Browns now had a son aged three, Oliver or 'Nolly', as he was called, who later showed considerable talent and was greatly mourned by them all when he died in his late teens. It appears that the Arthur Hughes family were also concerned in this plan, which like other commune ideas later never actually came to fruition. In the meantime Georgiana, not yet married, took Nolly to her father's house and cared for him when Mrs Madox Brown was ill. The Madox Brown household remained a firm family centre for his more mercurial artist friends, who affectionately exchanged among themselves stories of Brown's famous idiosyncratic slips of the tongue. ('There's no doubt', he announced once to their special delight, referring to Mary, Queen of Scots, 'that she had a real feeling for Boswell.')

After their marriage, Georgie grew very close to Lizzie. The Rossettis and Burne-Jones had even planned a honeymoon in Paris together, and though this fell through the bonds of friendship did not slacken. It was Georgie and her husband who found Lizzie rocking the empty cradle after the birth of her dead baby, and lifting a finger to her lips with a wild, 'Hush, Ned —you'll wake it.' And it is from Georgie that we get both the best word-picture of Lizzie and also the most sensible account of her relationship with Rossetti and her illness. She had, according to Dr Acland in 1855, no 'specific disease' and her

lungs were only slightly affected, if at all. But she was tall for her period and her grace had a languor in it. Her dependence on Gabriel was one of love: 'her whole manner changed when he came into the room', wrote Georgie.

In fact he was an energizing influence, with Lizzie as with so many, and once their marriage was established his attitude was less of neglect (as has sometimes been assumed from her tragic end) than of affection and encouragement—which indeed were a part of Gabriel's nature in his relationships with all his artistic friends. All the wives tried to become skilled enough to help their artist-husbands: 'Morris was a pleased man when he found that his wife could embroider any design that he made', wrote Georgie, and she herself tried wood-engraving. But these were amateur efforts: with Lizzie, she thought, it was different, 'she had original power', although with her, too, art was 'a plant that grew in the garden of love'. At Chatham Place Gabriel was 'happy and proud' in putting her drawings and 'beautiful little water colours' round the room, and when he moved to Tudor House after her death there was still a south-facing room filled with Lizzie's pictures, drawing her ghost back to him, as Georgie noted, if anything could.

It was in their brief home at Hampstead that Georgie most remembered her.

> I see her in the little upstairs bedroom with its lattice window, to which she carried me when we arrived, and the mass of her beautiful deep-red hair as she took off her bonnet: she wore her hair very loosely fastened up, so that it fell in soft, heavy wings. Her complexion looked as if a rose tint lay beneath the white skin, producing a most soft and delicate pink for the darkest flesh-tone. Her eyes were of a kind of golden brown—agate-colour is the only word I can think of to describe them—and wonderfully luminous: in all Gabriel's drawings of her and in the type she created in his mind this is to be seen . . .

Another of her memories had a poignant sting: it was of Lizzie and Jane sitting side by side on a visit to Georgie and her new baby. When Lizzie lost her own, such a short time before, Gabriel had written to the Burne-Jones: 'She herself is so far the

most important that I can feel nothing but thankfulness.' But already, in a sense, he had lost the mother too. In a true rather than sensationalized view of Lizzie's death, her mental state must be seen as the principal consequence of her baby's birth and death, and a new pregnancy over which the shadows of the old still lay.

What shadows, one wonders, lay over Gabriel as he sat next to Georgie, drinking water only, at the christening of Jane's first child, Jenny, soon after Lizzie's was born dead? Two shadows, perhaps, of two women; but it is still only a guess.

Georgie's own marriage was still radiant, as she and Ned moved from home to home. His grasp of his technique was growing, even though their income was not, and his imagination had already been illuminated by contact with Italy. Before his marriage he had travelled there with Prinsep and Faulkner, and lyricized about Venice, 'a million times the most beautiful' place in the world . . . 'there are two islands all covered with churches and palaces, and all full of pictures, and bell-towers with big bells that ring all day long, and all the evening we sit out in the great square again and listen to music and see the sunset on the sea and the night come up over the Adriatic'. After their marriage, both young Burne-Jones travelled to Italy again as guests of Ruskin, who thought Burne-Jones' talent would more than repay him. He did everything *en prince*, commented Georgie; but by the sea at Boulogne she noted his sudden mood of dreadful melancholy, his solitary figure 'the very emblem of loneliness'. With Rossetti, he was godfather of the Burne-Jones' first child. The beautiful women of Lugano and Como were described by Ned as 'spoiled studies for Janey', and he felt he would never paint another picture if he lived in Italy. Like Rossetti, he had constant doubts about his own talents, and a similar generosity about those of others. As his wife put it, 'His knowledge of what he aimed at was far too clear for him to be deceived into complacency about failure.' He went through a phase of misery at one stage with every picture—then 'the cloud lifted and he knew where he was and what to do'.

148

At the end of a long career, he was to write: 'No former work ever helps me—every new picture is a new puzzle . . . It takes an artist fifty years to learn to do anything, and fifty years to learn what not to do—and fifty years to sift and find what he simply desires to do—and three hundred years to do it, and when it is done neither heaven nor earth much needs it nor heeds it.'

In spite of the immense fame his later pictures brought him, including Gladstone's baronetcy (an irritant to the faithful Morris) and an unhappy acceptance of the title of Associate of the Royal Academy, which he eventually summoned the strength of mind to relinquish, his real major talents were as a designer. In Italy he joined in Ruskin's admiration of Botticelli, whose clear colouring seems at times a pre-echo of Pre-Raphaelitism; but whether from a sense of comparable inadequacy or simply the development of too rigid a personal style, his colouring in his paintings tended to the Academic dullness and his emphasis on dark blue and shades of green moves him far from early Pre-Raphaelitism. He had no feeling for 'nature' as such and concentrated on figures and symbolism: Christ leaning forward from the cross over the kneeling figure of a knight in vigil—*The Merciful Knight*—is one of the more striking examples of this symbolism, which did have its roots in Pre-Raphaelitism. So did the meticulously-painted marigolds at the foot of the cross, dully-gleaming where Millais' scattered flowers, by the drowning Ophelia, had been brilliant and multi-coloured.

Both in his pictures and designs there was no attempt at facial variety, character or emotion. This was a quite deliberate reduction of the human factor to a symbol, an aversion to the dramatic in pictures. He was quite specific on this:

> Of course my faces have no expression in the sense in which people use the word. How should they have any? They are not portraits of people in paroxysms . . . It is Winckelmann, isn't it, who says that when you come to the age of expression in Greek art you have come to the age of decadence?

149

Portraiture involved expression but not of passion, only of 'character and moral quality, not of anything temporary, fleeting, accidental'. Of his *Avalon* picture of the three queens, Morgan le Fay, Queen of Northgalis, Queen of the Waste Lands, he added not without wit: 'They are queens of an undying mystery and their names are Lamentation and Mourning and Woe. A little more expression and they would be neither queens nor mysteries nor symbols, but just . . . Augusta, Esmeralda, and Dolores, considerably overcome by a recent domestic bereavement.'

It was all a part of that fantasy-world in which he chose to live, both as an artist and also to some extent as a man. In spite of his early passion for reading he could never bring himself to read the sordid realism of Zola or the tragic novels of Thomas Hardy or Tolstoy: a 'happy ending' was all he could face, in life or in art. And in spite of the apparent common sense of his self-defence, his paintings did suffer from the blank prettiness of his female faces and the almost equally blank and sterile nobility of those of his male ones. His mysticism is too flaccid and biblical to have survived modern taste but his designs remain splendid in composition, with a semi-circular tubular line which when used horizontally shows the influence of Blake studies such as *The Devils with Dante and Virgil by the side of the Pool* and *Beatrice Addressing Dante from the Car*. Vertically, Burne-Jones' most celebrated use of it was in his painting *The Golden Stairs*, an S-shaped flight thronged with young girls (May Morris was one of them) carrying musical instruments, and it is repeated again in the vast serpentine coils that fill the whole space of *Perseus Slaying the Sea-Serpent*, one of the very fine Perseus series which he began in 1875 and took many years to complete.*

* The *Perseus* series in oils were included in the collection of the Huntington Hartford Art Gallery when it was opened in New York in 1964. Since this new gallery closed they have been in the Staatsgalerie, Stuttgart. An exhibition was held in Stuttgart in 1973 to celebrate the gallery's purchase of the works. The preliminary gouache sketches of *Perseus Slaying the Sea-Serpent* and others in the series are in the City of Southampton Art Gallery.

The musical instruments, old and new, of *The Golden Stairs* were not an accidental whim. Burne-Jones had been interested in seventeenth-century music ever since 1866, when Henry Wooldridge, Slade Professor at Oxford, had discussed with him the manuscript music, including the songs of Carissimi and Stradella, in the British Museum, the Bodleian and the Christ Church library in Rome. This taste did not make him easily adaptable to the music of Wagner, but when he heard *Parsifal* at the Albert Hall in 1884 his brand of early medieval mysticism responded instantly. 'He made sounds that are really and truly (I assure you and I ought to know) the very sounds that were to be heard in the Sangraal Chapel, I recognized them in a moment and knew he had done it accurately.' Some years before, in the spring of 1877 when Wagner was in England conducting his own music, George Eliot (for long a close friend of the Burne-Jones) brought Cosima Wagner to his studio. In the end Cosima came two or three times, he made a drawing of her, and in return, when the Wagners were back in Bayreuth, she sent him a cast of Beethoven's face.

Morris also met Cosima, at her own request, and was present at one of the Wagner concerts at the Albert Hall, but he had early rejected (without proper study) Wagner's *Die Walküre*, on the grounds that opera was 'the most rococo and degraded of all forms of art', totally unsuited to an epic subject. Of Wagner's creation of a new art form, music drama, he was apparently ignorant.

In 1890 Burne-Jones made a pencil drawing of the brilliant young pianist Paderewski, and was overwhelmed by his resemblance to another friend of a receding past.

> There's a beautiful fellow in London named Paderewski . . . He looks so like Swinburne looked at 20 that I could cry over past things, and has his ways too—the pretty ways of him . . . a face very like Swinburne's, only in better drawing, but the expression the same, and little turns and looks and jerks so like the thing I remember that it makes me fairly jump.

Like his wife, Burne-Jones when writing his impressions was

often a graphic reflector of people and the world around him.

In spite of his impermanent and always uneasy alliance with the Academy, Burne-Jones nevertheless kept his judgements and his values clear. 'Take your own way and never change it', he wrote to one of his children. '. . . there will be always people telling you how you shall think and act and dress, and what you are to say and how you are to live . . . meaning that you are to think and act and dress as they do.' When the President of the Old Water Colour Society, of which he was a longtime Associate, visited him in 1870 and politely asked him to withdraw his picture *Phyllis and Demophoon*, because the committee were worried by the naked figure of Demophoon, Burne-Jones agreed with the same impeccable courtesy, but also resigned and never exhibited there again. He was equally courteous in a letter to Sir Henry Irving in 1892, in spite of some disappointment at the execution of his designs for Irving's Malory-inspired production of *King Arthur* at the Lyceum Theatre. Not only Burne-Jones felt something was wrong— Bernard Shaw in his review of the play referred to Comyns Carr's plodding blank verse for the hero-king as 'the talk of an angry and jealous coster-monger'.

Music was one of the delights which Burne-Jones could share with Morris only in part, though Shaw records that Morris took real pleasure in the viol concerts of Arnold Dolmetsch, and was interested in medieval music when Shaw drew his attention to it. Indeed he loved this music as all things medieval, and in late life drew much solace from it. Neither he nor Ned was much excited by the dramatic theatre, although the Burne-Jones had been taken by Ruskin to the Christy Minstrels, and had been understandably astonished to find that grave philosopher and art critic received as an honoured patron, and an item included by the Ministrels at his special request. Ruskin and Burne-Jones also took an interest in dancing and admired the dancer Kate Vaughan. In Burne-Jones' case this was almost certainly an aspect of his love of music, as well as the artistry of pose and movement. The Javanese dancers who appeared in England at the Aquarium also fascinated him.

152

Morris never designed for the stage, and according to Shaw had seen no plays by any modern dramatist except himself, Henry Arthur Jones and the author of *Charley's Aunt* ('which bored him'). But almost equally surprisingly he did write a play on request for the Socialist League, to aid its funds, and appeared in it himself as an imaginary Archbishop of Canterbury. The play was a topical extravaganza, the two other principal parts being Sir Peter Edlin—notorious at the time for sending socialists to prison on dubious charges of 'obstruction'—and Tennyson. This comic take-off of contemporary pomposity apparently delighted its socialist audience ('There has been no other such successful first night within living memory', sparkled Shaw). But Morris' qualities of mind and imagination were too creative and basically serious for the standardized theatre of his day, although Shaw (who on Morris is almost as panegyric as Burne-Jones) believed he might have brought genius to this art, as all others, had its current style been more poetic, congenial or Ibsenite.

Although Burne-Jones never belonged to the Socialist League, he was not as alienated by his best friend's socialism as is sometimes suggested. If his social conscience was timid, and he preferred to withdraw into 'the little world that has the walls of my workroom for its furthest horizon', it was far from non-existent. No one so sensitive, and so concerned about human suffering that he could not even read about it, could remain William Morris' closest friend for forty years without realizing the social needs, even if, unlike Morris, he could not believe in an artist's ability to change society. It was Millais and Hunt who obliterated Kennington Common and the Chartists' Petition from their minds, and went their ways, in the end, as successful artists among the wealthy. Burne-Jones, who admired Morris almost as a god and loved him as a brother, could never turn his back entirely. The siege of Paris in 1870 was a 'waking nightmare' to him. 'I'm a born rebel,' he once said . . . 'I am not, and never was, fitted to belong to any institutions.'

Nevertheless, when England was rocked by the Bulgaria question in 1876 and 1877, and a war situation arose in which

it was feared the British Government would support Turkey, the oppressor of the unhappy Bulgarians, Burne-Jones joined Morris in the Hyde Park demonstration and like him became a member of the Eastern Question Association, of which Morris was soon elected Treasurer. Georgiana, writing of the events long afterwards, says this was for 'human not political reasons', in other words because of his devotion to Morris, but there is nothing written by Ned that supports this. Even Georgie, present at the crammed National Conference in St James's Hall (where Morris sat in the front row), noted 'Gladstone's reception and speech were memorable things'.

It was Burne-Jones who wrote to Ruskin in Venice and begged his help for the cause. Ruskin expressed the hope that 'neither Morris nor you will retire wholly again out of such spheres of effort'. It was Ruskin who, many years before in 1862, had taken the awed young Burne-Jones to see the great originator of Christian socialism, Carlyle, in Cheyne Walk, where, wrote Georgie, 'with the hand that wrote the French Revolution we saw him carefully reach the kettle from the fire for his wife when she made tea . . .' Ruskin was a friend to whom they could always turn. When one of Georgie's babies died and she lay seriously ill with scarlet fever, it was Ruskin who had watched over her 'with the most thoughtful and practical kindness', and had the street outside laid with tan so that she would not be disturbed by the clatter of horses' hooves.

In April 1877, when war broke out between Russia and Turkey, Morris was quick off the mark with a pamphlet: *Unjust War: To the Working-men of England*, pointing out that it was the English, if they joined Turkey in this war, who would 'bear wartime taxes, war-prices, war-losses of wealth and work and friends and kindred; we shall pay heavily, and you, friends of the working-classes, will pay the heaviest . . .' It would be an 'UNJUST WAR', fought for 'Greedy gamblers on the Stock Exchange, idle officers of the army and navy . . . desperate purveyors of exciting war-news for the comfortable breakfast tables of those who have nothing to lose by war . . .'; a war 'against a people who are not our enemies, against Europe,

154

against freedom, against nature, against the hope of the world'.

As for Burne-Jones, too exhausted to accompany Georgie to the National Conference, he rallied to unexpected frenzies of activity, at least on paper. 'My soul is a cauldron of mad fury all day and I am thinking of nothing but politics', he wrote in a letter to George Howard: 'I've a plan for pulling down Buckingham Palace and the Marble Arch and Burlington House— and tomorrow I speak in the park and on Sunday at a Clerkenwell temperance association, and on Monday at the Spitalfields Vestry Hall.' If there was a characteristic tongue-in-the-cheek humour, there was also some indication that the frail and gentle Burne-Jones was for once backing his friend's politics to the last ounce of his strength.

On 16 January 1878, he was present at the Workmen's Neutrality Demonstration at Exeter Hall, where 'the enthusiasm was so great that those present seemed to have but one heart'. But the fever of events was one thing, solid day-by-day socialism quite another. He was not unsympathetic to Morris' cause, but he distrusted the means. In fact, it was the other socialists—'noisy, rancorous . . . they got complete possession of him'—that he recoiled from. Perhaps he was a little jealous; certainly he thought of it as 'the only time when I failed Morris'.

Nevertheless the Sunday morning breakfasts continued every week, with Morris walking from Hammersmith to North End Road, Fulham, and, as his political activities grew, sometimes dashing off much earlier than his friends would wish. As his illness and waning powers became more and more apparent, and they watched in distress the grey beginning to cover his thick curls, they began to feel as Burne-Jones had felt, ten years or more before, watching the decline of Rossetti. 'Four or five times a year', Ned had written of his other early idol, 'I go and spend a ghostly evening with him.' Now Morris' magnificence, too, was fading into a ghostly shadow of the past.

In other ways the partnership had flourished. In 1879 Burne-Jones was as concerned as Morris at the threatened destruction of the west front of St Mark's, Venice, by so-called 'restora-

155

tion', and two years before they had together formed the Society for the Protection of Ancient Buildings, to meet just such eventualities. Meetings were called, Burne-Jones spoke at Oxford, and Gladstone was approached through his daughter and signed the protest. 'Dizzy did actually sign on Saturday', Morris recorded on 24 November.

But the real cement to their artistic partnership was The Firm, and afterwards the Kelmscott Press. It was The Firm which provided Ned with his first real flow of commissions, principally for coloured tiles, and the designs in stained glass with which he and Morris, sometimes together and sometimes alone, transformed church windows throughout the country. Where they worked together, Burne-Jones was responsible for the design and Morris for the colour. The Nativity and Crucifixion in the west window of St Philip's, Birmingham, was one such joint effort, and at St Michael's, Brighton, Burne-Jones designed the rose window, *The Creation*, while the chancel roof was painted by Morris, Faulkner and Webb. In Burne-Jones' triptych window at St Paul's, Brighton, Morris can be seen as one of the kings and Swinburne and Burne-Jones among the shepherds. At St Martin's, Scarborough, practically everyone, including Rossetti and Madox Brown, lent a hand; but Rossetti and Brown fairly early dropped out, leaving Burne-Jones and Morris as the stained-glass specialists, with Webb also prominent in the window schemes.

Burne-Jones studied this specialized subject with the technical care he brought to all the many sides of art he worked in. He was impatient with people who expected a picture rather than a glass cartoon. 'It is a very limited art, and its limitations are its strength, and compel simplicity.' His own principal outlook was aesthetic, and he left it to Morris to elaborate with his usual amazing erudition on the differences of enamel and mosaic glass, the processes of their manufacture, and the historic development of the craft from the twelfth century onward. Chambers Encyclopaedia, for its entry 'Glass, Painted or Stained', used a very lengthy article by Morris on this, in which he sustained Burne-Jones' argument about the unsuit-

156

tability of normal painting construction for the medium, whether it be an original design or, as too often, modelled from the picture of a well-known artist. Mosaic glass was, to his mind, 'the only method capable of producing stained glass which shall be beautiful and interesting, and which at the same time can plead some reason for its existence'. As to the design, '*suggestion*, not *imitation*, of form is the thing to be aimed at . . . The qualities needed . . . are beauty and character of outline; exquisite, clear, precise drawing of incident, such especially as the folds of drapery . . .'

Although he does not mention Burne-Jones by name, this was an oblique reference to one of his friend's artistic specialities. The draping and pleating of materials was an integral part of the composition of many Burne-Jones pictures and designs, and he used the flowing lines and folds like an infinite variety of cross-currents, sometimes heavy, sometimes transparent, but always flexible and full of grace. It aroused in Ruskin one of his rare acid responses: 'Nothing puzzles me more than the delight that painters have in drawing mere folds of drapery, and their carelessness about the folds of water and clouds, or hills, or branches . . .' Yet when Ruskin poured out even greater (indeed inexcusable) acrimony on the paintings of Whistler, Burne-Jones (deeply reluctant, but loyal both to Ruskin and his own meticulous principles of draughtsmanship) allowed himself to be persuaded to be a witness in Ruskin's defence, when Whistler brought his famous action for libel. It was perhaps the unhappiest moment of Burne-Jones' artistic life. As the French art critic Arsène Alexandre, who admired both painters, wrote: 'there are talents which, like substances, are and always will be incompatible. They are incapable of mingling, of fraternising, or even of mutually understanding . . . The very highest degree of incompatibility is that existing between the artist who *suggests* and the artist who *realises*.'

In the spring of 1873 Morris and Burne-Jones went to Italy again together, and the Italian influence, which never seriously turned Morris' head from the direction of the Arctic Circle, again left Burne-Jones conscious of the inadequacies of his own

efforts. But it stimulated his interest in mosaic and he later worked for a number of years on the mosaic decoration for the American Protestant Episcopal Church at Rome. This depicted, 'Christ hanging with outspread arms but not crucified, the cross is turned into a big tree all over leaves, and the stems of the tree are gold. Everything is done to make it not a picture, and the severe limitations of mosaic are all observed.' Although greatly tempted, he had the integrity to reject a suggestion that he should fill the four semi-domes beneath the large centre dome of St Paul's Cathedral with designs in mosaic. 'It's nonsense to put mosaic there—nonsense I think to try to do anything with it but let it chill the soul of man and gently prepare him for the next glacial cataclysm.'

His real home, he had written, 'would be in a society which embraces and covers all art—everything that art enters into'. Among his unusual experiments in design was the decorating of grand pianos, including one for Broadwood built of oak stained green, with green keys replacing the usual black ones.* He also made a study of coloured marble for his *Avalon*. 'I have learned all I shall ever know about marble now, and when I shut my eyes last night I could see nothing but the petrified waves and tide marks and signs of skimming winds on wet surfaces . . .'

It was the Burne-Jones' acquisition of a seaside house at Rottingdean, on the cliffs not far from Brighton, that sent him suddenly, like a demented sea-sprite, designing scenes under sea with mermaids. In the tradition of his humorous small devils playing cricket, was a drawing of a mer-wife giving her mer-baby an air-bath: the baby howling with misery. At Rottingdean, too, he designed his decorative *Book of Flowers* with its poetic titles, 'The Key of Spring', 'Witches' Tree', 'Grave of the Sea' and 'Love in a Tangle'. The Burne-Jones had now acquired a nephew who also became associated with Rottingdean. In 1855 Georgiana's sister Alice had married John Kipling and gone with him to India. The nephew was Rudyard Kipling.

* Pianos he decorated are on display in the City of Birmingham Art Gallery and the Victoria and Albert Museum.

Unlike Rossetti, Burne-Jones exhibited on a prolific scale. He produced eight pictures for the opening of the Grosvenor Gallery in 1877, including *The Beguiling of Merlin*, and it brought him his first wide fame as a painter. He was already forty-four years of age. In 1888 the New Gallery in Regent Street was begun, and again his was the main contribution when it opened. In 1892 it held a comprehensive exhibition of his work, and in 1895 exhibited his great picture which again reverted to a thronged S-shaped movement of descent, *The Fall of Lucifer*.

Yet he maintained he hated exhibitions and would prefer to work quietly, unpublicized and without haste, in his own studio. When late in life he went into the National Gallery, he was enormously impressed again by Van Eyck, the contemporary of Chaucer. 'But the like of it is not for me to do . . .' If he had his life all over again, he decided, he would 'try and paint more like the Italian painters. And that's rather happy for a man to feel in his last days—to find that he is still true to his first impulse and doesn't think he has wasted his life in wrong directions.'

His finest work remained with Morris and the Kelmscott Press, and included the illustrations to Morris' Nibelung epic, *Sigurd the Volsung*. 'I miss Gabriel at every turn and more and more', he had said in nostalgia; and the loss of Morris was one he could not long survive. One of his last commissions was a secret one by Gladstone's sons and daughters, for a stained-glass design for the west window of the church at Hawarden. It was meant to be a surprise for their ailing father, but Gladstone died on 19 May 1898, before the window was ready. The scene was the Nativity, and it was placed in position on 30 May 1898, a week after Gladstone's funeral (he was buried in Westminster Abbey). Burne-Jones died on 17 June, quite suddenly, of a heart attack, and was buried in the churchyard of St Margaret's Church, Rottingdean, whose stained-glass window, of the Jesse Tree and Jacob's Ladder, he had himself designed.

His last ideas had been strangely prophetic, not only in matters of art but politics. 'I suppose by the time the "photographic

artist" can give us all the colours as correctly as the shapes, people will begin to find out that the realism they talk about isn't art at all but science', he wrote. And of the British Empire he remarked to his wife (in 1896, the year before Queen Victoria's Empire-glorifying Diamond Jubilee), that it was only a material empire and therefore could not last for ever; 'that formerly the destruction of great empires used to take long years, but now things moved so quickly that one might go in fifty years or even half the time . . .'

'Let's have no more dominant races, we don't want them—they only turn men into insolent brutes . . . Things never will be right at all until the same rule that governs individuals in a society in their behaviour to each other is applied to nations.' Even when beginning the design of Sigurd killing the Dragon, who was guarding the stolen Nibelung hoard, he had said: 'The story of the Gold-wallower is very applicable to the present moment—the English are after gold everywhere.' He had absorbed, at the end, the creed of Morris, and Shaw's own reflections on the Nibelung gold in *The Perfect Wagnerite*. Perhaps Cosima Wagner had already given him the clue.

If his own pictures seem now outdated, he was never an Academician in spirit and he disliked the didactic pictures, telling a story or pointing a moral, that were so much to Victorian taste. Words were the fitting medium for a story—'Dickens could do it.' His admirations were those we would echo today—of Blake ('Calamity! Calamity. Calamity in every line of them' he wrote of the false comforters of Job), and of Aeschylus and Michelangelo ('A mere difference of time and milieu'). In the end, he measured his own scale, although Michelangelo he had described as 'immeasurable'.

> A pity it is I was not born in the Middle Ages. People would then have known how to use me—now they don't know what on earth to do with me.

In a sense, it was Morris' epitaph too.

VIII

Swinburne:

Poet and Enfant Terrible

⚡⚡⚡⚡⚡⚡⚡⚡⚡⚡⚡⚡⚡⚡⚡⚡⚡⚡⚡⚡

Swinburne was the fever in the blood of the Pre-Raphaelites. If Rossetti in his poetry had broken through the reserve of Victorian literature in touching on the fleshly aspects of love and union—but had drawn nervously back in the case of some verses when it came to publication—Swinburne seared through the reticences like a flame.

> Where between sleep and life some brief space is,
> With love like gold bound round about the head
> Sex to sweet sex with lips and limbs is wed . . .

If his *Hermaphroditus* lines shocked less from their explicitness than their bi-sexual implications, in other poems the heat was so strong that it drove critics like Robert Buchanan screaming out of the kitchen. Buchanan's *Fleshly School* was as much an attack on Swinburne as on Rossetti: on the poet who could write that 'love is more cruel than lust' and in one of his more famous extravagances of alliteration coin the now almost burlesquable lines:

> Could you hurt me, sweet lips, though I hurt you?
> Men touch them, and change in a trice
> The lilies and languors of virtue
> For the roses and raptures of vice.

If Swinburne wished, as he claimed, to celebrate one of the seven deadly sins every day, and sometimes pushed the roses and raptures of vice beyond the limits of either good taste or good poetry, it is only fair to say, to a generation that no longer reads him, that at their best his lyrical gifts and experiments with rhythm fashioned some splendid verse and imagery, and that he was as fully aware of the dangers of excess that sometimes trapped him as of his mission to free the writer from moral shackles.

It was N. St John-Stevas, in *Obscenity and the Law*, who saw, in John Dixon Hunt's words, 'the poetry of Rossetti and Swinburne as foreshadowing the open revolt of later writers against the Victorian conscience and its laws';* and it was Swinburne himself who, more buoyant in the face of attack and spirited in answering it than Rossetti, challenged Buchanan's aesthetic assumptions with the forward-looking question as to 'whether or not the domestic circle is to be for all men and writers the outer limit and extreme horizon of their world of work'.†

Swinburne's concern—and there is no reason to suppose that it was not a genuine concern—for the freedom of the writer to cover all the experiences of life was supplemented by an equal concern that he, as a human being, should not personally miss any of them. How much of this passionate thirst for knowledge was actually gratified it is not easy to say, as he was by no means above boasting of a frantic virility it seems questionable that, more than spasmodically if at all, he actually possessed. In fact there is much in his life to support the view that pornographic cravings on an unbalanced scale are often accompanied by impotence and frustration, or a sadism as much self-inflicted as satisfied on others. What is unquestionable, is that Swinburne achieved more of his defiantly-propagated dissipations in youth than his slight physique could sustain, and his early death would have been certain if Theodore Watts-Dunton had not (with the aid of a grant from Swinburne's distracted mother) stepped in,

* *The Pre-Raphaelite Imagination.*

† *Notes on Poems and Reviews.* This material was also published in *Under the Microscope.*

taken charge of the invalid, and more or less kept him in wrappers until he died a mild and apparently contented old man as late as 1909.

Algernon Swinburne had been born at 7 Chester Street, Grosvenor Place on 5 April 1837, during a visit of his parents to London. He was the only Pre-Raphaelite of aristocratic descent, coming of a Northumberland family tracing back to a Thomas Swynbourne who had received a Bordeaux château from Richard II in 1396. Swinburne's grandfather had been born in Bordeaux, and his father, Captain (later Admiral) Charles Henry Swinburne, and his mother, Lady Jane Hamilton, were second cousins. Swinburne as a child divided his time between the family seat of Capheaton, near Newcastle—an area of woods and moorlands—and the Isle of Wight, all of which had a lasting effect on his verse, in which there are often echoes of the wild Northumberland countryside and still more often, in his finest poetry, of the surge and foaming spray of the sea.

Red-haired, small but wiry, and bright with promise, he went to Eton in 1849 and like others before and after him absorbed the corruptive influences of sadistic floggings and an exclusively male society. This experience, too, left permanent marks on Swinburne. In later years he not only received flagellations at a notorious establishment in St John's Wood, but whole areas of his writing were obsessed with the subject. His secret contribution of stories to the underground flagellation publishing market was not, of course, widely known at the time, but both his correspondence and unpublished novels more than touch on the theme. And de Sade quite early became a special passion. In much of this he is now known even to have had a feminine confidante and companion, his cousin Mary Gordon, with whom he seems to have been genuinely in love until she devastated him by her marriage, in 1865, to an Army colonel twenty-one years older than herself. The association was never broken, but Swinburne's reaction erupts into many of his works, most notably his novel *Lesbia Brandon*.

At twelve years old he was taken by his parents to visit Wordsworth, who recited Gray's *Elegy*, a poem which Swin-

burne ever after defiantly disliked. Even before he left Eton he was reading the Elizabethan and seventeenth-century dramatists and poets, of whose works he became a fine critic, and attempted a Jacobean-style 4-act tragedy owing more than a little to Tourneur. He was a voracious reader of wide scholastic and classical range, and later absorbed French, Italian, Greek and Latin poetry and literature on an immense scale. His reading of Victor Hugo's *Notre Dame* was the beginning also of his revolutionary zeal, in which he matched Morris, with whom he had conspicuously little else in common.

Even before he went to Oxford, he had become conscious of the Pre-Raphaelites, for while staying at Wallington he heard of them through Lady Pauline Trevelyan, one of their patrons and a friend of Ruskin. In 1855 there were alterations to the central court of Wallington, and William Bell Scott was engaged to decorate the walls with scenes from Northumbrian history, while Ruskin began but failed to finish a panel depicting oats and cornflowers.

However, artistic impressions were swept aside by the news of the disastrous charge of the light brigade at Balaclava, when Swinburne was suddenly enflamed with the unlikely ambition to become a cavalry officer. Thwarted by his parents in this, he risked his life (and showed something of the inherited toughness beneath his slight frame) by climbing the practically vertical Culver Cliff near Bonchurch.

He entered Balliol College in January 1856, and was soon a rampant atheist and republican, whose hero was Mazzini, the Italian libertarian who divided his time between agitation in his native land, parcelled out among the despots of Europe, and exile and political writings in England. Only seven years before, in 1849, Mazzini and Garibaldi together had actually conquered and held Rome (a Papal State) for a period before being driven out of this revived Roman Republic by the forces of Louis Napoleon (later Napoleon III of France). Mazzini was the linchpin of the Triumvirate that governed Rome, and proved himself an able statesman. But by the mid-1850s Mazzini was a London exile for the second time, supporting himself by

writing pamphlets, cold-shouldered by the Establishment (who later fêted Garibaldi as a picturesque but less dangerous doctrinal rebel) but warmly supported by a loyal band of English followers. There had been only one love in Mazzini's life, but the many women who followed this 'dark, handsome, ascetic man, who was in love with no woman except Italy', as Jasper Ridley has written, were content to admire him with a kind of platonic fervour.

That fervour the young Swinburne reflected in both life and verse, overlooking Mazzini's passionate belief in God and a divine mission for the sake of his political extremism and rejection of orthodox Catholicism. Mazzini, briefly a member of the Carbonari like Rossetti's father, had retained the belief of that organization in political assassination as a weapon in the fight for Italy's freedom, and when one of his followers unsuccessfully attempted to assassinate Napoleon III, Swinburne characteristically put a portrait of the martyr, Orsini, on the wall of his room beside that of Mazzini. In the autumn of 1856 he wrote an *Ode to Mazzini* (abusing Ferdinand of Naples, one of Italy's despoilers, as 'Bourbon's murderous dotard') and it was followed by other poems of similar theme.

Some years later, his *Songs Before Sunrise*, which he always claimed to be his best work, was dedicated to Mazzini. He had intended to name it *Songs of the Republic*, and later Mazzini's own preference, *Songs of the Crusades*; but the nervous publisher demurred and the innocuous-sounding *Songs Before Sunrise* was the result. It was not merely a pro-republican celebration of pantheism, it was also (as indeed one of the poems was titled) a *Hymn of Man* in which Wagner's admirer Swinburne, like the composer-dramatist of *Siegfried*, sang of the divinity of humanity alone, and a world wrenched from the power-lust and greed of the ancient gods.*

It was, of course, widely dismissed as blasphemous; yet *Genesis* now seems merely imaginatively post-Darwinian and even space-age:

* The influence of Mazzini in Victorian England lives on in the character of that son of freedom-loving parents, Mazzini Dunn, in Shaw's *Heartbreak House*.

In the outer world that was before this earth
 That was before all shape or space was born,
Before the blind first hour of time had birth,
 Before night knew the moonlight or the morn;

Yea, before any world had any light,
 Or anything called God or man drew breath,
Slowly the strong sides of the heaving night
 Moved, and brought forth the strength of life and death . . .

Sunbeams and starbeams, and all coloured things,
 All forms and all similitudes began;
And death, the shadow cast by life's wide wings,
 And God, the shade cast by the soul of man.

It is often overlooked that revolutionary doctrine had originally been instilled in Swinburne by his grandfather. Sir John Swinburne had been born and educated in France, had known Voltaire, and been a disciple of Mirabeau, the aristocratic early leader of the French Revolution. He had also been a friend of John Wilkes, whose fight to retain his seat in Parliament after a series of elections in which the Government reversed the voters' decision, had been supplemented by an equally tough struggle on behalf of the freedom of the press, the widening of the suffrage and government support of the arts (he had urged a National Gallery of Painting and the equivalent of the British Museum Reading Room long before either was seriously considered). If the young Algernon also heard tales of Wilkes' well-known and cheerful profligacy from Sir John, whose education had been that of the eighteenth-century Enlightenment, this too may have widened his perceptions about the breaches possible in orthodox morality. And the youthful admirer and imitator of Shelley, the poet, atheist and radical, must have been no less stirred by his grandfather's tale of how he had volunteered to pay the fine of Shelley's friend, Leigh Hunt, when that freedom-loving journalist was tried and imprisoned for slandering the Prince Regent.

At Oxford, Mazzini was an idol 'between shadow and sub-

stance', not yet an acquaintance; but Swinburne submitted for the 1857 Newdigate Prize a poem composed of heroic couplets in praise of republican Rome, from Tarquin to Rienzi, from Rienzi to Ferdinand 'the crowned snake of Naples', and from Ferdinand to Mazzini, the founder of a new Rome. Liberty was symbolised by vast natural forces and upheaval, like the birth of new worlds. The influences were Aeschylus and Shelley, but not unnaturally he did not win the prize.

Another influence the same year was to have more far-reaching personal effect. It was in November that he first met Morris, Burne-Jones and Rossetti working on the Union hall, and the bright presence of 'little Carrots', as Burne-Jones called him, burst on the Pre-Raphaelite scene. There was an early bond of sympathy with Burne-Jones and nine years later Swinburne dedicated his *Poems and Ballads* to him. Morris and Swinburne exchanged ideas and poems on Queen Iseult and Tristan, although it was Swinburne who responded to the stimulus of Wagner's story and music when writing his *Tristram of Lyonesse* in 1869. The ballad form he learned from Morris at Oxford was not to be a lasting influence; it was the French one that remained. Stendhal, Balzac, Baudelaire, Michelet, Hugo, the *Lettres de Marie Stuart*, de Laclos' *Les Liaisons Dangereuses*, Gautier's *Mademoiselle de Maupin*—all these and more were read by Swinburne at Oxford. Baudelaire's *Fleurs du Mal*, reviewed by him later, was to be a dark lodestar to his whole literary life.

After the boisterous Pre-Raphaelites left, Swinburne's turbulence increased enough to disturb the Oxford authorities, and he finally (not without a sense of triumph) shared the same fate as Shelley. Bell Scott found his company 'like champagne', and noticed his pockets were always stuffed with MSS. When he first visited Italy in 1861 he absorbed all the art galleries with Pre-Raphaelite eyes, and soon made a lasting and congenial friendship, with Richard Burton, the traveller, diplomat, orientalist, and collector and translator of erotic literature of many nations.

In London, he moved into Tudor House for a time with Rossetti and made friends with Simeon Solomon, the young

167

Jewish painter who designed for The Firm and whose career was later ruined when he was charged with homosexual soliciting. For a time they made a ribald trio with Burne-Jones, who had a submerged side to his nature of which his bride Georgiana, the Methodist minister's daughter, had little inkling. The young men exchanged lively obscene drawings, verse and letters, of which Rossetti was sometimes the recipient, until Swinburne's excesses became so alarming that even Rossetti felt things were going too far, and something must be done about 'Carrots'. Burne-Jones had already vanished like a ghost, shocked into insubstantiality by his own temerity.

By 1862, Swinburne was a regular contributor to *The Spectator*, where *Faustine, A Song in the Time of Revolution* and *Sundew* were published, along with his review of *Les Fleurs du Mal*, which once again upset the Establishment. In October, he began his commentary on Blake, doubtless under the influence of Rossetti who had been completing the Gilchrist biography. It was the first serious attempt at analysis and appreciation of Blake at a time when the artist-poet had slipped virtually into public oblivion. He was a man, wrote Swinburne, with a truth even now not always fully realized,* 'born and baptized into the church of rebels', and he formed this view partly from the Prophetic Books, then still unpublished. Their obscurities puzzled him, nevertheless, for he seems unaware of the political pressures of the Pitt régime of the 1790s which, alarmed by the French Revolution, had instigated treason trials against radical writers and in 1795 suspended Habeas Corpus. Blake's continued Jacobinism had therefore to be heavily masked in the elaborate symbolism of his verse, which has only in our own time been gradually unravelled by scholars and writers such as David V. Erdman, Jacob Bronowski, A. L. Morton and G. R. Sabri-Tabrizi. It was, wrote Erdman, a 'withdrawal from the essential experience of communication', and it has made him an easy victim of misrepresentation. The fact that we live in a visual-

* *Vide* the critical reception of Adrian Mitchell's *Tyger*, a satiric but perceptive 'celebration' of Blake, his times and rebellion against orthodoxy, presented by the National Theatre in London in 1972.

minded age, drifting away from the literate image, has greatly aided this distortion of Blake. The pellucid imaginative energy of his paintings and engravings has obscured all but the most easily assimilated of his poetry, and both criticism and religious wishful-thinking have combined to give an orthodox interpretation to works which were actually great paeans of freedom *against* the fetters of the orthodox, in church, state and art. As Dr Bronowski wrote: 'Blake speaks the discontent of his time.'

What Swinburne and the Pre-Raphaelites did find in Blake was an anticipation of their own artistic ideas of colour transparency and general (as opposed to political) symbolism of approach. As Swinburne wrote:

> To him the veil of outer things seemed always to tremble with some breath behind it . . . Flowers and weeds, stars and stones, spoke with articulate lips and gazed with living eyes. Hands were stretched towards him from beyond the darkness of material nature . . . To him all symbolic things were literal, all literal things symbolic.

He was a spokesman for the independence of art, and 'if he spoke strangely, he had great things to speak'. Swinburne's instinct understood the seriousness of Blake's message even though he could not fully comprehend it. But Swinburne's intuitions as a literary critic were nearly always worth study, and were still often quoted until after the Second World War, when the basis of nineteenth-century criticism began to be forgotten, often to the loss of modern literary and dramatic perception.

On Shakespeare, he could analyse character with a flash of illumination, as in his apprehension of 'the combination of unusual intellect with supreme evil in Iago. It is rare but it exists.' In modern stage productions Iago has become fashionably vulgarized, an inferior officer of common mentality and rough manners, grubbily jealous of the obvious superiority of Cassio. In 1938 Laurence Olivier's glittering Iago at the Old Vic fixed the intellectual basis of his evil with a marvellous Swinburnian *hubris*. (He also touched on a homosexual drive Swinburne might have appreciated, but dared not name, adding with

169

imaginative suggestiveness a gesture beside the fallen, epileptic body of Othello, when he stooped over his victim and flexed his fingers, like cuckold's horns, against his hair.)

It may have been the death of Lizzie Siddal that drove Swinburne into his extremely equivocal and damaging friendship with Simeon Solomon. He was devoted to Rossetti's wife with a genuine but intense platonism; romping with her in child-like games, grieving and shaken by her death. He had almost feminine tenderness in certain friendships and absolute loyalty, and was deeply touched too by the death of the Burne-Jones' newly-born baby son whom, he wrote, he had been longing to see. Inwardly, there was probably an instinct that he would have no child of his own, and his passion for babies as an elderly man, the recluse of The Pines in Putney, was to alarm some of the more psychologically-awakened young parents.

Certainly his friendship with the brilliant, sexually unorthodox Burton must have stimulated his more wayward impulses, no less than his penetrating appreciation of Baudelaire. At the home of Monckton Milnes (later Lord Houghton) he and Burton mixed in somewhat alien company, other members of the house party being Carlyle, Kingsley and Froude; and it was Milnes whom Swinburne reminded of a promise to allow him to 'look upon the mystic pages of the martyred marquis de Sade'. Swinburne's French poem, *Charenton*, arose from this.

It was as an antidote to all this, and an attempt to establish him in a more normal relationship, that his Pre-Raphaelite friends encouraged (if they did not actually arrange) his famous and much-publicized 'affair' with Adah Dolores Menken, whose speciality at Astley's Circus was riding apparently naked, in flesh-pink tights, strapped to a white horse, in a pictorial reconstruction of Byron's *Mazeppa*. Adah, a good-hearted, much-married American, who was also admired by Dickens and Tennyson, obligingly went to bed with Swinburne who boasted deliriously of the experience, and had himself photographed with her. The photographs were much on view and certainly a striking contrast, the tiny Swinburne standing daintily beside his robust conquest, who might be termed a

brunette version of Rossetti's voluptuous Fanny Cornforth. How successful the liaison actually was it is impossible to say: no doubt Adah did her by no means inexperienced best.* When she died in Paris not long afterwards Swinburne was deeply grieved. She was only thirty-three years old and even though she had obviously taken some advantage of the friendship to obtain publication of her own (rather unexpected) poems, there seems no doubt her feelings towards Swinburne were kindly and affectionate.

In the meantime, in 1865, Swinburne had published *Atalanta in Calydon* and woken, like Dickens and Byron before him, to instant fame. He had begun it two years before and it had been written under the emotional pressures of Mary Gordon's engagement and the death of his sister Edith at Bournemouth. He dedicated the poem to Walter Savage Landor, that 90-year-old relic of the Shelley era whose recollections stretched right back to a youthful meeting with Thomas Paine. Swinburne had gone to see him in Florence, and was saddened by his death in September 1864, before his dramatic poem could be published. It was begun by the sea, in the Isle of Wight, and finished by the sea at Tintagel in Cornwall, and its chorus contained lines that still echo in many minds:

> When the hounds of spring are on winter's traces
> The mother of months in meadow or plain
> Fills the shadows and windy places
> With lisp of leaves and ripple of rain . . .

Ruskin described it as 'the grandest thing ever done by a youth, though he is a demoniac youth', and Burne-Jones thought it went on 'with such a rush that it is enough to carry the world away'. Even Tennyson, not adulated by Swinburne (who, in the only meeting arranged between them by a hopeful host, disappeared into an adjacent room), wrote to say he envied the

* The story that she returned a £10 cheque given to her by Rossetti on the grounds that 'she did not know how it was, but she hadn't been able to get him (Swinburne) up to the scratch', sounds like someone's *bon mot* rather than fact.

young poet his 'wonderful rhythmic invention'. Yet the tone was not only deeply pessimistic, it was also atheistic. God, described as 'the supreme evil', matched 'the Galilean serpent' of Swinburne's earlier description of Christ. The verbal splendours were still enough to obliterate Victorian unrest.

This was not the case with his *Chastelard* the same year, the first part of his dramatic trilogy on Mary, Queen of Scots. It was, wrote the *Spectator* reviewer, 'a forcing-house of sensual appetite' and the *Athenaeum* described it as 'inherently vicious'. Swinburne was merely diverted, and took it as a confirmation of his contempt for critical philistines. He had been roistering with Burton at the Cannibal Club, a macabre atheistic organization which held dinners at Bartolini's, Leicester Square, and included Charles Bradlaugh, the MP who later was nearly ejected from the House of Commons for refusing to take the oath, among its members. Swinburne, who could not carry his alcohol but refused to allow this trifle to limit his intake, was often carried out insensible, and indeed it was soon creating a serious problem, ending in his ejection from the British Museum Reading Room, one of the rarer and more picturesque episodes in its history.

Burton, who normally carried Swinburne downstairs and placed him in a cab after the club sessions, left to take up a post at Santos, Brazil, in May 1865, although the friendship was to continue later both in England and abroad, and include a climbing expedition which caused Swinburne (who was himself an intrepid climber) to describe Burton as 'born of iron'. Whether from alcoholic zest or the more fashionable twentieth-century theory of occult powers, he recalled in a letter to William Rossetti 'bending double one fork in an energetic mood at dinner'.

The energetic moods led to his being asked to resign from the Arts Club, although Whistler proved a warm friend here, telling the committee, according to Ezra Pound, 'You ought to be proud that there is in London a Club where the greatest poet of our time *can* get drunk, if he wants to, otherwise he might lie in the gutter.'

Whistler and Swinburne, both small, witty and irrepressible, had taken to each other almost on sight, and visited Paris together, where they met Fantin-Latour and Manet, but not (to Swinburne's grief) Baudelaire. It was Swinburne who wrote a poem, *Before the Mirror*, inspired by Whistler's *Little White Girl*, and alone of the Pre-Raphaelites, perhaps because he was not stylistically and creatively involved as an artist, he appreciated this new vital movement from the Paris art scene, in which impressionism and a sense of atmosphere were replacing the naturalistic detail so valued by his English painting friends. Characteristically, he became devoted to Whistler and Whistler's mother, who lived together in an uneasy, unspoken-of association with Whistler's model Jo on the Chelsea Embankment; and equally characteristically he utterly charmed Mrs Whistler, who had no idea of the kind of nurseling her maternal affection was being lavished on. When invited to Whistler's first one-man art show at 48 Pall Mall, he declared it 'only second—if *second* to anything—to the very greatest works of art in any age'. Pre-Raphaelites, when a personal loyalty was involved, never damned with faint praise.

By the end of the 1860s, the solicitor Theodore Watts-Dunton had arrived on the scene, investigating Swinburne's business affairs with the publisher John Hotten, who had withdrawn a Swinburne work for fear of prosecution (Swinburne's rage at 'the hound of a publisher' was not unmixed with fear that Watts-Dunton might discover 'the school list'—a reference to his contributions to the flagellant side of Hotten's publishing house. He had already found Watts-Dunton shocked by de Sade, and warned Howell, who was inevitably involved in these transactions). Swinburne, like Rossetti, had his diplomatic or hypocritical side, where actions rather than writings were involved, at least after his first youth. When the wretched and unfortunate Solomon was arrested, he had almost instantly deserted his friend, expressing horror at his having '*done* things'. Solomon's desertion by his friends and unhappy, wasted end, was one of the more discreditable episodes of Pre-Raphaelite history. He was not untalented as an artist.

Swinburne, though, also like Rossetti, had his generous loyalties, and when Morris published *The Life and Death of Jason* he was warm in response: 'Here is a poem sown of itself, sprung from no alien seed, cast after no alien model; fresh as wind, bright as light, full of the Spring and sun.' Of Rossetti's *House of Life* sequence of sonnets he was to write that there had been 'no work of the same pitch since Dante sealed up his youth in the sacred leaves of the *Vita Nuova*'. (Morris compared it to the sonnets of Shakespeare, a minor Elizabethan poet whom Swinburne seems momentarily to have forgotten.) Later, Rossetti was to break with him entirely, a division, regretted by a mystified Swinburne, which was never to heal; but in 1870 both he and Fanny nursed the young poet through an illness at Cheyne Walk (it did not prevent Fanny, rummaging with her usual acquisitiveness through Rossetti's drawers in after years, and finding some of Swinburne's more indiscreet letters, from attempting a little discreet blackmail under her married name of Mrs Schott. But by then the guardian solicitor Watts-Dunton was running Swinburne's life and fully able to cope with the situation).

The proclamation of the French Republic on 4 September 1870 sent Swinburne, the natural republican, into 'a state of lyric discharge with brief intermission'. The result was a Shelleyan *Ode on the Proclamation of the French Republic*, which 'literally burst out of me'. When Mazzini died at Pisa in 1872, he wrote to his mother that he had lost 'the man whom I most loved and admired of all men on earth'. Eleven years later he was to mark the death of Richard Wagner with a poem, very different from the diatribe on tyranny and impotence with which he celebrated the death of the hated Napoleon III. A link with Shelley, much closer than Landor's, that he particularly appreciated was a meeting with Edward Trelawny, who had been Shelley's close companion in the last tragic days at Leghorn, and who in old age sat for Millais in his picture, *The North-West Passage*. Not unexpectedly, Trelawny proved full of 'passionate sympathy with the exiles of the Commune', and doubtless enthralled the young poet with the tales of his dubious piratical exploits and

174

Arabian adventures, as he had enthralled the Shelleys and their circle so many years before. It would be interesting to know if he met Howell, who had more than a touch of a seedier Trelawny about him.

Another enthusiasm of Swinburne's was François Villon, whose disreputable magic as a poet magnetized him as much as it magnetized Rossetti. Like Rossetti, he translated Villon's poetry and also wrote a splendid Villon pastiche, *Prince of all Ballad-Makers*, on the medieval poet himself:

> Bird of the bitter bright grey golden morn
> Scarce risen upon the dusk of dolorous years
> First of us all and sweetest singer born
> Whose far shrill note the world of new men hears
> Cleave the cold shuddery shade as twilight clears

He shared his enthusiasm with a friend, Justin McCarthy, whose popular novel on Villon, *If I Were King*, became in the twentieth century the basis of a stirring and romantic American musical play, *The Vagabond King*, with music by Rudolf Friml.

He poured out verse and works of criticism, between mercurial moods of depression and manic high spirits, 'the dull monotonous puppet-show of my life' and 'my endless passionate returns to the sea in all my verse'. Edmund Gosse, a new literary friend of suspect loyalty and a forked tongue, remarked that he seemed 'to divide his hours between violent cerebral excitement and sheer immobility'; and he developed a waspish dislike for the works of George Eliot, in some way looking on them as a menace to the novels of Charlotte Brontë, which he much admired. Long before the rest of the world, he appreciated the genius of Emily Brontë's *Wuthering Heights* and perhaps deliberately cribbed her 'wild Decembers' in his *To a Seamew*, written on Beachy Head in his fiftieth year:

> When I had wings, my brother,
> Such wings were mine as thine:
> Such life my heart remembers
> In all as wild Septembers . . .

175

Perversely, when the Bulgaria–Turkey question set Morris and Burne-Jones campaigning against war and the possible British siding with Turkey, Swinburne allied himself with Disraeli, who was moved by fear of a more national Russian threat to India, and supported the Turks. Vituperatively, in verse and pamphlet, Swinburne attacked Ruskin and Carlyle ('the most foul-mouthed man of genius since the death of Swift'). Carlyle had attacked Swinburne as standing in a cesspool and adding to its contents, and Swinburne was never the man to give back less than he got. Backing Disraeli meant attacking Gladstone, and further severing himself from, in particular, Burne-Jones. Swinburne afterwards pointed out bitterly that the far worse murders of the native population by Governor Eyre in Jamaica did not arouse his fellow Pre-Raphaelites' agitation.

The Gladstone attack had repercussions in 1892, when Tennyson died and Queen Victoria is said to have ventured the remark that she had heard Swinburne was the best poet in her dominions. Gladstone pointed out the unsuitability of an avowed republican for the post of Poet Laureate, and doubtless thought of other unsuitable qualities in addition; but it is doubtful if Swinburne, the rebel, would have accepted in any case. Two years before his death he refused an honorary degree at Oxford, and a year later, when *The Times* reported he was to be given the Nobel Prize for Literature, he responded sharply that he had not been offered 'the honour of taking a back seat behind Mr Rudyard Kipling!' (Kipling had been awarded the Nobel Prize the year before, 1907.) Burne-Jones had been dead for ten years, and could not be disturbed by this waspish sting of his nephew. Morris also brushed aside the suggestion of becoming Poet Laureate, remarking characteristically to his family that he could not see himself 'sitting down in crimson plush breeches and white silk stockings to write birthday odes in honour of all the blooming little Guelflings and Battenburgs that happen to come along'. In the end, the recipient was a safe nonentity, Alfred Austin.

There is no doubt that by the age of just over forty Swinburne was almost literally staring death in the face through his

excesses, especially his drinking excesses. And whatever the real truth (which may have been less lurid), he courted some most disagreeable publicity, including rumours of bestiality as well as homosexuality at his friend George Powell's cottage at Entretat, named 'La Chaumière de Dolmance' after Sade's *La Philosophie dans le Boudoir* (the servants were certainly all good-looking boys chosen in London, supplemented by a female ape who was claimed to be something more than a pet, and to have ended up in the stew-pot). His publication was now often of earlier material and it was Lord Houghton who, finding Swinburne in a delirious, naked and semi-starved state in an unclean room, finally got in touch with his mother, Lady Jane, and the guardianship by Watts-Dunton was arranged. Swinburne, with his father's legacy in trust and an allowance handled by Watts-Dunton, was deposited like a broken doll at the gloomy suburban villa, The Pines; fed and mended; weaned from brandy to port and finally beer; and apparently thriving on the treatment, and without regrets, ensured a long life to the age of seventy-two, in which gurgling over babies in their prams on Putney Heath, during his very active daily walks to Wimbledon, seems to have been the major excitement.

It is true there were visitors, carefully vetted by Watts-Dunton, who also tried to vet some occasional reversions to more dangerous ideas or descriptions in Swinburne's poetry. But it is not really true that his influence was Frankensteinian, or that Swinburne did not continue to have an intellectually stimulating and creative life. Already, before Watts-Dunton took over, critics not ill-disposed to his work had suggested the spring of his poetic genius had not so much run dry as remained static, without serious development, over a period of years; and this has been true of other poets than Swinburne. In fact in October 1881, two years after coming to The Pines, he finished *Mary Stuart*, the last play of his monumental dramatic trilogy, although it is true *Bothwell*, the second play, is usually the most admired.

It was by no means a purely romantic or one-sided characterization: Swinburne's perceptions on character, nurtured in

his studies of Shakespeare, Marlowe, the Jacobeans and Greek tragedy, had nothing of the sentimentality of his era and his political sense, too, was keen. For all the fascinations that he saw in Mary, he also gave Elizabeth her due both as a character and as a monarch pressed into Mary's execution by state necessity as well as sudden, and fully understandable, feminine rage. Mary was

> Unmerciful, unfaithful, but of heart
> So fiery high, so swift of spirit and clear,
> In extreme danger and pain so lifted up,
> So of all violent things inviolable,
> So large of courage, so superb of soul,
> So sheathed with iron mind invincible
> And arms unbreached of fireproof constancy . . .
> She shall be a world's wonder to all time,
> A deadly glory watched of marvelling men.

In *Bothwell*, Mary takes leave of her native Scotland with lines that anticipate this 'deadly glory' and 'iron mind', going forth

> On this grey sterile bitter gleaming sea
> With neither tears nor laughter, but a heart
> That from the softest temper of its blood
> Is turned to fire and iron. If I live,
> If God pluck not all hope out of my hand,
> If aught of all mine prosper, I that go
> Shall come back to men's ruin, as a flame
> The wind bears down, that grows against the wind,
> And grasps it with great hands, and wins its way,
> And wins its will, and triumphs . . .

If Schiller's *Mary Stuart* is still actable (and it has been staged at least twice in England in my lifetime), it is not unfair to say that Swinburne's might still be revivable in a necessarily compressed form. Already our time has seen two notable productions of Ford's *'Tis Pity She's a Whore* (by the great actor Donald Wolfit and by the Actors' Company), unthinkable on the stage

in Swinburne's time, notwithstanding his fine and penetrating commentary on this tragedy of incest.

In the only other tragedy of the time based on incestuous love, Massinger's 'Unnatural Combat', the criminal is old and hardened, a soul steeped in sin, a man of blood and iron from his youth upwards; but on Giovanni his own crime falls like a curse, sudden as lightning ... The curious interfusion of reason with passion makes him seem but the more powerless to resist, the more hopeless of recovery. His sister is perhaps less finely drawn, though her ebbs and flows of passion are given with great force, and her alternate possession by desire and terror, repentance and defiance, if we are sometimes startled by the rough rapidity of the change, does not in effect impair the unity of character, obscure the clearness of outline. She yields more readily than her brother to the curse of Venus, with a passionate pliancy which prepared us for her subsequent prostration at the feet of her confessor, and again for the revival of a fearless and shameless spirit under the stroke of her husband's violence ... That swift and fiery glance which flashes at once from all depths to all heights of the human spirit, that intuition of an indefinable and infallible instinct which at a touch makes dark things clear and brings distant things close, is not a gift of his; perhaps Webster alone of English poets can be said to share it in some measure with Shakespeare. Bosola and Flamineo, Vittoria Corombona and the Duchess of Malfi ... good characters and bad alike, all have this mark upon them of their maker's swift and subtle genius; this sudden surprise of the soul in its remoter hiding places at its most secret work. In a few words that startle as with a blow and lighten as with a flame, the naked natural spirit is revealed, bare to the roots of life. And this power Ford also has shown here at least.

William Hazlitt wrote that the great actor Edmund Kean illuminated Shakespeare by 'flashes of lightning': all great critics, too, have this power, and Swinburne did not need the aid of Sigmund Freud and psychoanalysis, any more than did the dramatists whose work he was assessing. His essay on Ford was, of course, written at the height of his creative life and energy. But his reading life continued vibrant at The Pines, and his visitors included Madox Brown, William Rossetti, Morris,

Burne-Jones, Bernard Shaw, Max Beerbohm, and even Isabel Burton, who had once bitterly resented Swinburne's riotous companionship with her husband and who on Burton's death, to Swinburne's helpless fury (and that of some portion of posterity), had burned her husband's journals. Now she referred to Swinburne's 'charming den', in which, unexpectedly daring, she smoked a cigarette. Swinburne had, after all, dedicated his *Poems and Ballads*, Second Series (1878) to Burton, although he celebrated her burial of her husband in the Catholic cemetery at Mortlake with acerbity:

> Priests and the soulless serfs of priests may swarm
> With vulturous acclamation, loud in lies,
> About his dust while yet his dust is warm
> Who mocked as sunlight mocks their base blind eyes.

Burton himself had a tribute in his more splendid vein:

> A soul whose eyes were keener than the sun,
> A soul whose wings were wider than the world.

In spite of his disapproval of Burton's Christian burial, and his explicit instructions that the burial service should never be read over his own grave, he too was buried with the full rites of the Established Church, next to his closest relatives at Bonchurch, Isle of Wight. Watts-Dunton, who had promised him to the contrary, did send a telegram to the worried vicar, but without effect. It is not quite clear why Watts-Dunton was not present, except that he was now very elderly himself. A few years before he had been spry enough to marry a young girl of scarcely twenty years old, an arrangement that seems to have proved surprisingly happy for all three parties, including Swinburne. The funeral was an imposing affair with a number of famous people present, and *The Times* wrote, with a respect which could only have aroused the new-born ghost's derision, that it was 'a fitting and beautiful end to a noble and beautiful life'.

Peaceful it had been, following a chill caught on a rainy walk

across the Heath; and Swinburne died quietly surrounded by relics of the past, under portraits of Mazzini, Landor and William Morris, and drawings and paintings by Rossetti and Burne-Jones. It was, for all the intermittent turbulence, an essentially Pre-Raphaelite end.

Whistler, Wilde and the
Aesthetic Influence

Less than twenty years after their first eruption on the artistic world, the Pre-Raphaelites were facing a new painting style and a new threat. It came from Paris, and was at first recognizable only as a young companion in their midst, of volatile wit and with the élan of a natural *poseur*. The young painter was Whistler, a butterfly hovering around the perimeter of the group, with a house just off Cheyne Walk and a passion for the river scene as ineradicable as Rossetti's own.

It was Rossetti who had suggested to Whistler a device for signing his pictures that eventually solidified into a butterfly. And it was through Ruskin, later, that the Pre-Raphaelite scene endured the volcanic stresses of one of the most famous law-suits in artistic history. Although this was Whistler's main contribution to the movement, he cannot be entirely divorced from it, as a person if not as a painter.

American-born, he had been brought up in Russia where his father, a civil engineer and former Major in the American army, was engaged by Czar Nicholas I to supervise the construction of the 420-mile railway line from Moscow to St Petersburg. At the age of ten James McNeill Whistler began to take drawing lessons at the Imperial Academy of Fine Arts in St Petersburg, heading the first-year students' examinations in 1846. He had already, when ill, been given a book of illustra-

tions which caused him to maintain that William Hogarth was the greatest English artist, and when he was sent to England, soon afterwards, to avoid the Russian cholera epidemic, he attended lectures at the Royal Academy. His father died, weakened by cholera, in 1849.

Jimmy then went back to America with his mother and became a cadet at West Point, where he began to study and practice lithography for topographic purposes. True at least in this to Swinburnian form, he was expelled for persistent late revelling, and became for a time a draughtsman in the Washington Coast Survey, engraving and etching maps on which unexplained seagulls began increasingly to appear. This quite valuable experience also came to an abrupt end. 'I was not late: the office opened too early,' commented Whistler airily. And in 1855, at the age of twenty-one, finding the American art world utterly restrictive, he took a first-class ticket to Paris, where he lived in a state of artistic bohemianism and some penury for the next few years.

His inspiration had been Henri Murger's *Vie de Bohème*, and soon he was a part of the whole George du Maurier group which later formed the basis of *Trilby*. His adopted master was Courbet, he sketched Fantin-Latour in bed, and like Swinburne was influenced by the writers Gautier and Baudelaire. 'In our beginnings', wrote Degas, 'Fantin, Whistler and I were all on the same road, the road from Holland.' It was an art world quite outside the world of the Pre-Raphaelite painters, and when Whistler moved on to London, so far from rejecting the marks of the Industrial Revolution, he absorbed them as part of his aesthetic experience. Setting himself up at first in that haven of English artists, Newman Street, he was soon going downstream tirelessly to Wapping, painting and etching grimy river scenes and wharves which would have made the young Millais of *Ophelia* merely shudder.

Rejected by the Paris Salon, his *At the Piano* and five etchings were accepted by the Royal Academy, and soon he met Ruskin, Rossetti and Burne-Jones. Millais even praised some of his work. But Whistler, unlike the Pre-Raphaelites, was moving

183

on in style. His *The Thames on Ice*, painted at Rotherhithe dock-side, began to show atmospheric, rather than realistic, qualities in the painting, and his 'harmonies' and 'nocturnes' later rejected the whole Victorian outlook of seeking a story in a picture, and developed a form of suggestion, dim in outline and colour, that earned him much abuse yet established him as a painter popular among more forward-looking patrons, anticipating as he did the new French impressionist tradition.

His own canvas, he wrote to *The World* of one of his paintings, was 'a snow scene with a single black figure and a lighted tavern. I care nothing for the past, present or future of the black figure, placed there because black was wanted at that spot.' His 'nocturnes' deliberately studied the night, always a difficult subject for a painter. He had painted the first of them in Valparaiso harbour, and *Twilight on the Ocean* (later retitled in his new manner, *Crepuscule in Flesh Colour and Green*) appeared in the Paris International Exposition at the Champ de Mars in 1867, together with *Old Battersea Bridge*, *The White Girl* (later called *Symphony in White*) and *Wapping*. His intelligent, red-haired model Jo was the model in the last two pictures and, like himself, mixed easily in the social group at Rossetti's Tudor House.

As a designer Whistler was as original, in one direction, as Morris, and even nearer to the twentieth century in his uncluttered white and yellow scheme for the rooms of his Chelsea house, with furniture kept to a minimum. The only thing he seems to have absorbed from Rossetti (whose painting he disliked) was an interest in the decorative values of the peacock. It reached a reverberating climax with one of Whistler's most ambitious and disastrous commissions, the decoration of the main room of the house of a wealthy patron with the most famous and (in the opinion of the reluctant owner) infamous peacocks in artistic history. The Whistler peacock panels became legendary, and the owner, stuck with them on a large and all-pervading scale, seems to have reached a state of something like Nirvana, acting as host at dinner parties composed of thinly-disguised bird-watchers.

In his caustic wit and total disregard for conventional reactions, Whistler was closer to Swinburne than any of the Pre-Raphaelites. His natural counterpart later was Oscar Wilde. All three could be said to be reflected in Gilbert's satiric figure of Bunthorne, the 'fleshly poet', in *Patience* in 1881, and although Whistler's famous white lock of hair and affectation of an eyeglass were copied by George Grossmith, the original player of the part, and his successors, it must not be forgotten that Bunthorne's poetic style, like Swinburne's, was in his own words 'highly spiced'. Wilde, at the time *Patience* was completed (November 1880), had not yet published his first collection of poems, which appeared in the spring of 1881 (*Patience* was staged in April), and probably the only echoes of him in Bunthorne are in the cult of 'dirty greens' and the sunflower, which the aesthetes had taken up and inflated from its early Pre-Raphaelite beginnings, to Rossetti's disgust. 'If you walk down Piccadilly with a poppy or a lily in your medieval hand' may well have glanced at Wilde but no less at the lilies held by so many figures in Pre-Raphaelite paintings, and the reference to 'stained-glass attitudes' reflects more on Morris and Burne-Jones.

> A greenery-yallery, Grosvenor Gallery
> Foot-in-the-grave young man!

could have applied to almost any of them, for the Grosvenor Gallery when opened by Sir Coutts Lindsay became largely, as it was intended to be, a Pre-Raphaelite stronghold.

Nevertheless, *Patience* was a send-up with obvious opportunities for the alert publicity-minded egotist, and in fact Oscar Wilde toured America as a lecturer to coincide with, and certainly by his style of dress to publicize, the production there of Gilbert and Sullivan's new comic opera.

Whistler, too, was never averse to this kind of publicity; an attack of savage bile on the whole nature and value of his work as a painter was another matter. Ruskin was in one of his states of mental decline and depression when, in his review of the Grosvenor Gallery exhibition in 1877 (two years after the death

of Rose La Touche), he saw Whistler's *Nocturne in Black and Gold: The Falling Rocket* (an impression of fireworks at Cremorne) and wrote:

> For Mr Whistler's own sake, no less than for the protection of the purchaser, Sir Coutts ought not to have admitted works into the gallery in which the ill-educated conceit of the artist so nearly approached the aspect of wilful imposture. I have seen, and heard, much of Cockney impudence before now; but never expected to hear a coxcomb ask two hundred guineas for flinging a pot of paint in the public's face.

It was not his first attack. In 1873 in a lecture at Oxford, without naming the painter, he had referred to 'a daub, professing to be "a harmony in pink and white" (or some such nonsense); absolute rubbish, and which had taken about a quarter of an hour to scrawl or daub'. (In fact Whistler took almost as long a time to complete some of his canvasses as Burne-Jones. Impressionistic effects can be just as studied and painfully acquired.) It is just possible Whistler had not read this, although the artistic grapevine was extensive; but the new attack was in the prominent *Fors Clavigera*, and a suggestion that it was libellous made to Whistler in the Hanover Square Arts Club sent the aggrieved artist rocketing into litigation.

As it happens 'rocketing' was not quite the right word, in spite of the subject-matter of his picture, for the case took over a year to get into Court, partly because of Ruskin's illness. Whistler had already been near bankruptcy, and indeed achieved it not long afterwards, and he had some genuine concern about the effect of this attack, denying him the right even of art gallery exhibition on his merits. The Paris impressionists had few supporters in London at this time. Ruskin's was less a balanced appreciation or criticism than an outright, seemingly malicious and total dismissal, challenging Whistler's right to earn his living, and charge a good fee, as an artist. Nevertheless, the critic's long support of and kindness to others in the same field made it very difficult for them not to side with him, more especially as Pre-Raphaelite painting was itself so meticulous in

186

its detail and so alien in style to the new, as yet unaccepted, tenets of impressionism. The fact that basically Whistler, with his draughtsman's experience, was at least as good a technician as some of them, but was quite deliberately blurring that technique and experimenting in a new and valid form, which also took time at the easel, was beyond the comprehension of Ruskin as it was of Burne-Jones, that labourer for long years in the vineyard of a single painting.

Ruskin's reaction was as unbalanced as his criticism. 'It's mere nuts and nectar to me', he wrote to Burne-Jones, '. . . and the whole thing will enable me to assert some principles of art economy which I've never got into the public's head by writing.' His duty as a critic was to recommend artists of merit, and to prevent those of no merit from receiving public attention. Ruskin was, frequently and at his best, a very good critic, the critic who appreciates rather than derides, but his dangerous assumption of Olympian judgement on matters of merit was here of the kind most disastrously (for themselves and sometimes the attacked) assumed by third-rate critics with stereotyped qualities of mind, and there was little legal hope of Ruskin's winning the case, in spite of Burne-Jones' reluctant appearance to defend the principles of technically-exact painting.

William Rossetti, with great honesty and courage, appeared for Whistler. 'I consider the *Blue and Silver* an artistic and beautiful representation of a pale but bright moonlight.' When pressed, he denied the same merits to *The Falling Rocket*, but steadfastly maintained it was still a work of art, and the price of two hundred guineas asked represented the full value of the picture.

In spite of a comic diversion when Whistler's nocturne in black and gold was placed upside-down in the court-room by mistake (and without anyone except himself being the wiser), the judgement was in Whistler's favour, although with a contemptuous nominal award of one farthing damages instead of the £1,000 for which he had asked. Moreover, both litigants had to pay their own costs. The Pre-Raphaelites rallied round Ruskin and helped to meet his, but for Whistler it was

momentary disaster, and *The Falling Rocket* was not sold until 1892. In the end, his reputation, and ability to sell his pictures, were not seriously impaired. Long afterwards, the French impressionists for whom he had prepared a way in England were to overwhelm his own work in critical and public evaluation. It was not totally a just verdict, when it came, and Whistler's poetic and atmospheric nocturnes and symphonies may yet have a fashionable revival. The *Nocturne in Blue and Silver*, showing the 'Cremorne Lights' reflected distantly over the long stretch of water; the light behind the sky above the ships of Valparaiso harbour; and the deeper night enveloping Battersea Bridge with its towering pier and near-invisible spray of dying fireworks, all to be seen in the Tate Gallery, still retain impressionistic beauties which some of the lesser French and English pictures, of altogether coarser fibre, around them never had.

His personal genius was as a wit, and Wilde in this owed much to him. It was said that at a dinner party, following a sparkling *bon mot* by Whistler, the younger man remarked to him: 'I wish I'd said that, Jimmy.' 'You will, Oscar,' replied Whistler instantly. 'You will.' Perhaps one or two children of Whistler's acute brain did creep into Wilde's brilliant and stylish dialogue later, but Wilde's work, like that of Aubrey Beardsley and others, grew out of new directions in art, design and literature, and a new decadence. Yet the whole nineties and early Edwardian scene were at the end of an umbilical cord stretching back to the Pre-Raphaelite revolution. It was originally Wilde's main inspiration, beginning at Oxford when he laboured so unexpectedly at road-making for Ruskin, and came also under the influence of Walter Pater who believed in Art for Art's Sake, as Rossetti had done. He won the Newdigate Prize for English verse which had escaped Swinburne, and a double first in Classics. And according to his son, Vyvyan Holland, he 'filled his rooms looking over the Cherwell with blue china and reproductions of paintings by Rossetti and Burne-Jones'. He was even capable, in *The Critic as Artist*, of drawing a parallel: 'And I assure you, my dear Ernest, that the Greeks chattered about painters quite as much as people do nowadays, and had

their private views, and shilling exhibitions, and Arts and Crafts guilds, and Pre-Raphaelite movements . . .' The dialogue form came naturally to him as it did to Plato and Thomas More, and for all their witty shimmer the exchanges in his plays—for instance between John and Algy in *The Importance of Being Earnest*—are based on the same classic style of argument-through-conversation.

It is wrong to look on Wilde as the aesthete pure and simple. Art for art's sake was only a part of life, unrealizable for most people, and even most artists, in modern conditions. Because the lines are usually cut in stage performance, audiences fail to realize that even his plays show an occasional social or political comment, and *The Soul of Man Under Socialism* is a curious example of what he owed to Ruskin and Morris. Even before his own imprisonment, Wilde had the sensitivity to understand with particular vividness the dilemmas of poverty and industrial conditions, and in this essay he tried to come to grips with the only possible solution. Whatever this solution might be, it could not lie in charity, so comforting a self-justification for wealthy Victorians. '. . . their remedies do not cure the disease: they merely prolong it. Indeed, their remedies are part of the disease.'

They try to solve the problem of poverty, for instance, by keeping the poor alive; or, in the case of a very advanced school, by amusing the poor.

But this is not a solution; it is an aggravation of the difficulty. The proper aim is to try and reconstruct society on such a basis that poverty will be impossible. And the altruistic virtues have really prevented the carrying out of this aim. Just as the worst slave-owners were those who were kind to their slaves, and so prevented the horror of the system being realised by those who suffered from it, and understood by those who contemplated it, so, in the present state of things in England, the people who do most harm are the people who try to do most good; and at last we have had the spectacle of men who have really studied the problem and know the life—educated men who live in the East End—coming forward and imploring the community to restrain its altruistic impulses of charity, benevolence,

and the like. They do so on the ground that such charity degrades and demoralises. They are perfectly right. Charity creates a multitude of sins.

Socialism is the answer:

> Socialism, Communism, or whatever one chooses to call it, by converting private property into public wealth, and substituting co-operation for competition, will restore society to its proper condition of a thoroughly healthy organism, and ensure the material well-being of each member of the community. It will, in fact, give Life its proper basis and its proper environment.

But authoritarian Socialism will not do: what is needed is Individualism. 'If the Socialism is Authoritarian; if there are Governments armed with economic power as they are now with political power; if, in a word, we are to have Industrial Tyrannies, then the last state of man will be worse than the first.' At the moment Individualism is only possible for a few of the rich: under socialism, without private property, the poor, too, will develop individuality and mind. And they will do so when the machine is used to take over the more disagreeable tasks (allotted to criminal slaves, in the absence of machines, we remember in More's Utopia), leaving the men free to work in the way their varied individualities indicate—in the arts, the sciences, or crafts.

This was Morrisian, and Wilde joined him too in urging agitation among the poor to change society. '. . . the best among the poor are never grateful. They are ungrateful, discontented, disobedient, and rebellious. They are quite right to be so.' The unthrifty, rebellious poor man 'is probably a real personality, and has much in him'. So far he could follow Morris to his agitation among the Glasgow socialists and Durham weavers, and so far, too, he could reject the Carlyle–Ruskin doctrine of the dignity of labour. 'There is nothing necessarily dignified about manual labour at all, and most of it is absolutely degrading . . . all work of that kind should be done by a machine.' 'Under proper conditions machinery will serve man', almost a paraphrase of Morris.

190

There is also an extraordinary Godwinian optimism, an echo of *Political Justice* which he had most probably never read. 'When private property is abolished there will be no necessity for crime, no demand for it; it will cease to exist.' But if Wilde did not know his Godwin he certainly knew his Shelley. 'There will be great storages of force for every city, and for every house if required, and this force man will convert into heat, light, or motion, according to his needs. Is this Utopian? A map of the world that does not include Utopia is not worth even glancing at . . .' His knowledge of this particular aspect of a new Utopia did not need Shelley's powers of scientific pre-vision, which near the beginning of the century had foreseen the time when electricity would be so harnessed that houses would be lit or heated at the press of a button. The new Savoy Theatre built by Richard D'Oyly Carte, and to which *Patience* was transferred from the Opéra-Comique in the middle of its run, was the first theatre in Europe to be illuminated entirely by electricity instead of gas.

The influence of prison on Wilde was to take him out of Utopia into Reading Gaol, but the experience only intensified a social conscience that had always been present. The com-passion *and* common sense of his two long letters on prison reform, and the imprisonment and ill-treatment of children, in the *Daily Chronicle* in 1897, simply gave body and specific direction to his sense of dire social needs. And now he kept to the matter in hand, with human pity and without diversions on art, into which *The Soul of Man Under Socialism* had meandered in the days when he could look on the people as units for art reform and intellectual morons, rather than as human beings. There is no talk of art, or vulgar popular taste, in these two letters. Like Lear, he had torn off the robes and furr'd gowns, and come down to 'the thing itself'.

His early poetry and prose have much in them of Swinburne, not the least in the Preface to *The Picture of Dorian Gray*: 'No artist is ever morbid. The artist can express everything.' No-thing could be more Swinburnian than *Salome*, which, in fact, he was forced to write in French (Lord Alfred Douglas' transla-

tion was forbidden English theatre performance. What the poet could get on to the printed page, the English dramatist until very recently could never get spoken on the stage). And what of *The Garden of Eros*, that poem full of Pre-Raphaelite echoes?

> Morris, our sweet and simple Chaucer's child,
> Dear heritor of Spenser's tuneful reed,
> With soft and sylvan pipe has oft beguiled
> The weary soul of man in troublous need,
> And from the far and flowerless fields of ice
> Has brought fair flowers to make an earthly paradise . . .
>
> . . .
>
> Spirit of Beauty, tarry yet awhile!
> Although the cheating merchants of the mart
> With iron roads profane our lovely isle,
> And break on whirling wheels the limbs of Art,
> Ay! though the crowded factories beget
> The blind-worm Ignorance that slays the soul, O tarry yet!
>
> For one at least there is,—He bears his name
> From Dante and the seraph Gabriel,—
> Whose double laurels burn with deathless flame
> To light thine altar; He too loves thee well,
> Who saw old Merlin lured in Vivien's snare,
> And the white feet of angels coming down the golden stair, . . .

The Wilde scandal and tragedy threw the whole aesthetic movement into disrepute, until some thirty-five years later when Noel Coward was able to echo the period, with humour and without adverse comment, in the 'Green Carnation' quartet in *Bitter Sweet*. In the meantime there were Beardsley and the Yellow Book, further features of *fin de siècle* decadence and the glitter of Art Nouveau. Beardsley was a follower who disconcerted the remaining Pre-Raphaelites. His curvacious feminine outlines still showed the Japanese influence which had first invaded London in the Japanese Exhibition which inspired Gilbert to write *The Mikado*, and which could be seen, through

the inspiration of Japanese prints and the West's discovery of Hokusai, in Manet's running of his pictures out of the frame. (Yet Madox Brown had done this in *The Last of England* as early as 1855.) Japanese prints were already admired by Ruskin and Rossetti soon after the mid-century, and decoratively the influence was apparent in English ceramic and other designs, including some associated with The Firm.

In literature and criticism the fastidious Max Beerbohm, who succeeded Shaw as a dramatic critic, continued the line but with sparse output. Bernard Shaw's early novel *Immaturity* was drawn from the Pre-Raphaelite scene, and in spite of their sometimes differing views of socialism Morris had a profound effect on him. To his mind, Morris represented that looking to the future which with Shaw himself culminated in *Back to Methuselah*.

He was ultra-modern—not merely up-to-date, but far ahead of it: his wall papers, his hangings, his tapestries, and his printed books have the twentieth century in every touch of them; whilst as to his prose wordweaving, our worn-out nineteenth century Macaulayese is rancid by comparison. He started from the thirteenth century simply because he wished to start from the most advanced point instead of from the most backward one—say 1850 or thereabouts.*

In 1891 Shaw went on an Art Workers Guild tour to Milan, Verona, Venice, Padua, Mantua and Pavia, and wrote an immense letter to Morris from Venice, ridiculing the naïvety and wonder of the Guild tourists: 'They stare at turners and coppersmiths, and buy the antiquities which the blackguards are making under their very noses . . .' He then launched wittily into a diatribe on Milan Cathedral: 'it struck me as representing the result of giving a *carte blanche* order for the biggest thing of the kind that could be done. Every sort of decoration is heaped up and elaborated and repeated. There are windows miles high and acres broad . . .' And Morris was doubtless duly horrified to learn of St Mark's that Shaw 'expected above all things color, and it is *scraped clean*'.

* *Pen Portraits and Reviews.*

Shaw knew his man. 'Splendid walls, splendid windows, splendid stairs, splendid pinnacles, but no vital, unanswerable, convincing arches, vaultings, and growths of stone into one great rooftree', he wrote of a disappointing Italy ('This is a generalization of my first hasty impression'). He also knew his Ruskin. 'The first day we were here was a very fine day & it convinced me completely that the only painter who had the least notion of what he had to paint was Turner.' As soon as he could afford to do so he followed Ruskin in publishing his own works, using the firm of Constable as Ruskin had set up George Allen, and providing all the money (which safeguarded his total literary control) while the publisher arranged mundane details of printing, production and distribution.

A whole artistic and literary generation of the nineties owed something to Pre-Raphaelitism, and also to the Pre-Raphaelite resuscitation of Blake. W. B. Yeats was particularly conscious of this, as Arthur Symons in his verse was conscious of Rossetti and Whistler:

> Shake out your hair about me, so
> That I may feel the stir and scent
> Of those vague odours come and go
> The way our kisses went . . .

The Rossetti hair-fetish is as recognizable as the atmospheric shimmer of Whistler's nocturnes:

> . . . the Embankment with its lights,
> The pavement glittering with fallen rain,
> The magic and mystery that is night's . . .

Symons, who made a special study of the Symbolist movement in literature, also wrote a book on Blake, and his own poetic version of *Beata Beatrix*:

> So I have seen the face of Beatrice,
> In pictures, dead, and in a memory,
> Seeing the face of Dante out of heaven,
> O, out of heaven, when for my sake you lean . . .

Beatrice and the Blessed Damozel, for Symons, are one. The influence, with Symons, worked both ways. When he was editing the Shakespeare Quarto Facsimiles he was among the visitors to The Pines, for Swinburne felt his discoveries could be useful to him in his own study of Shakespeare. Yeats also came to The Pines.

In spite of the widely different pathways taken by painting and sculpture since their time, there are still many art-lovers attracted to the Pre-Raphaelites. Exhibitions of some of the Manchester Art Gallery's collection and of the Aesthetic Movement, 1869–90, have been held in London, and an Arts Council film of coloured slides with narrative on the Pre-Raphaelite painters is shown regularly in English museums and galleries. In some ways this gives the most comprehensive idea of their work, for the fact that their finest paintings, designs and drawings are scattered in many art galleries, in England, Europe and America, has tended to give a very restricted idea of their range and scope. The colour in reproductions of the paintings is often very distorted.

The art criticism of Roger Fry, and the Impressionist, Post-Impressionist, Cubist and other stylistic triumphs, for a time eclipsed the Pre-Raphaelite school, but their colour revolution was influential on modern painting. Stanley Spencer's work-man-like figures in religious themes, in our own time, represent only one of the extensions of Millais' *Christ in the House of His Parents*, considered so blasphemous when he first exhibited it. The Kelmscott Press started a whole movement towards beauty in book production and illustration, of which the Vale Press, founded by the artist Charles Ricketts in 1896, was notable. Ricketts himself did designs for the bindings of Wilde's poems, and the last book the press published, a Bibliography of the Vale Press in 1904, was beautifully illustrated by him in the style of the Kelmscott *Chaucer*. In 1924, he designed the scenery and costumes for the first London production of Shaw's *Saint Joan*, and soon afterwards the most striking and imaginative D'Oyly Carte presentations of *The Gondoliers* and *The Mikado*. (Ricketts nevertheless expressed a curious antipathy to Morris as a man.)

In some ways it was Morris who provided the most lasting influence, in a wide variety of directions, and it is wrong to suggest, as already stated, that his involvement with the revival of arts and crafts was pure escapism, a rebellion against the whole machine society. Morris never believed that his little world of hand-made and decorated textiles and tapestries could provide goods and employment for a nation. It was the *quality* of design which he hoped to raise, including in machine-made goods for the many. 'What business have we with art at all unless all can share it?'

This was the basis of his socialism: to change the nature of man you had to change his environment, and change it for the better, both in the designs and art he lived amongst and his housing conditions. Walter Crane wrote of him:

> He naturally approached the question [of Socialism] from the art side, and it was the conviction of the hopelessness of any real and permanent or widespread improvement in design and handicraft . . . under the existing economic system and the deplorable effects of modern machine industry, both upon art and the workers under the control of competitive capitalistic commerce which really drove him into the Socialist camp. He hated the shams and pretences and pretentiousness of modern life and its glaring contrasts of wealth and poverty; he noted the growing ugliness of our cities; he loved simplicity; and, with all his keen artistic sense and instinct for colour and inventive pattern, I believe he preferred plainness, and even rudeness, to insincere or corrupt forms of art.

It is still a battle being fought today, against the growing ugliness of our motorways and cities and the pollution and spoiling of the environment. In this sense Morris was a pioneer, as were the Pre-Raphaelites in their earlier revolt.

Select Bibliography

RUSKIN

LEON, DERRICK: *Ruskin: The Great Victorian* (Routledge & Kegan Paul, 1949)

LUTYENS, MARY: *Millais and the Ruskins* (Murray, 1967)
(A revealing and indispensable collection of correspondence, with commentary, on the Effie Gray affair: a sequel to the same author's *Effie in Venice*)

QUENNELL, PETER: *John Ruskin: The Portrait of a Prophet* (Collins, 1949)
(Not as full and detailed a biography as Leon's, but still a very understanding and literate portrait)

ROSENBERG, J. D.: *The Darkening Glass: A Portrait of Ruskin's Genius* (Columbia University Press, 1961)

Works

Life, Letters and Works of John Ruskin (39 vols, Ed E. T. Cook and A. Wedderburn, 1900–11)

Unto This Last (1862) (Collins Illus Pocket Classic Ed)

Sesame & Lilies, etc (1863) (Dent 'Everyman' Library, Ed and Intro John Bryson, 1970)

Modern Painters, Vols I–V (1843–1860) (Universal Edition of Ruskin's Works, George Routledge & Sons Ltd)

The Stones of Venice (1851–3)

The Seven Lamps of Architecture (1849)

Munera Pulveris (1872: first published as Essays on Political Economy in *Fraser's Magazine*, 1862)

Fors Clavigera (1871–84)

Praeterita (Autobiography, 1885–9. Dent 'Everyman' Library, Intro Kenneth Clark, 1949)

Notes on the Construction of Sheepfolds (1851)

ROSSETTI

GRYLLS, ROSALIE GLYNN: *Portrait of Rossetti* (Macdonald, 1964)

PEDRICK, GALE: *Life with Rossetti* (Macdonald, 1964)
 (A supplement to Rosalie Grylls' excellent biography, concerning the relationship of Rossetti with his helper and secretary, the Cornish artist Henry Treffry Dunn)

Works

Letters to Mrs. Morris (catalogued under William Morris papers, vol XXV, add MSS 52,333 A & B, Add MSS 52,332 A & B, British Museum)

Poems (Dent 'Everyman' Library, Ed Oswald Doughty, 1961)

HUNT

Works

Pre-Raphaelitism and the Pre-Raphaelites (1905)

Pre-Raphaelitism (Chambers Encyclopaedia, 1908)

MILLAIS

LUTYENS, MARY: *Millais and the Ruskins* (1967) (See *RUSKIN*)

MORRIS

CRANE, WALTER: *William Morris to Whistler* (1911)

GLASIER, J. BRUCE: *William Morris and the Early Days of the Socialist Movement* (1921)

HENDERSON, PHILIP: *William Morris: His Life, Work and Friends* (Thames & Hudson, 1967)
 (The most up-to-date life, fully documented and lavishly illustrated. Also obtainable in paperback (Pelican))

MACKAIL, J. W.: *The Life of William Morris* (2 vols, 1899)

198

MORRIS, MAY: *William Morris: Artist, Writer, Socialist* (2 vols, 1936).
Vol II, 'Morris as a Socialist', consists of reprints of Morris' political
writings and a long account by Bernard Shaw: *Morris as I Knew
Him.*

THOMPSON, E. P.: *William Morris: Romantic to Revolutionary* (1955)
(A scholarly work with emphasis on Morris' socialistic side)

[A new biography, *William Morris,* by Jack Lindsay (Constable,
1975) appeared after this book was completed. His second half has
much emphasis on Morris' Marxism, adding to Thompson]

Works

Collected Works, Ed May Morris (24 vols, 1910–15)
The Letters of William Morris (Ed Philip Henderson, 1950)
William Morris. Selected Writings and Designs (Ed Asa Briggs. Pelican
paperback, 1962)
*William Morris. A Selection of his writings ed by G. D. H. Cole
(Nonesuch Library, 1948)
Art, Labour and Socialism (Reprint of Morris' lecture *Art Under Plutocracy*
(1884) by the Socialist Party of Great Britain, with 'a Modern
Assessment', 1962)
News from Nowhere (1890) (RKP paperback)
Also in paperback (Ballantine):
 The World of the Wondrous Isles
 The Wood Beyond the World
 The Well at the World's End

BURNE-JONES

BURNE-JONES, GEORGIANA: *Memorials* (1904)
ALEXANDRE, ARSENE: Preface, *Edward Burne-Jones,* Second
Series (Newnes Art Library)

[The first full biography of Burne-Jones since his wife's *Memorials,
Edward Burne-Jones* by Penelope Fitzgerald (Michael Joseph, 1975),
appeared after this book was written. It is most valuable on the
Zambaco affair.]

SWINBURNE

GOSSE, EDMUND: *Life of Algernon Charles Swinburne* (1917)

HENDERSON, PHILIP: *Swinburne: The Portrait of a Poet* (Routledge & Kegan Paul, 1974)
(The most valuable biography with the most up-to-date research)
LAFOURCADE, GEORGES: *La Jeunesse de Swinburne* (1928)
('The most illuminating analysis of the essential character of the man and his work'—Henderson)

Works

Letters (Ed Dr Cecil Y. Lang, Yale University Press)
The Complete Works (Bonchurch edition, 1925–27)
A Swinburne Anthology: Verse, Drama, Prose, Criticism: selected, with biographical intro by Kenelm Foss (Richards Press, 1955)
Lesbia Brandon (unfinished novel, pub 1952 with commentary by Randolph Hughes)

WHISTLER

WEINTRAUB, STANLEY: *Whistler* (Collins, 1974)

WILDE

The Complete Works (Intro by Vyvyan Holland: Collins, 1948. Reprint 1971)

BLAKE

BRONOWSKI, JACOB: *William Blake: A Man Without a Mask* (1947)
[Extended, revised and re-published as *William Blake and the Age of Revolution* (Routledge & Kegan Paul, 1972)]
ERDMAN, DAVID V.: *Blake, Prophet Against Empire* (Princeton, Revised Ed, 1969)
GILCHRIST, ALEXANDER: *Life of William Blake, with Selections from his Poems and Other Writings* (1863)
(Completed and edited by Dante Gabriel Rossetti)
MORTON, A. L.: *The Everlasting Gospel, a Study in the Sources of William Blake* (1958)
SABRI-TABRIZI, G. R.: *The 'Heaven' and 'Hell' of Willian Blake* (Lawrence & Wishart, 1973)
YEATS, W. B.: *The Works of William Blake* (1893)

GENERAL

CARLYLE, THOMAS: *Past and Present* (1843) (Dent 'Everyman' Library)

DARWIN, ERASMUS: *The Botanic Garden* (1789)

GAUNT, WILLIAM: *The Pre-Raphaelite Dream* (1943: 1st pub 1942 as *The Pre-Raphaelite Tragedy*)
(Imperceptive on Morris as man and socialist, but otherwise one of the best and most readable books on the subject, by a distinguished art critic)

HARRISON, MARTIN (Ed and Intro): *Pre-Raphaelite Paintings and Graphics* (1971: St Martin's Press, USA, 1973)

HUNT, JOHN DIXON: *The Pre-Raphaelite Imagination: 1848-1900* (Routledge & Kegan Paul, 1968)
(Very erudite and ranging in scope, concentrating on the writings and their influences in England and France. For the scholastic-minded.)

INGLIS, BRIAN: *Poverty and the Industrial Revolution* (Hodder & Stoughton, 1971. Paperback, Panther Books, 1972)

KLINGENDER, FRANCIS D.: *Art and the Industrial Revolution* (1947: Paladin paperback, 1972)

MORE, THOMAS: *Utopia* (Trans & Intro Paul Turner: Penguin Classics, 1965. Reprinted 1973)

NEWTON, ERIC: *European Painting and Sculpture* (Pelican, 1941)

PAINE, THOMAS: *Rights of Man* (Ed Henry Collins. Pelican Classics, 1969)

RUBINSTEIN, DAVID (Ed): *People for the People* (Intro Michael Foot. Ithaca Press paperback, 1973)
(A useful collection of essays on social history from 1381 onwards, including excellent studies of *William Morris: Art and Revolution* by Anthony Arblaster and *The Sack of the West End, 1886* ('Bloody Monday') by David Rubinstein.)

SHAW, BERNARD: *Pen Portraits and Reviews* (includes two studies of Morris: *William Morris*, a review of J. W. Mackail's biography, first pub *Daily Chronicle* 20 April 1899; and *William Morris as Actor and Playwright*, from 'The Saturday Review', 10 Oct 1896)

SHAW, BERNARD: *Collected Letters, 1874-1897* (Ed Dan H. Laurence. Max Reinnardt, 1965)

SHAW, BERNARD: *The Complete Prefaces* (Paul Hamlyn, 1965)

SHELLEY, P. B.: *A Philosophical View of Reform*

SHELLEY, P. B.: *Queen Mab.*

SHIELDS, CONAL (Intro): *Landscape in Britain* (Tate Gallery Exhibition, 1973)

SPENCER, CHARLES (Intro): *The Aesthetic Movement, 1869—1890* (Exhibition organized by Arkwright Trust, London Borough of Camden, 1973)

TERRY, ELLEN & BERNARD SHAW: *A Correspondence* (Reinhardt & Evans, 1949)

TOLKIEN, J. R.: *Lord of the Rings*

VILLON, FRANCOIS: *Ballades* (French and English. Selected by André Deutsch & Mervyn Savill. Limited Edition, Allan Wingate, 1946. Includes translations by Rossetti and Swinburne)

WELLS, H. G.: *The Time Machine*

WILLIAMSON, AUDREY: *Gilbert & Sullivan Opera: A New Assessment* (1953)

(Chapter VII, on *Patience*, includes a study of the Pre-Raphaelite/ Aesthetic influences in Gilbert's satire)

Index

INDEX